PHOTOBOOTH

PUBLISHED BY
PRINCETON ARCHITECTURAL PRESS
37 EAST SEVENTH STREET
NEW YORK, NEW YORK 10003

FOR A FREE CATALOG OF BOOKS, CALL 1.800.722.6657.
VISIT OUR WEB SITE AT WWW.PAPRESS.COM.

ALL PHOTOGRAPHS FROM THE COLLECTION OF BABBETTE HINES.

EDITOR: JENNIFER N. THOMPSON
DESIGNER: DEB WOOD

SPECIAL THANKS TO: NETTIE ALJIAN, ANN ALTER, NICOLA BEDNAREK,
JANET BEHNING, MEGAN CAREY, PENNY CHU, JAN CIGLIANO,
RUSSELL FERNANDEZ, CLARE JACOBSON, MARK LAMSTER,
NANCY EKLUND LATER, LINDA LEE, JANE SHEINMAN, KATHARINE SMALLEY,
AND SCOTT TENNENT OF PRINCETON ARCHITECTURAL PRESS
—KEVIN C. LIPPERT, PUBLISHER

LIBRARY OF CONGRESS CATALOGING-IN-PUBLICATION DATA

HINES, BABBETTE, 1967-
 PHOTOBOOTH / BABBETTE HINES.
 P. CM.
 ISBN 1-56898-381-6 (HARDCOVER : ALK. PAPER)
 1. PORTRAIT PHOTOGRAPHY--UNITED STATES. 2. PHOTOBOOTHS--UNITED
 STATES. 3. SELF-PORTRAITS--UNITED STATES. I. TITLE.
 TR680.H56 2002
 779'.2--DC21

 2002009019

photobooth

BABBETTE HINES

PRINCETON ARCHITECTURAL PRESS NEW YORK

2002

for

GINO CALARESE

Is it just me or did you, too, ever have the sense back then, climbing
into the photobooth, that you were actually clambering aboard H. G.
Wells's Time Machine? In fact, I used to think that's where Wells had
gotten the idea for his contraption in the first place: shows you what I
knew about history and chronology in those days.

 But it turns out I did know something about *time*: for here these
photographs come hurtling back into the present, right this very
instant, these traces from another era, fresh and cocky, spry and shy,
goofy and glum, tender and tendentious, clueless and self-conscious as
the day they were first prized. Such that now·this little compilation—
product of the daft, gentle passion of Ms. Babbette Hines—in turn revs
itself up and sends us hurtling back there, back to that prior age: a
sequence of little wormholes, coiled right here, unsuspecting, on the page.

 In a luminous little essay entitled "The Face," Jean-Paul Sartre
once evoked a marble bust in his exploration of the human face, in an
effort to heighten the contrast between the two. A marble bust, he
suggested, exists in "universal time," which is to say, the time "of
instants set end to end, of the metronome, of the hourglass, of fixed
immobility." Such a bust floats in "a perpetual present." But the face
"creates its own time within universal time.... Against [that] stagnant
background, the time of living bodies stands out because it is orient-
ed.... In the midst of these stalactites hanging in the present, the face,
alert and inquisitive, is always ahead of the look I direct toward it....
A bit of the future has now entered the room: a mist of futurity
surrounds the face: its future." The face, Sartre goes on to insist, "is
not merely the upper part of the body.... It is corporeal yet different

from belly or thigh: what it has in addition is its voracity; it is pierced with greedy holes." The greediest, the most ravenous of those holes, of course, are the eyes. For "now the two spheres are turning in their orbits: now the eyes are becoming a look," and in so doing changing the very nature of the thing they are looking at—say, that chair over there—a change which is in turn reciprocal. "If I watch his eyes, I see that they are not fastened in his head, serene like agate marbles. They are being created at each moment by what they look at."

But look at what is going on here. Indeed, the sitters are orienting themselves toward a future, composing themselves (in fact, they are gauging their own reflections in the pane of glass that intervenes between themselves and the camera), beholding themselves, looking at how they will be seen. They try on this pose and then that (funny the way that by the third or fourth pose, as if on second thought, they often revert to the first), addressing first themselves (there in the mirrored glass) and beyond that the intended other (girlfriend, boyfriend, parent, sibling, pen pal, bureaucrat), but beyond that, well, something like the undifferentiated future—the faceless posterity—*us!*

Sartre goes on to conclude how, "If we call transcendence the ability of the mind to pass beyond itself and all other things as well, to escape from itself that it may lose itself elsewhere; then to be a visible transcendence is the meaning of a face."

You hold in your hands an album of such transcendings. Nameless, typified (the Flirt, the Dowager, the Hood, the Accountant, the Kid, the Sailor and his Buddy, the Patriot, the Lovers, Pals, the Tough, Pattycakes, the Virgin, the Cadet, Grandpa), and yet each one tinctured with individuality (that hat, that drooping cigarette, that broche, those brows, that smirk, that muff, that grin, that grief) like nobody so much as we ourselves, here on the far side of the page: nameless, typical, typified individuals momentarily struck dumb, pillow of air lodged in our mouths, marveling, particulate, as the transcendence comes hurtling forth and strikes home.

aren't these
pictures
dreadful

8 for 25.
They look
it!

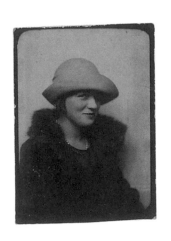

THE PHOTOGRAPHS CHOSEN for this volume are the result of many hours spent searching through piles of other people's photographs. Inevitably, they were found at the bottom of a box after looking through countless school and wedding pictures, pictures of smiling couples and laughing singles, and photographs of pets and babies. Events and milestones, once deemed noteworthy, were eventually discarded when, I imagine, the subjects of the photographs were no longer valued or possibly even recognized by those who possessed them. Unlike those who let go of their family's images, I am extraordinarily interested in mine. I hoard and examine them, searching their faces for a resemblance to my own, watching my story unfold as theirs does. I have a photograph of my mother when she was a young girl; she is small, somewhat serious, and pressed against her cousin in a photobooth. When I found the picture in my grandmother's collection, I didn't know that there had been photobooths in the forties and could never have imagined my mother in one. And she, as she stared into the camera, could never have imagined, thirty years later, her own daughter in a similar booth. As I considered the link between her experience and mine, I began to imagine the link between the thousands and thousands of people who, like my mother and me, had slipped into a photobooth and, behind a securely drawn curtain, waited for the flash and a picture to emerge.

There is something both strangely familiar and absolutely fresh in photobooth pictures. You look at them and know that the soldiers staring into the camera with a cocky eye are off to a war fought sixty years ago, and you know that the women with their hair in finger waves, carefully coiffed, are more than likely gone. You know, and yet it doesn't matter. It is as easy to imagine their stories as it is to recall your own. If you look at them long enough, resemblances to people you know start to emerge. And if you look even longer, you begin to see yourself reflected in the faces staring back at you.

Patented in 1925 by Siberian immigrant Anatol Josepho, the Photomaton (the original name of the photobooth) was born. While

working as an itinerant photographer in the early 1920s, Josepho had the idea for a "coin-in-the-slot machine which would automatically photograph the sitter, develop the photographs, dry them and deliver them" (as reported in the *New York Times* on March 28, 1927). Certain that he had a commercially viable idea, he came to the United States to develop the first machine. His efforts were immediately rewarded. The *New York Times* proclaimed in its headline "Slot Photo Device Brings $1,000,000 to Young Inventor." A group of businessmen headed by Henry Morganthau, former ambassador to Turkey, bought Josepho's interest in Photomaton Inc. for the equivalent of $10 million in today's money. Mr. Morganthau told the *New York Times* that they planned to "make personal photography easily and cheaply available to the masses of this country and do in the photographic field what Woolworth has accomplished in novelties and merchandise (and) Ford in Automobiles." Josepho, a socialist, was reported to have given half the money to charity and administered the other half with an eye toward helping his brother inventors. Morganthau and his associates had plans for immediate and extensive expansion, intending to place seventy machines in strategic points up and down the East Coast. Within a month, the president of the corporation was sailing for England to introduce the Photomaton to Europe and the world.

The new photographic device was an immediate success. The first studio, in New York's theater district, drew large crowds, willingly waiting in line for their chance to take their place in front of the camera. According to *Outlook Magazine* in an article dated April 27, 1927, "even such NY celebrities as Governor 'Al' Smith and senator-elect Robert Wagner have taken their turn in the Broadway shop, adjusting their hats and cigars to different angles for each exposure." Both the curious and the practical visited the studio, taking advantage of the ease and affordability of the technology. What the *New York Times* had deemed a "smart fad" was on its way.

"Aren't these pictures dreadful. 8 for .25. They look it!" wrote one customer on the back of her photogaph.

With her fur collar and string of pearls, dressed perhaps for a night on the town, the woman looks out from under her hat with a mixture of wariness and humor. She claims that the pictures are dreadful, but this didn't stop her from giving them away, albeit with a disclaimer. Whether satisfied or not, she couldn't resist the lure of the new invention. She wasn't alone. Millions of people around the world couldn't resist either. An article in *Photo Era* from 1928 described the process: "Into the booths slip wearied suburban shoppers, with packages dangling from every finger; girls 'on their lunch hour,' young men who will not be parted from their caps, photo or no photo, and whose mouths are a glitter of gold. One by one they take their places under the spotlight, smile widely from left to right and straight, and at last join the waiters by the picture-slot. It is as exciting as a roller-coaster at a seashore amusement park or an airplane ride."

From the late 1830s when Daguerre produced the first readily available photographic portraits, virtually everyone has found in them an endless source of fascination. It is a natural curiosity; we are as curious as we are social and want to know what people look like, no matter how often we are told that looks don't matter. They *do* matter in that the portraits we scrutinize so carefully do indeed reflect something of the character of the sitter. As early as the 1840s, portrait studios began to open around the world, in response to the demand of the middle class for images not just of the famous and infamous but also of themselves. In the late 1880s, George Eastman introduced a simple box camera, which came loaded with film. It was designed to inspire in the masses the confidence to forgo the limitations and formality of the studio environment. "You push the button, we do the rest," he promised. For the first time, the public was at liberty to turn the camera on whatever, or more importantly, whomever, they chose.

In a photograph dated March 18, 1918, a young woman stares in the mirror, "scared friendless for fear I'd bat my I." Her camera carefully placed, she produces a self-portrait. While she does look concerned, willing herself not to blink, she also looks absolutely

comfortable. Within the context of her own carefully constructed environment, she controls the image that she presents to the world. It is not an "artistic" portrait, to be sure, but it is, I believe, an honest one that reflects our innate desire to record our own image, on our own terms.

The perfect amalgamation of studio photograph, snapshot, and self-portrait, the photobooth possesses the greatest advantages of each. It combines the convenience and immediacy of the studio portrait—you just show up, sit down, and wait—with the informality and spontaneity of the snapshot. Finally, it offers an easy and inexpensive opportunity for self-portraiture with both comfort and accessibility.

The earliest photobooth pictures, those from the late 1920s, often retained some of the studied formality of studio portraits. The subjects of these portraits dutifully obeyed the commands of the attendant without, apparently, a great deal of pleasure. They glanced left, they glanced right, and they stared straight ahead. Although often smiling, they frequently looked a bit wary, sometimes even grim. By the 1930s, however, more familiar expressions began to appear. Faces and postures relaxed, the smiles weren't quite as forced, people began to shed their inhibitions. More than likely, this development coincided with the removal of the attendant, allowing the solitude we now take for granted and cherish. Perhaps it is only in solitude that we are free to decide which face to present to the camera, which story we want to tell.

It doesn't matter whether you are in a train station, on a busy street, or in the middle of an amusement park. Nor does it matter whether you have deliberately sought out the booth to record a specific moment or happened upon one unexpectedly. What matters is that you are both photographer and subject. Alone in the booth, you forgo the behaviors and attitudes expected when a camera is forced upon you. You cannot be coaxed into position; you cannot be commanded to smile. You can be sexy or goofy or tough. You can even pretend to be happier than you really are, and you get eight (or at least four) chances to do it. And if, when the picture emerges after the interminable wait,

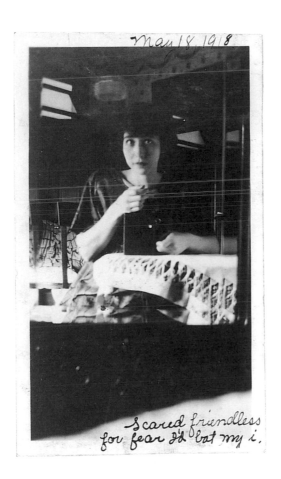

May 18, 1918.

Scared friendless
for fear I'd bat my i.

you are not pleased with the results, if it doesn't tell the story you want, there is no proof that it ever existed. The portraits of those who are truly alone in a photobooth (as opposed to those who pose with another, no matter how close the relationship might be) are almost always more open and forthcoming. There remains, in couples or in groups, a sort of performance, albeit a charming one—they cuddle, they smile broadly, they ignore the camera. They often seem intent on proving to the camera and to each other, that they really are happy, that they really are together, and that they are capable of frolicsome good times. Alone in the booth there is nothing to prove.

Photographs, snapshots, and portraits come in an enormous variety of shapes and sizes. The proportions of the photobooth, however, have remained virtually unchanged for the last seventy-five years and so are instantly recognizable. The physical confines of both the booth and the image disallow the distracting details found in other forms of portraiture. Although different hairstyles and clothing are apparent, there is a timelessness to the pictures, provoking little of the nostalgia that accompanies other photographs. Most of us have been inside a photobooth and have had at least a similar experience to those portrayed. The pictures act as a visual diary of sorts, not of a particular place and time per se (there are other photographs better suited to that purpose), but of that same impulse that compels us, again and again, to seek out and place ourselves in front of a camera. We still believe that photographs are a truthful record of an event, or a person, despite our ever-increasing awareness of the manipulation of images in both content and meaning.

A picture is worth a thousand words, knowing that words spoken are often false. Memory and imagination merge with fact and transform a single moment into an entire story, and eventually, all we will remember is the moment defined and distilled in the picture. When our memories are no longer accessible as actual memories, when they are simply stories that we tell, we will look at ourselves and show

our friends and will say, "See here, this is how I was." It doesn't matter if the situation represented changed dramatically the very next day, that the lover we were so cozy with has broken our hearts, or that we have grown old and no longer resemble our youthful selves. In the photobooth picture, unlike any other portrait or photograph, truth and fiction easily commingle. In a photobooth we choose the moment and the way in which we represent ourselves. We choose our truth.

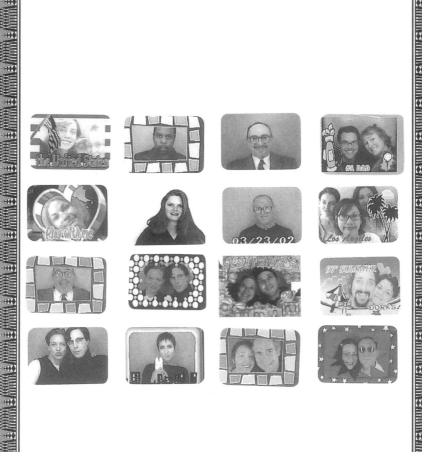

ACKNOWLEDGMENTS

THANKS TO CATHERINE BULL, BRENDA BYNUM, WHITNEY COOK, MICHAEL GLASS, ARLENE HINES, WENDY HINES, ROBIN HURLEY, LEE KAPLAN, STEVE KILFOY, KEVIN LIPPERT, NANCY MUNGCAL, DAVID NIELSEN, ALAN RAPP, JEANNETTE SHARF-MAN, MARK SHARFMAN, TERRI SHAFT, A.J., CAROLINE THOMAS, JENNIFER THOMPSON, JESS TUCKER, TABATHA TUCKER, LAWRENCE WESCHLER, AND DEB WOOD.

FOR THEIR HELP WITH THE PICTURES, I THANK FRED DORSETT, TAMMRA ENGUM, RAY HETRICK, LEONARD LIGHTFOOT, SABINE OCKER, NICHOLAS OSBORNE, TERRY REYNOSO, AND JOEL ROTENBERG.

EXTRA SPECIAL THANKS TO CARLOS GRASSO FOR SEEING ME THROUGH MY TANTRUMS AND EVERYTHING ELSE.

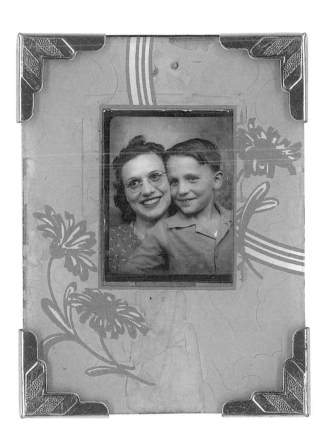

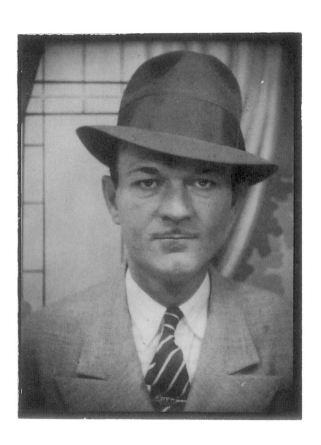

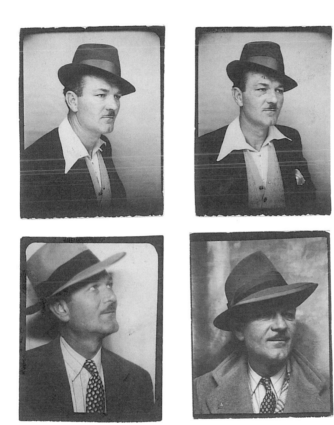

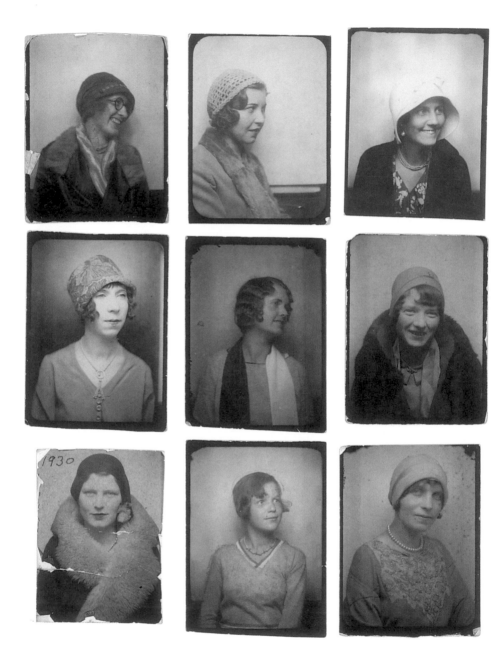

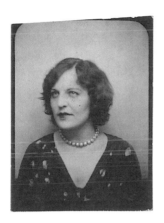
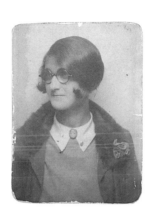
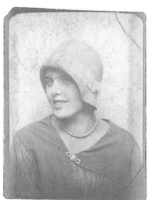
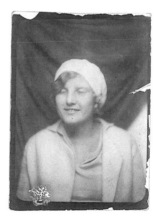

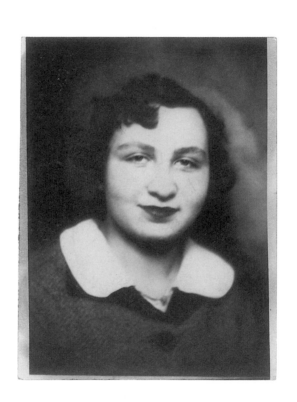

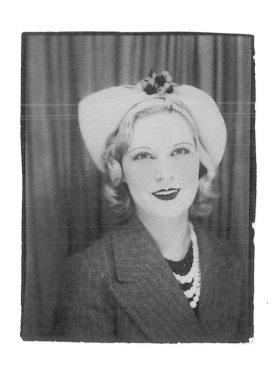

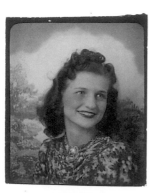
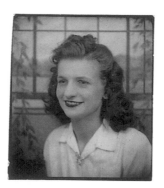
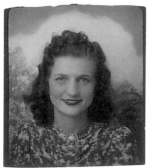
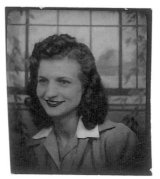

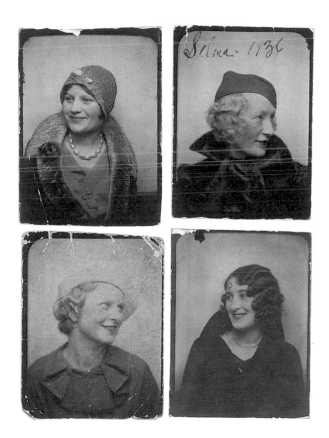

Selma. 1936

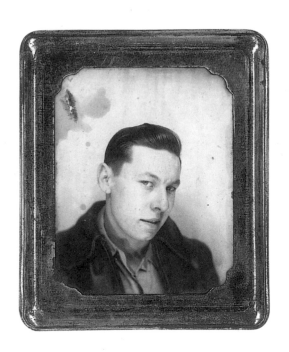

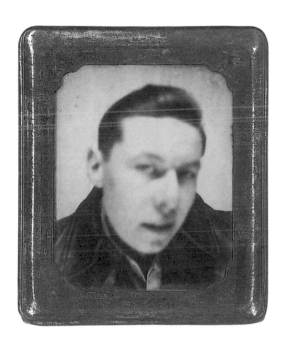

"MONDAY NIGHT MAY 20 1940 ON THE VENICE PIER"

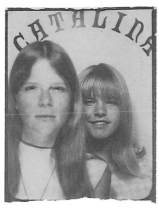
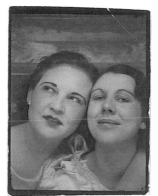
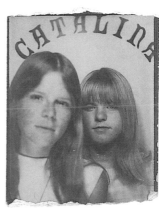
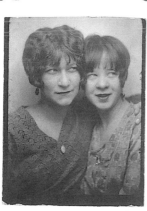
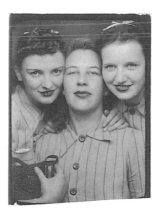
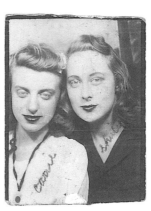
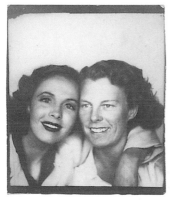
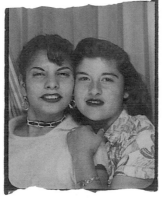
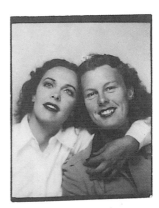

april 30/33

april 30/33

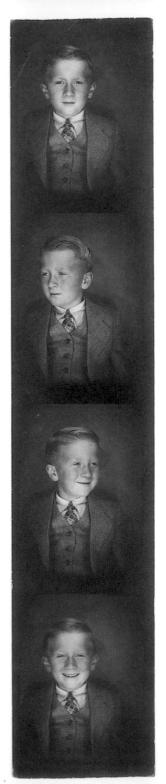

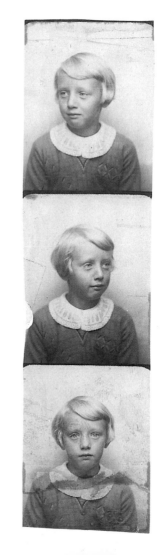

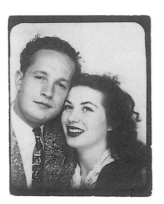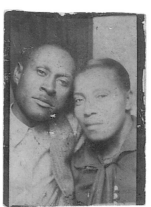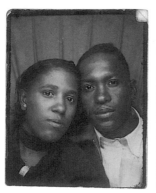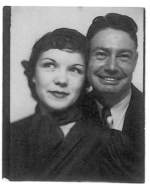

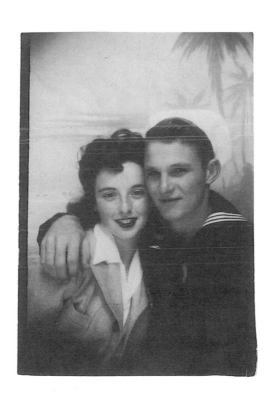

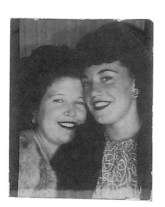
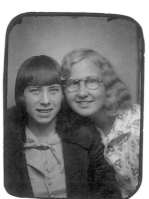
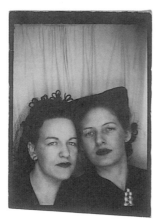
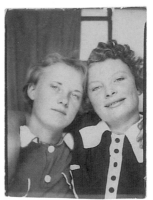

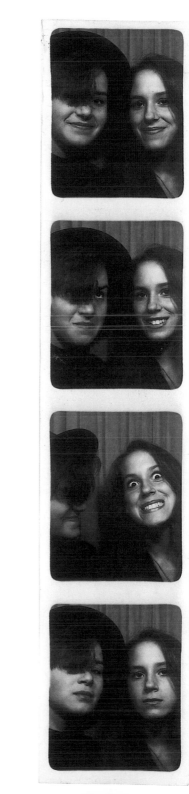

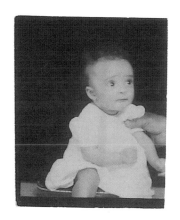
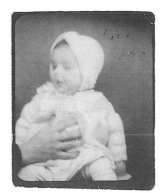
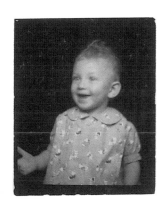
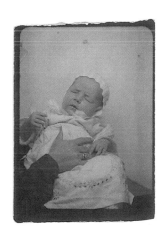

1 yr. 9 months

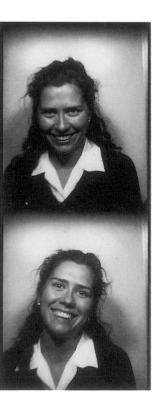

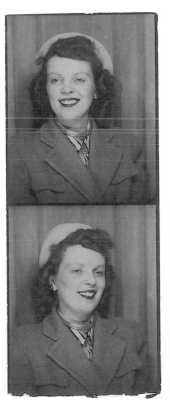
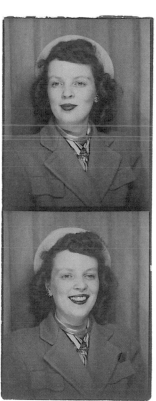

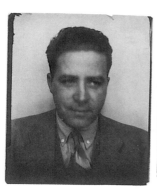

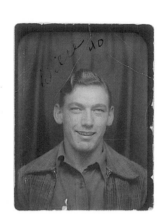
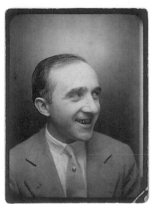
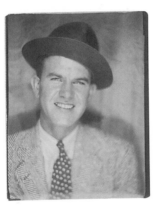
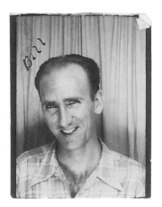
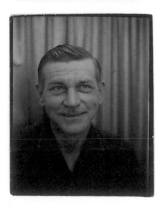
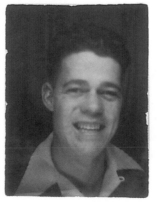
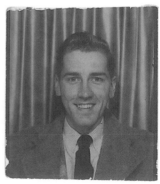

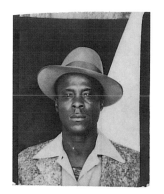

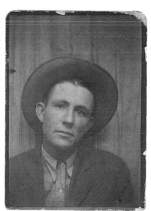

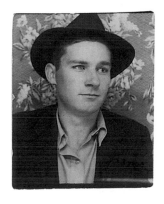

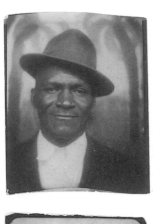

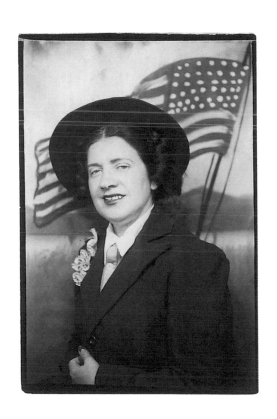

"I HAD THIS TAKEN LAST MARCH"

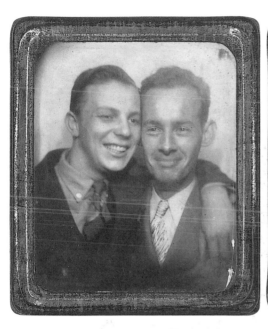

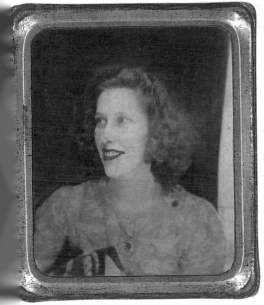
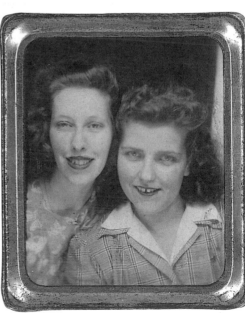

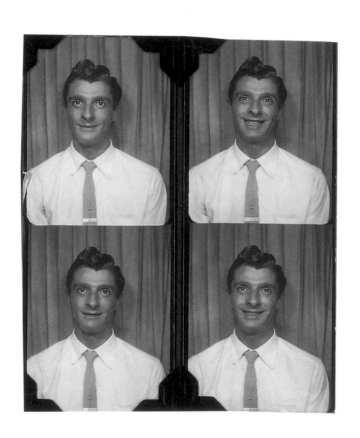

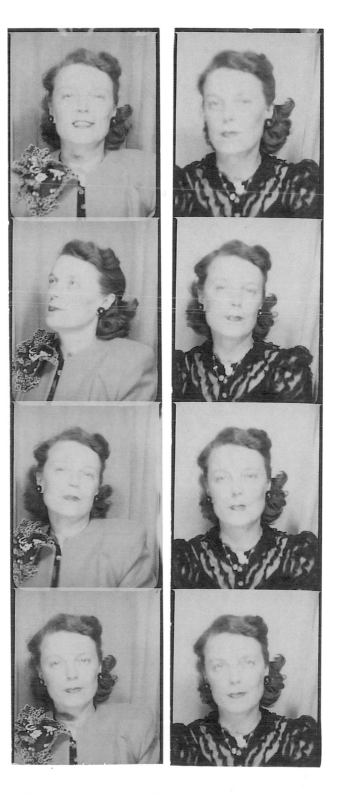

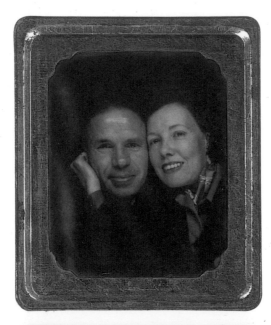

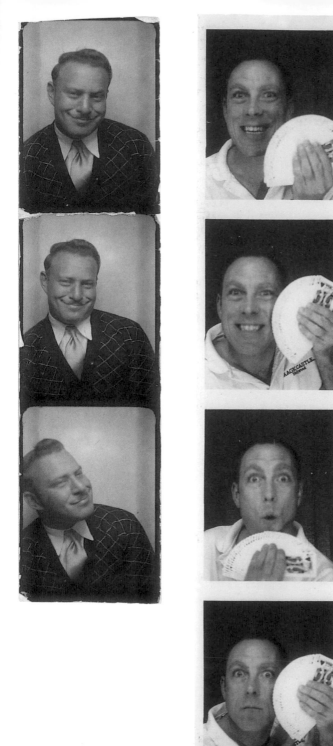

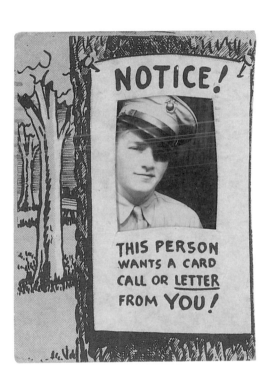

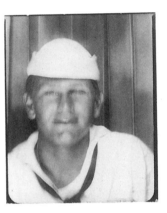
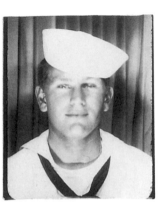
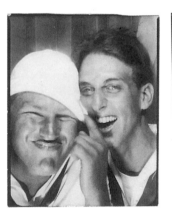

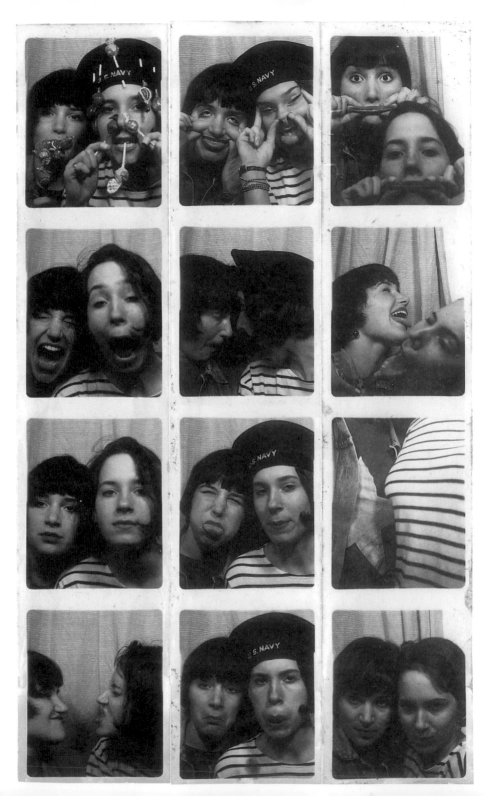

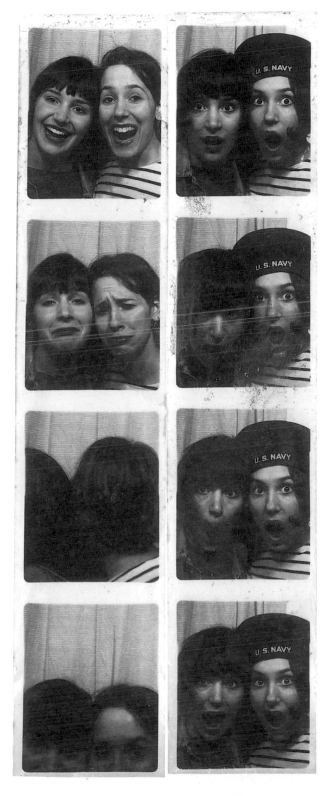

Bobbie

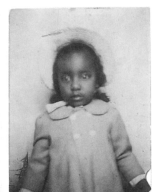

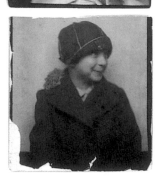

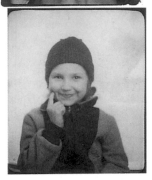

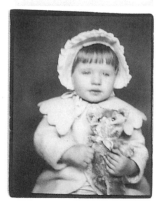

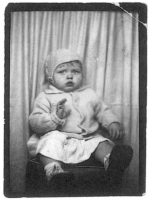

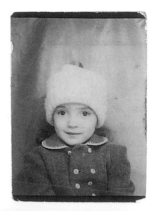

Rita

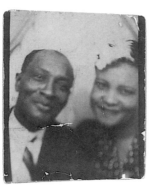
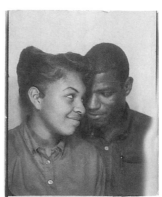
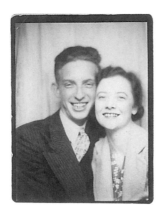
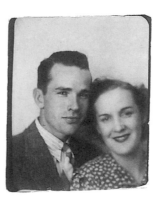

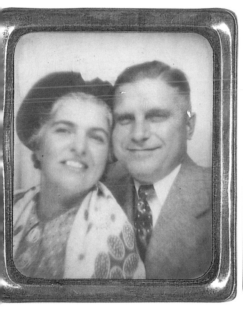
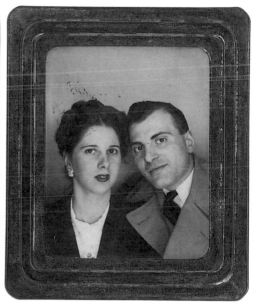

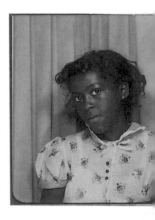
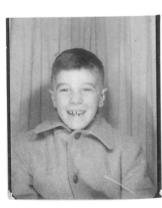
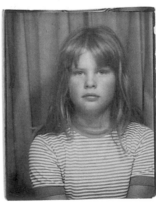
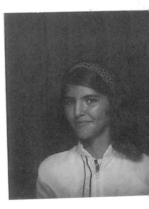

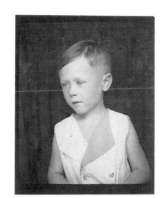

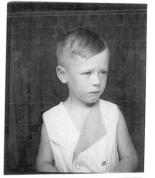

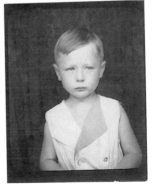

8-14-71
age 14
chinatown

14th Bd
8-14-71
Chinatown

august 23,
1972
Chinatown
Sandra &
Erin

15 years
old

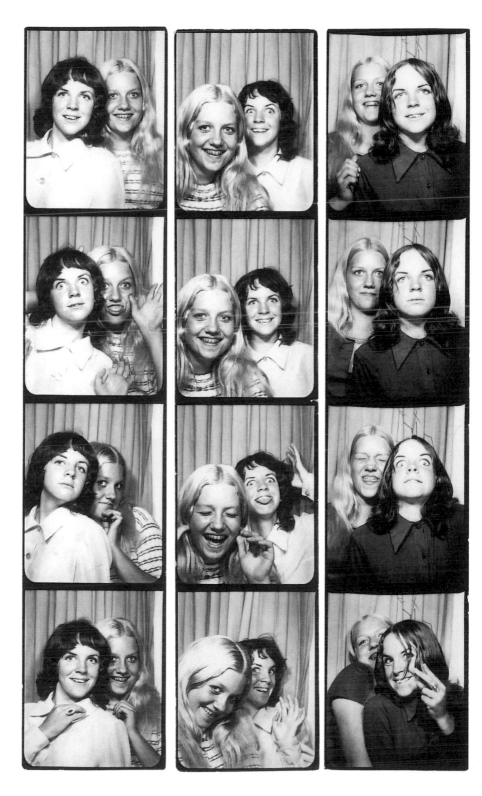

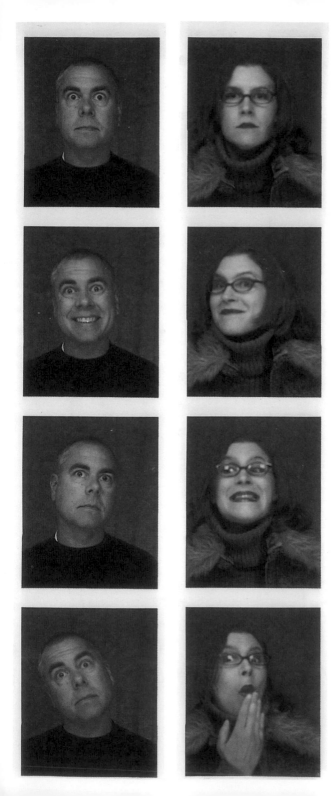

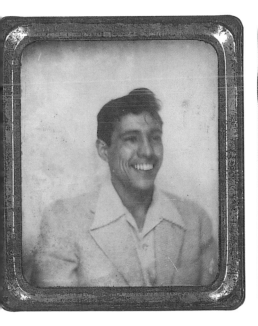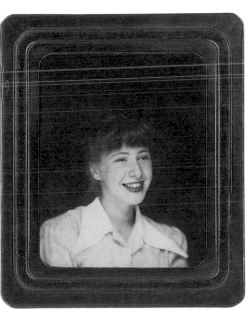

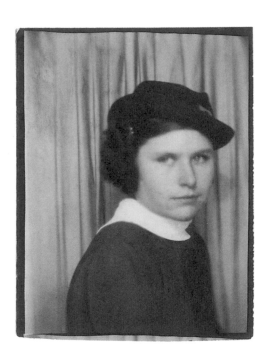

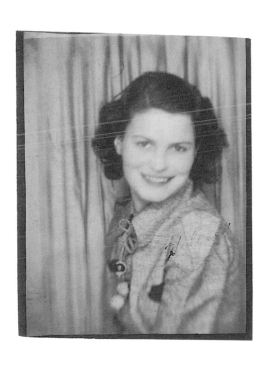

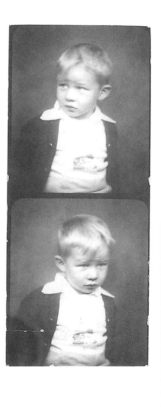

"ONCE A FRIEND"

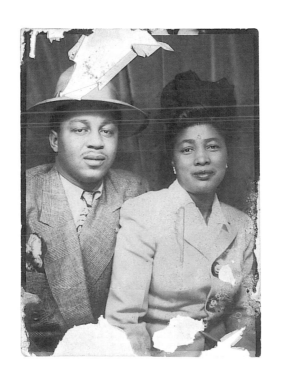

Jan. 19, 1933
To
Daddy

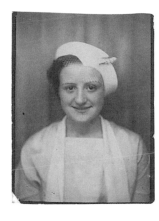
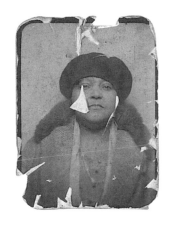
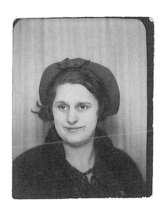
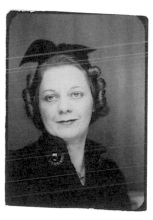
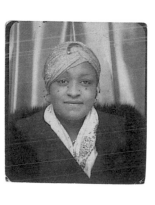
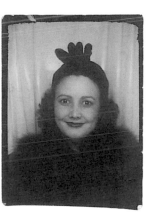
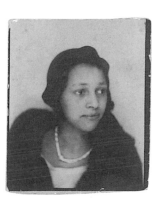
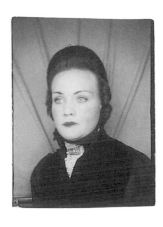
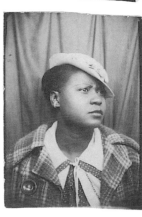

"MARJORIE"

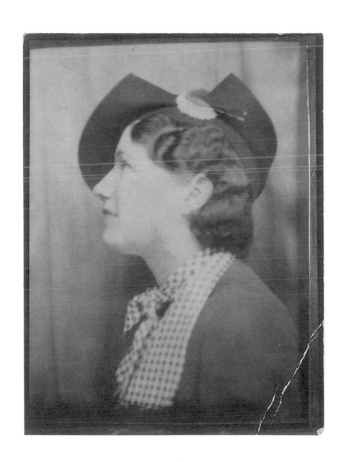

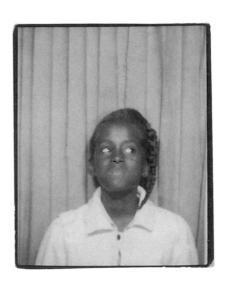

"APRIL 1940 'GENE' AUTRY + ME"

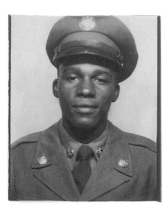
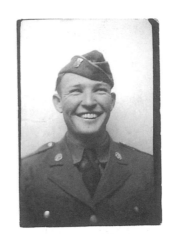
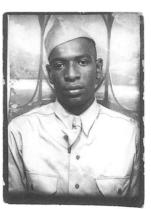
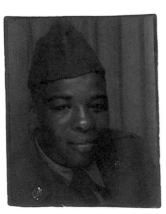
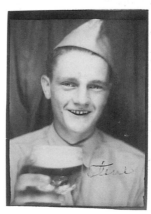
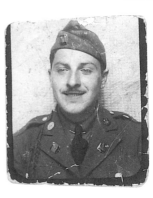
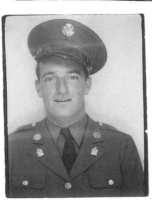
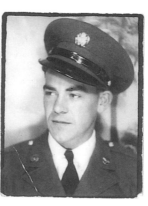
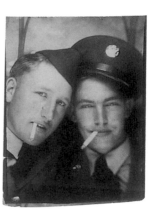

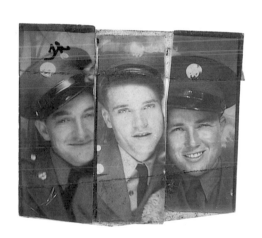

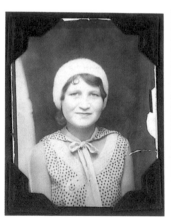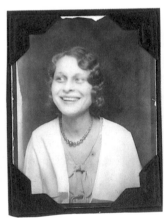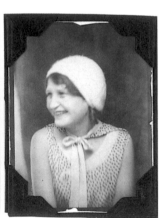

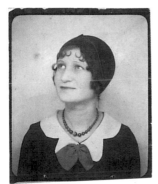

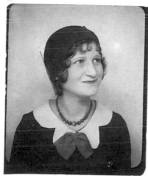

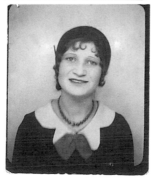

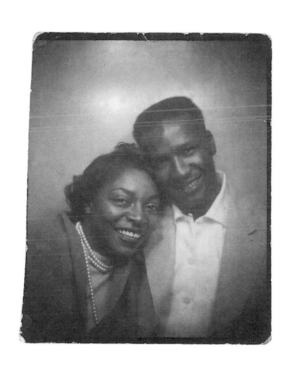

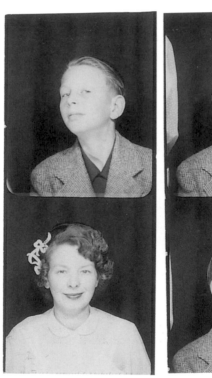
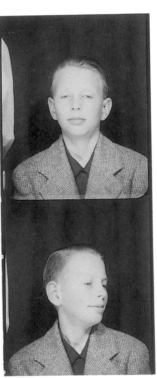

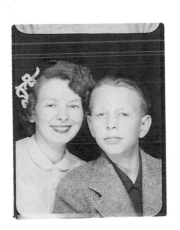

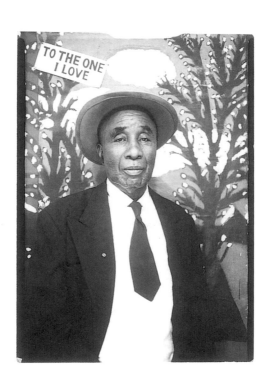

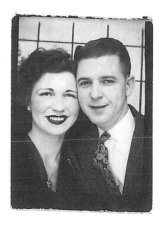
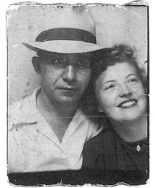
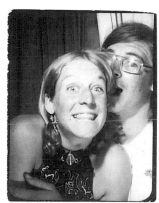
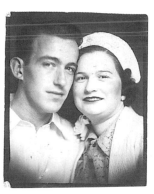
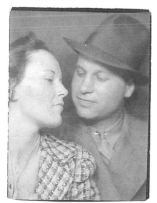
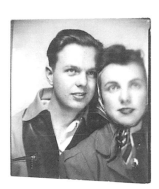
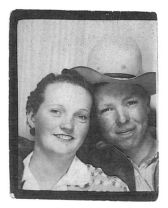

Tom and Lenore

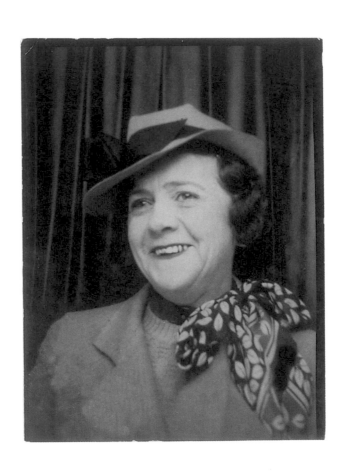

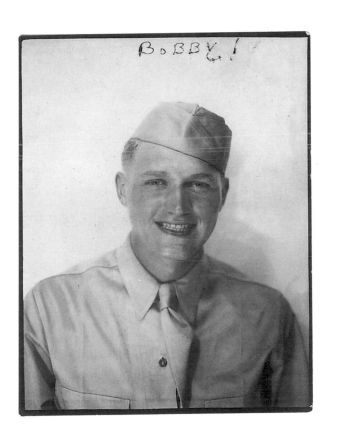

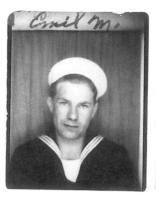
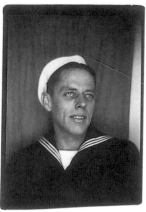

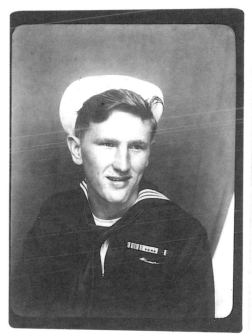

Williamson
shot in algiers

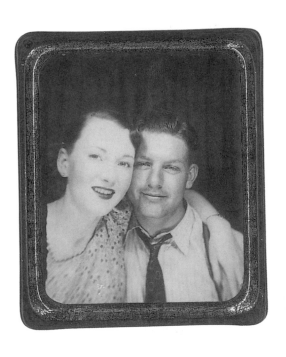

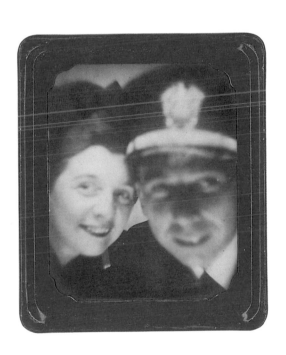

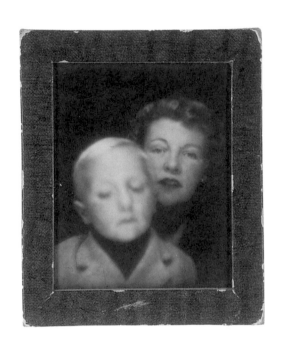

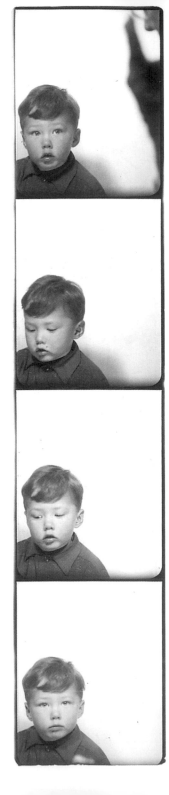

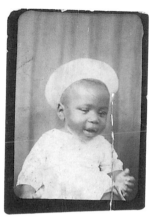
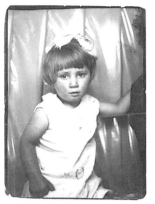
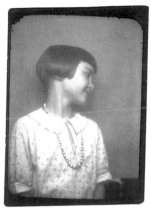
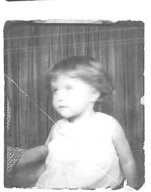
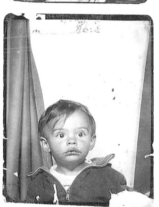
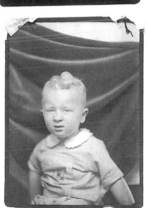
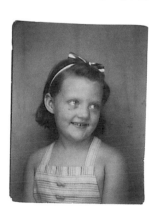
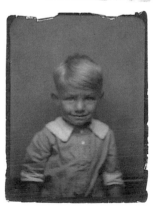

"WELCOME HOME JULY 15 1936 PICNIC"

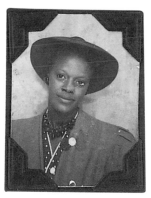
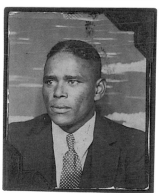
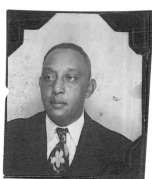

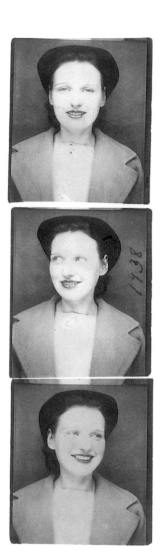

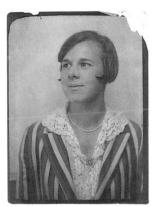

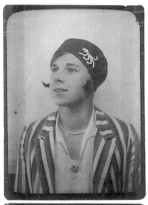

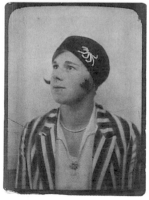

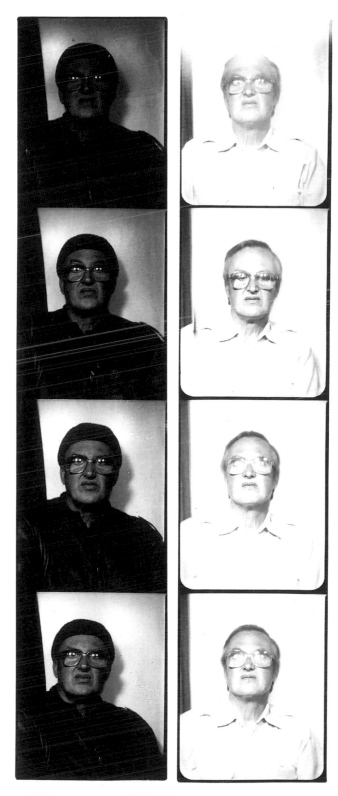

Guess what?
how can it
be ?? FROM
How the ZOO
amazing
Payne 364
Vischineder

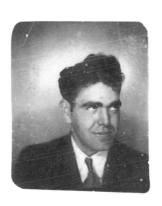

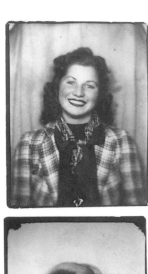
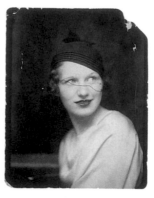
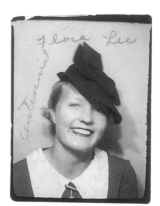
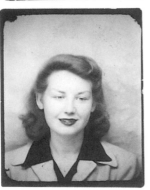
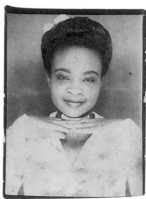
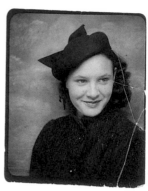
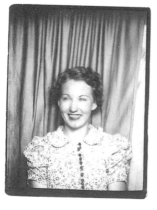
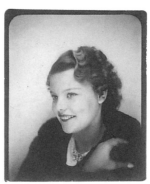
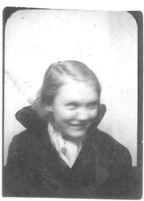

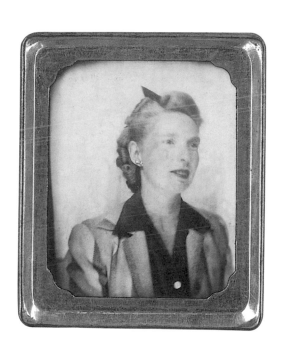

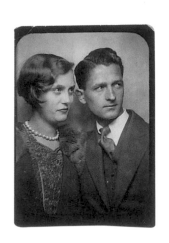

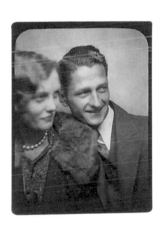

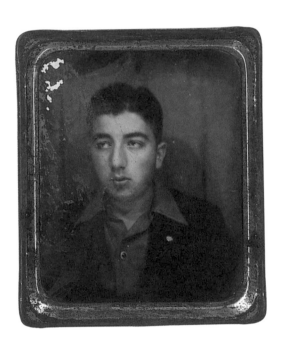

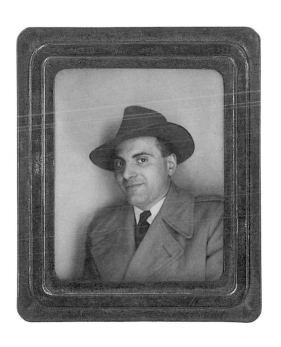

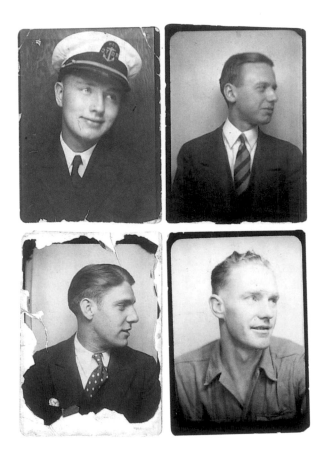

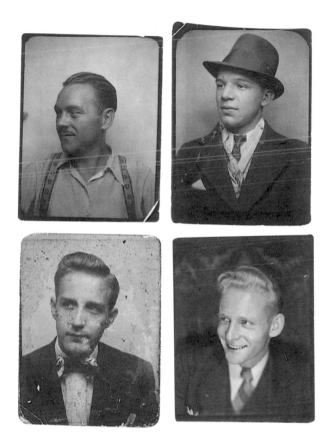

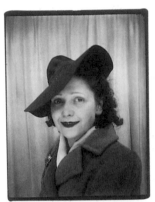
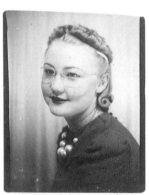
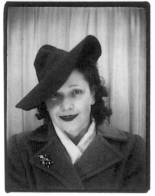
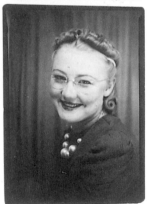

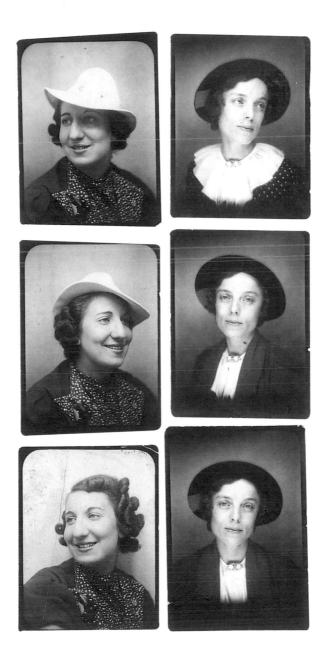

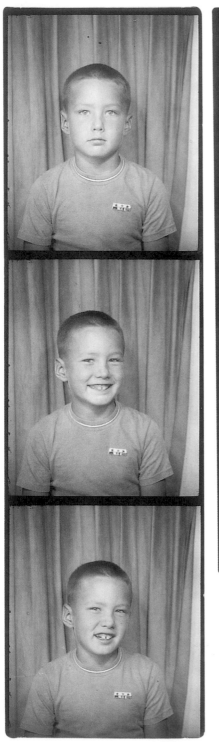
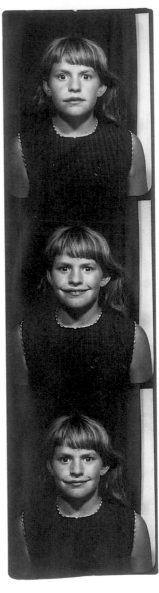
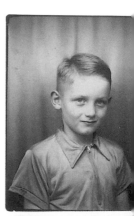
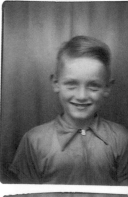
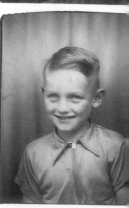

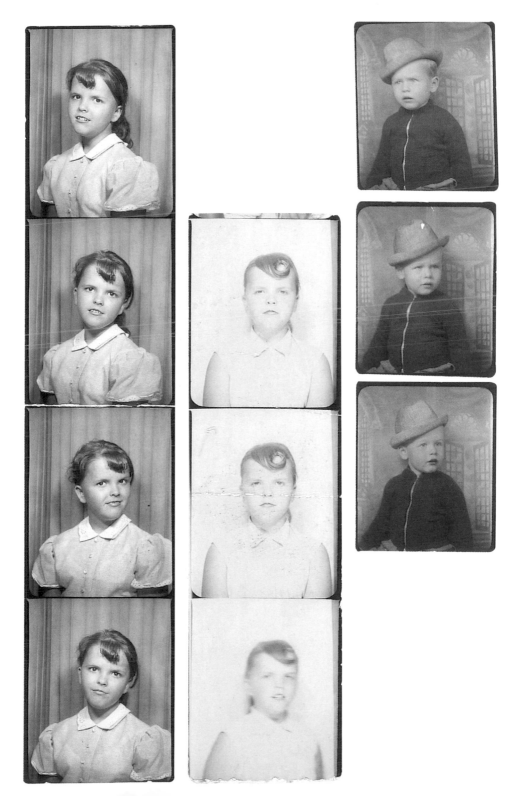

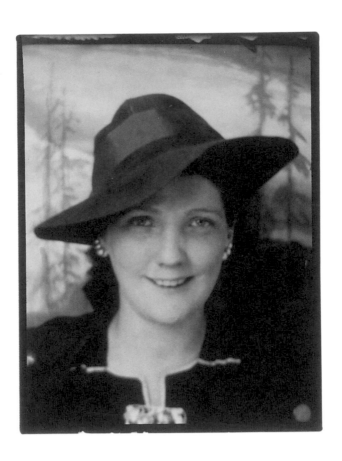

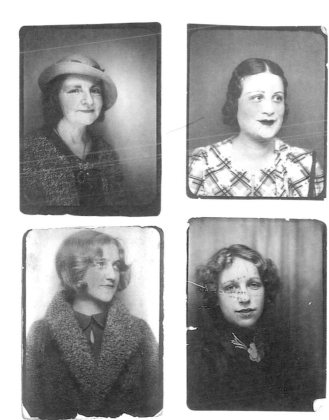

"FROM RUTH TO EMILY"

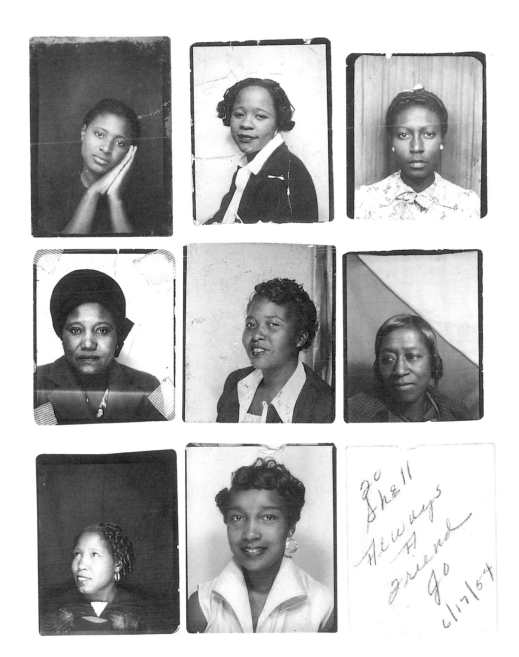

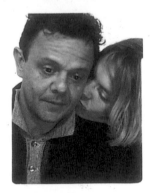

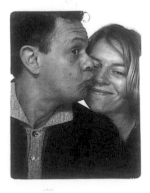

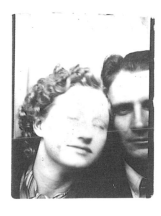
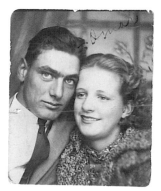
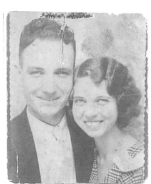
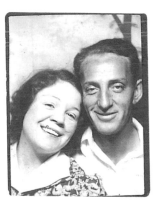
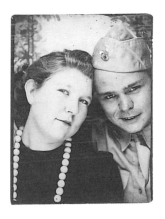

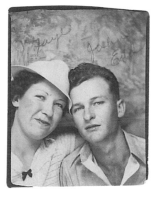
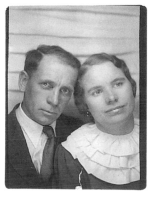
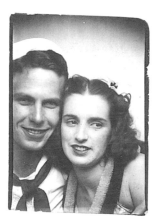

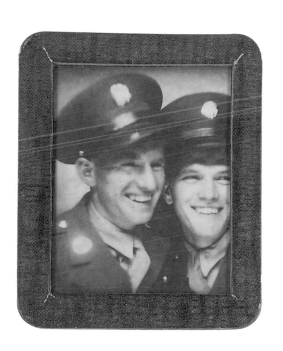

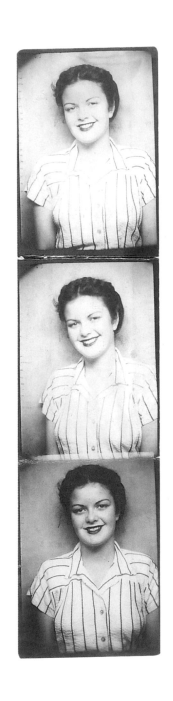

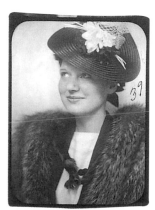

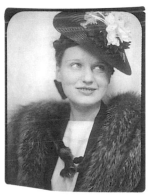

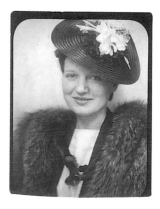

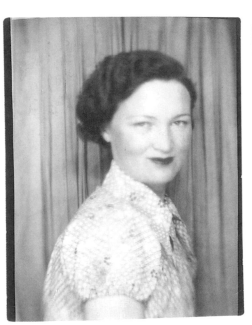
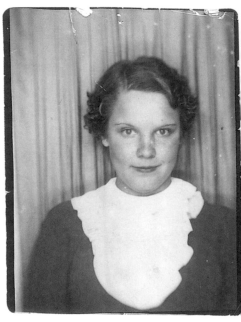

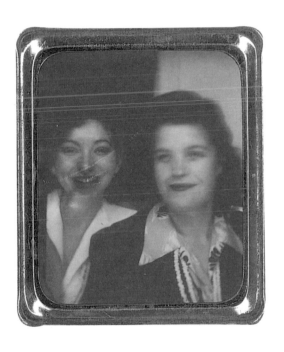

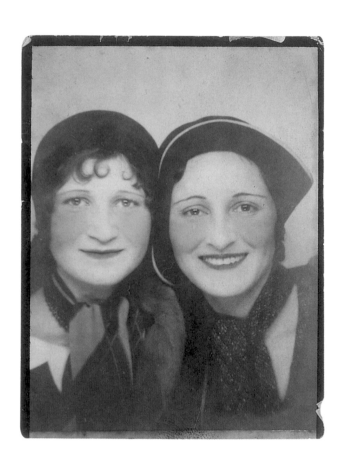

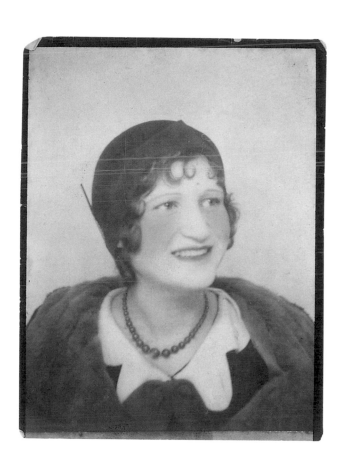

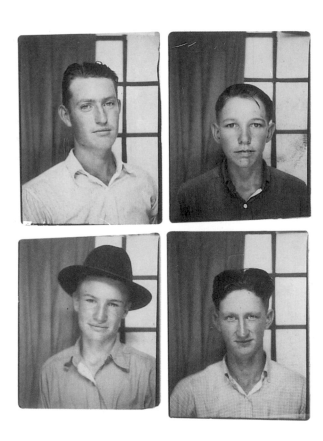

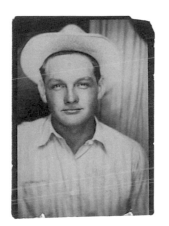

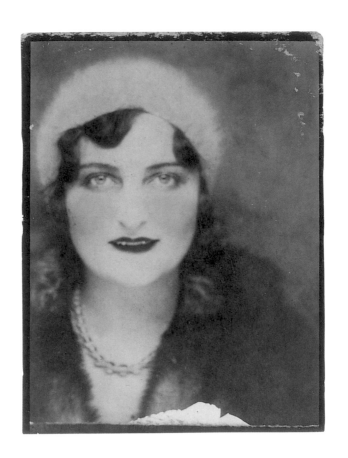

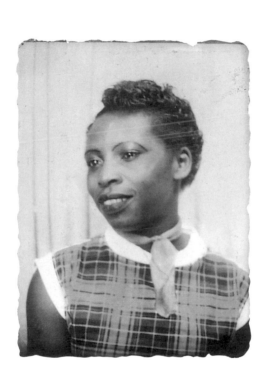

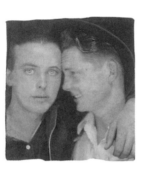
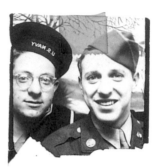
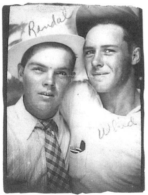
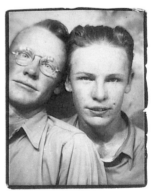

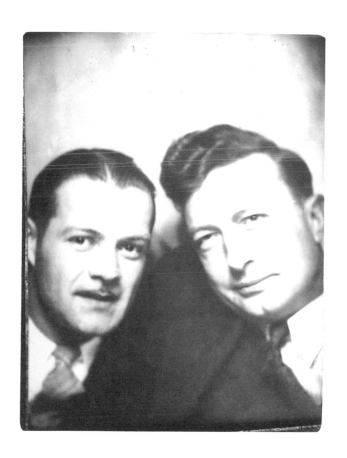

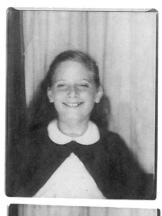

May 30 d 1953

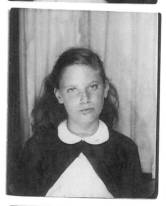

mo

mv

m

9 s 0 d le

may 30 d 1953

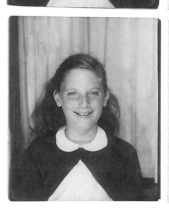

may 30 d 1953
1953

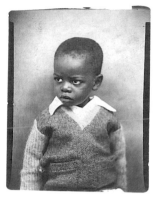
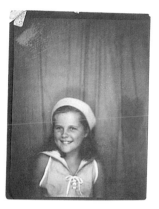
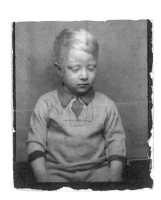
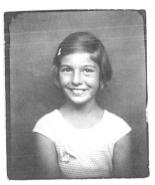
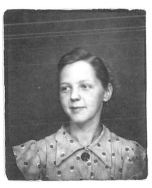
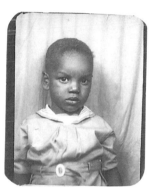
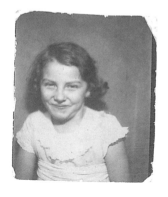
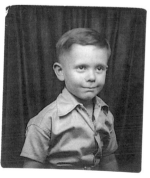
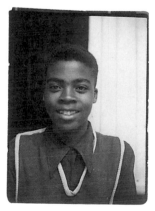

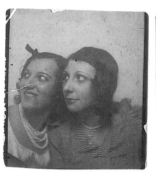
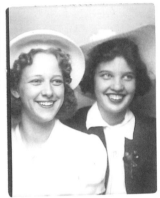
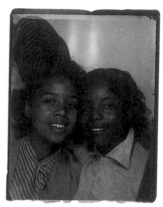
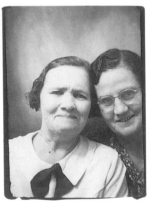
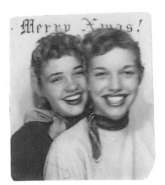
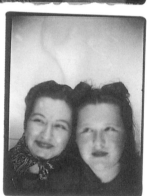

Merry Xmas!

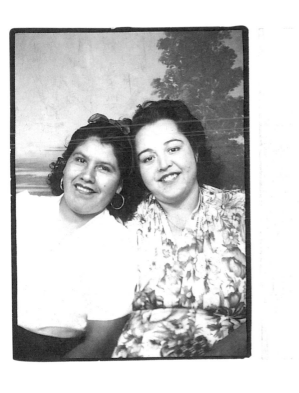

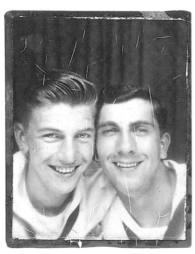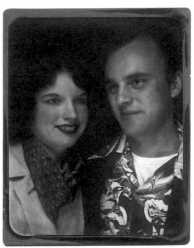

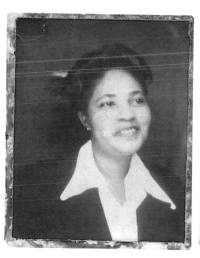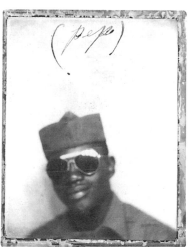

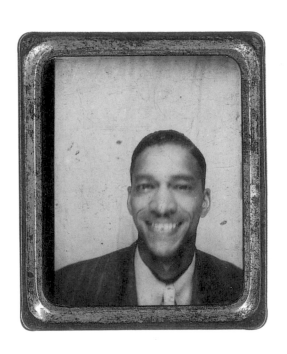

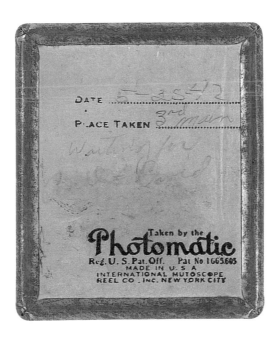

"HAPPY NEW YEAR"

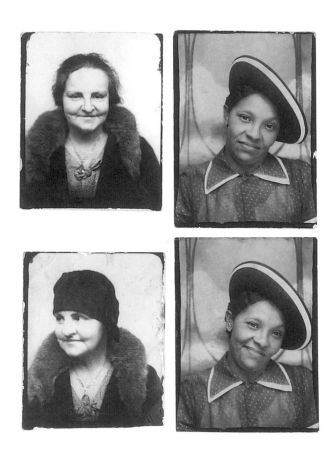

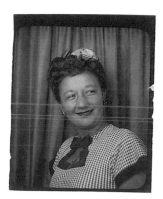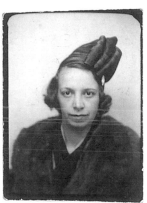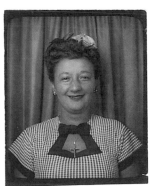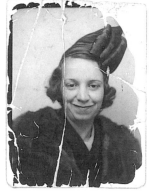

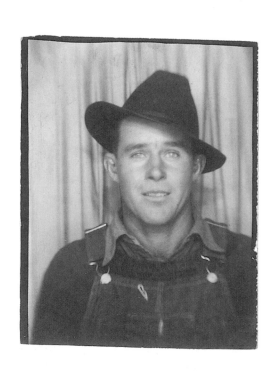

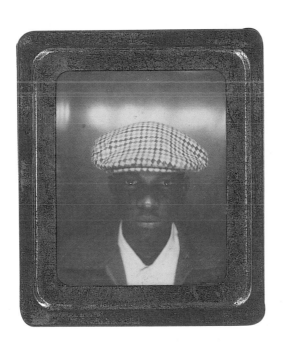

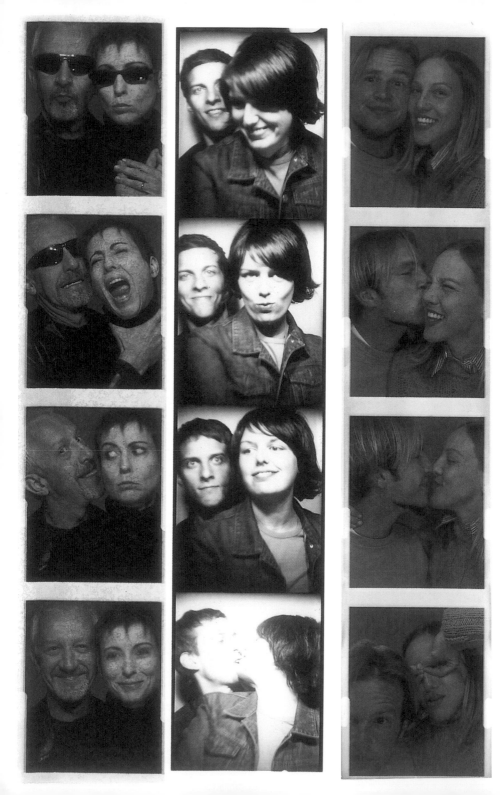

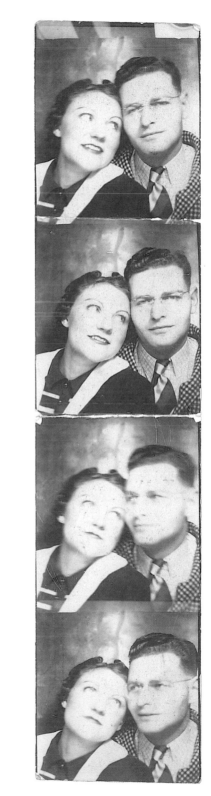

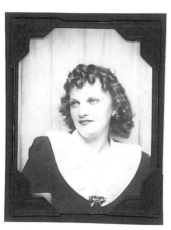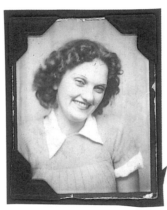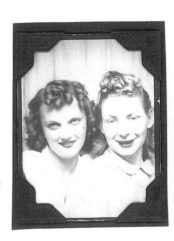

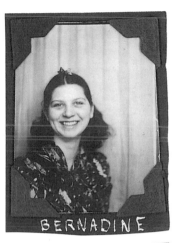

BERNADINE

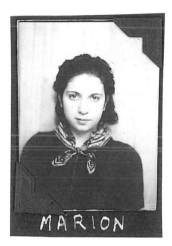

MARION

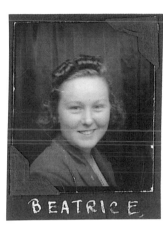

BEATRICE

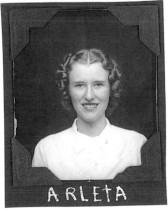

ARLETA

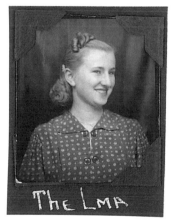

TheLma

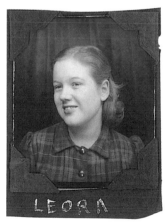

LEORA

"TULSA"

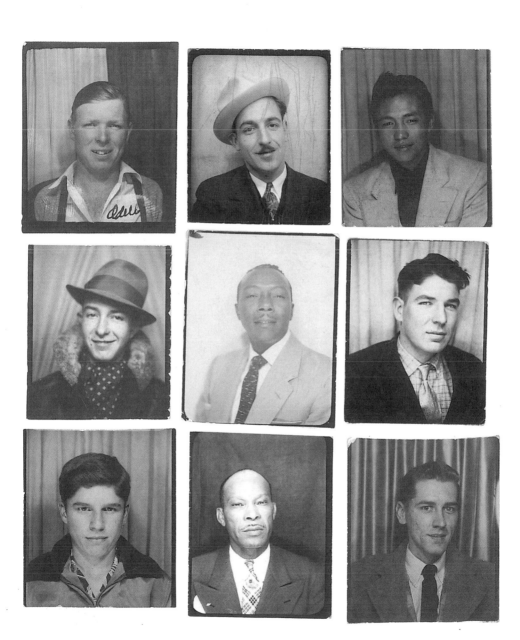

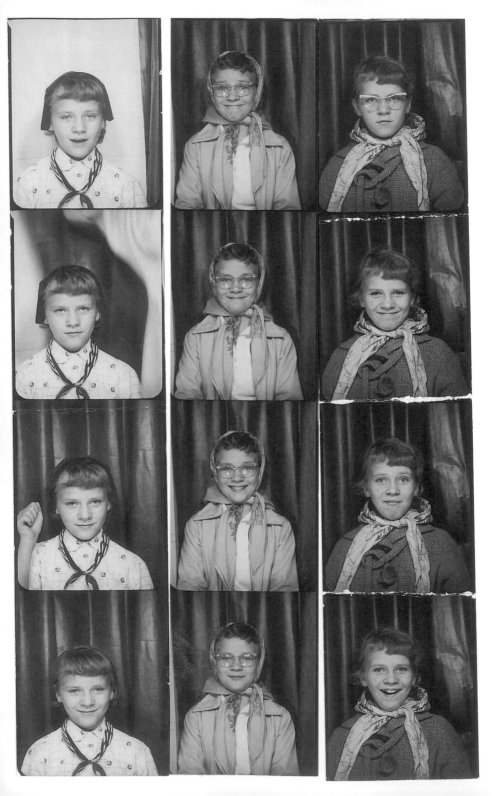

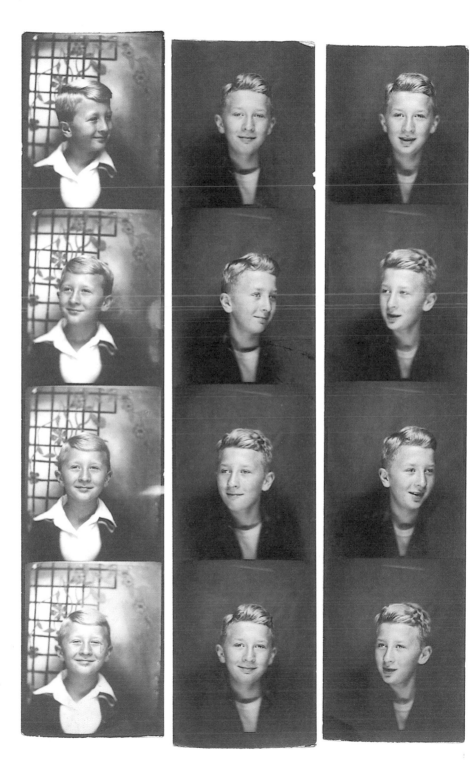

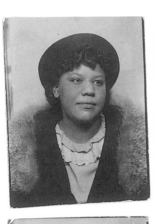
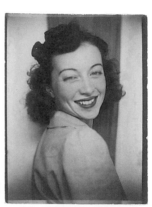
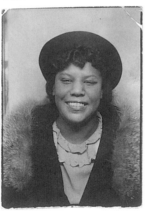
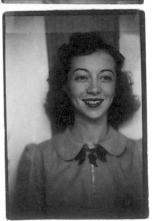

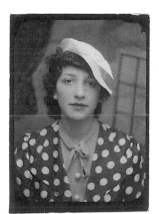

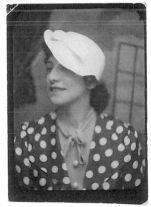

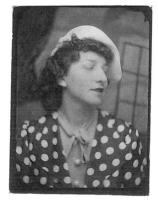

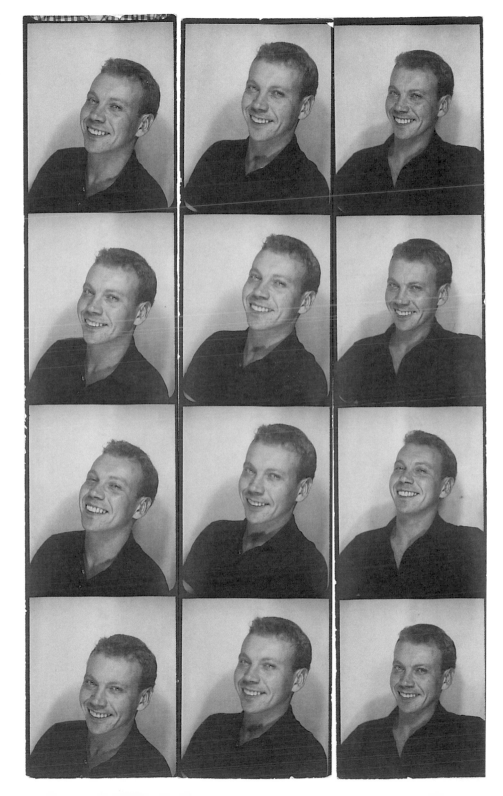

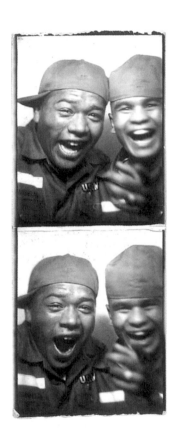

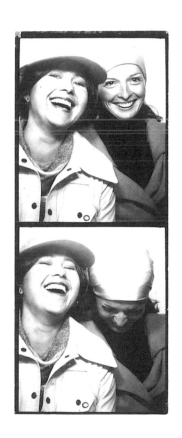

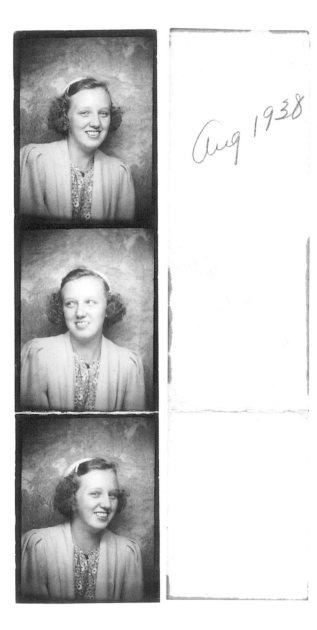

Aug 1938

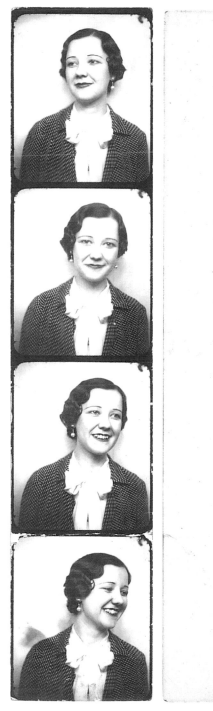

Sept 14 1934

"ME"

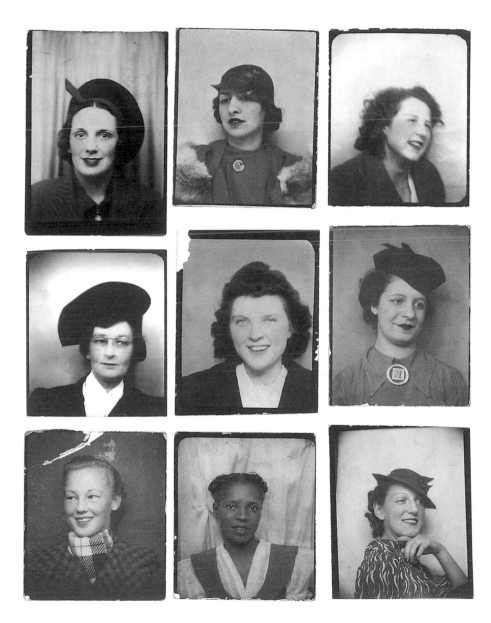

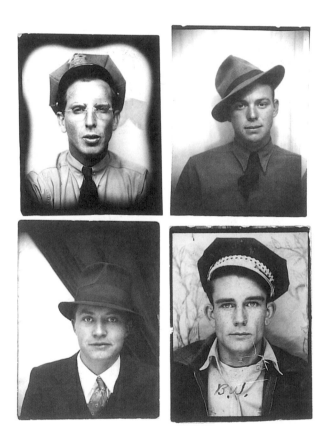

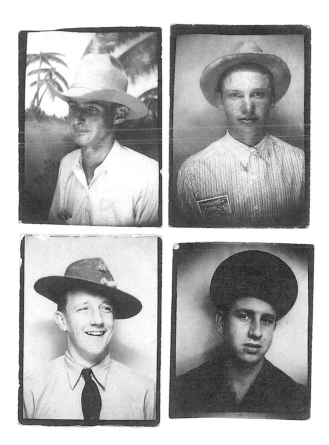

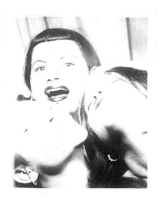

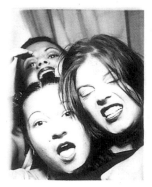

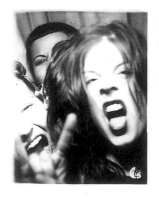

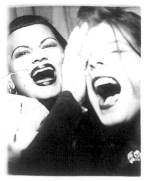

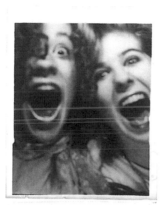
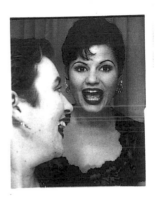
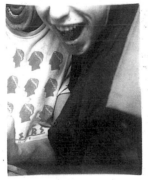
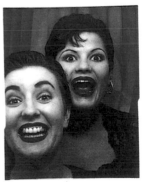

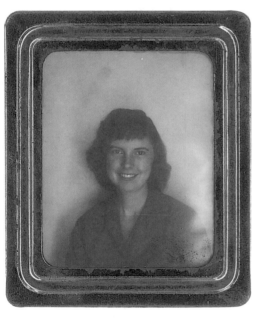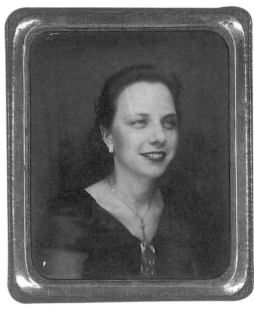

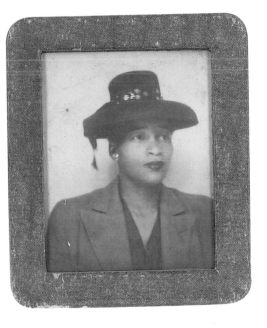
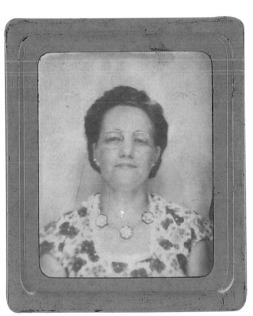

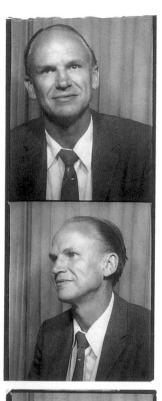
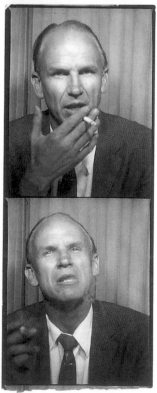

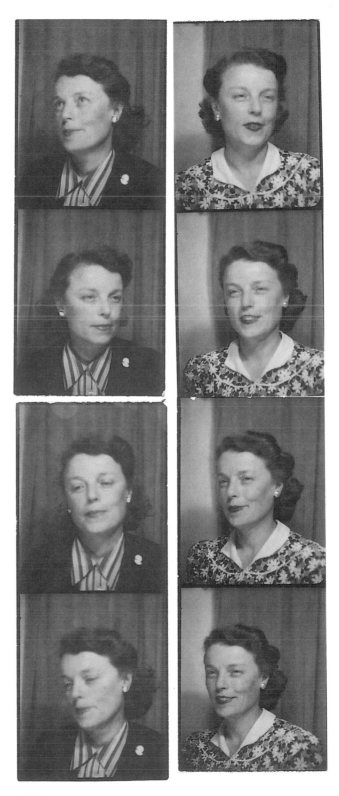

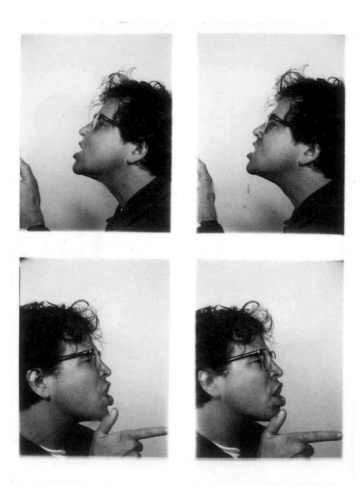

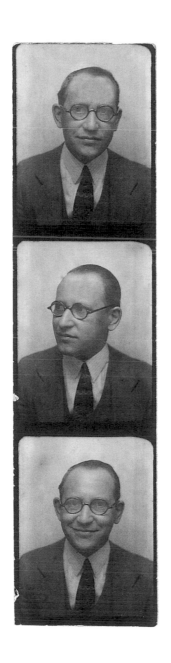

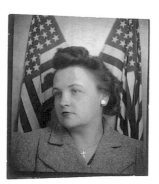
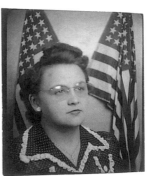
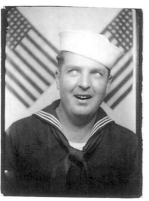
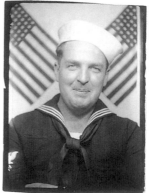

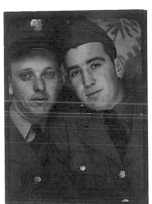
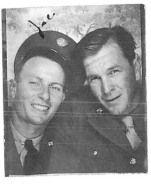
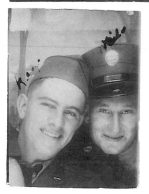
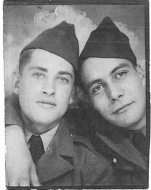

“POMONA FAIR”

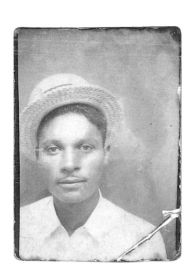

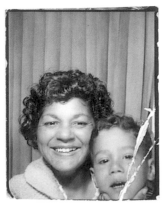 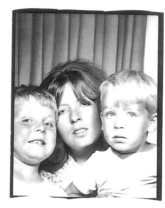 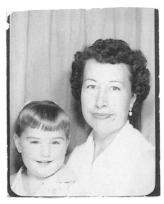

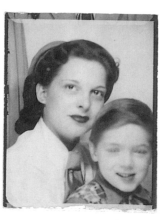

 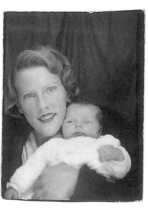

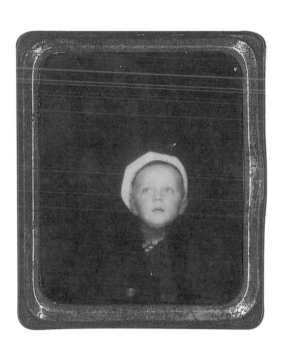

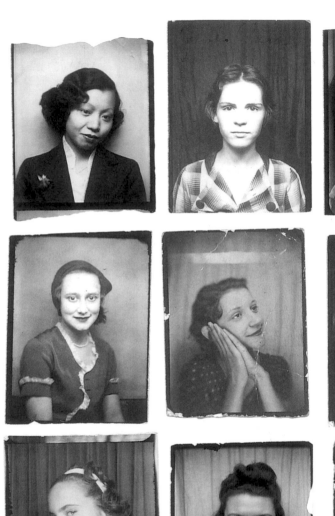
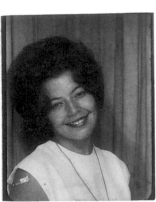
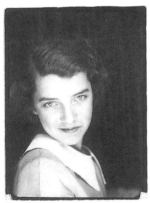
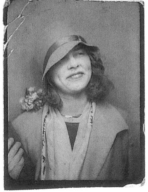
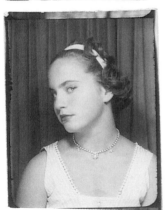
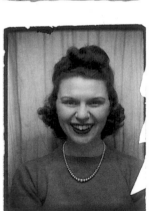

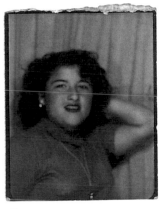
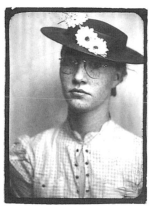
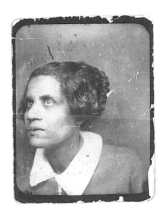
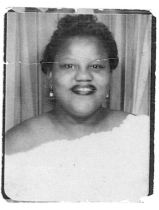
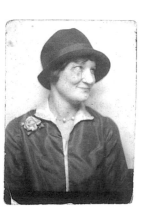
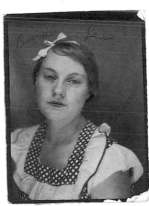
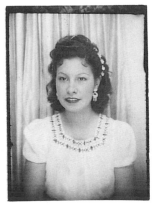
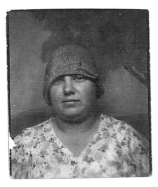

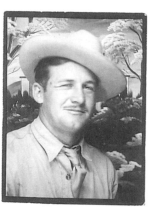
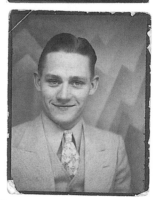
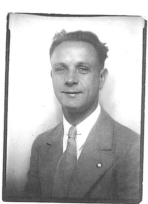
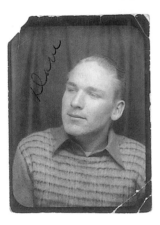
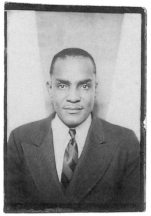
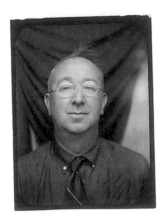

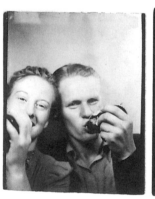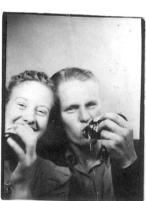

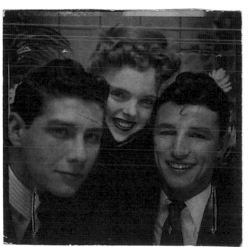

My Wife & Jack Sexton

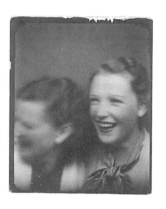

Baseball Is a Funny Game

Joe Garagiola

Baseball

is a funny game

J. B. LIPPINCOTT COMPANY

PHILADELPHIA / NEW YORK

TO
August A. Busch, Jr.
Who kept the Cardinals in St. Louis
and found a place for
a finished catcher

Martin Quigley
My literary coach, without whom this
book wouldn't have been finished

Joey, Steve, and Gina
My kids, without whom it would have
been finished sooner

Audrie
My wife, without whom it wouldn't
have been started

and

Edward Ross
My late father-in-law, who has been in
my corner all the way

Contents

1. THROUGH THE CLUBHOUSE DOORS 11

2. INSIDE THE CLUBHOUSE 20

3. DIGGING IN THE DUGOUT 42

4. BETWEEN THE FOUL LINES 58

5. THE MEETING ON THE SUMMIT 74

6. THE BULLPEN 87

7. THE LONERS 102

8. THE HEARTLINE 121

9. THE SOCIAL SECURITY NUMBERS 138

 I. *Of Scouts, General Managers, Schedule Makers, Groundskeepers and Others Behind the Scenes* 138

 II. *Of Official Scorers, Sports Writers, Broadcasters, and Others Who Also Serve* 166

10. THE BANQUET TRAIL 177

11. THE WINDUP 189

Baseball Is a Funny Game

Through the Clubhouse Doors

"I walked through the clubhouse doors. . . ."

That's the last part of the dream of many a kid, to walk through the doors into the place where the guys on the bubble gum cards come alive.

I walked into my first big league clubhouse because Dee Walsh, the Cardinal scout, had watched me play out in Sherman Park in St. Louis. He would sit in the stands, a one-man crowd, and watch us.

I was thirteen years old and just as juvenile as our juvenile delinquents of today. That was the reason for this league, a project undertaken by the WPA to keep us juveniles off the streets. This was in 1939.

I played with the Andy Highs, a team named after the great little guy who was an infielder with the Dodgers in the '30's and is now scouting for them. A fellow I grew up with who has now become, I think, a part-owner of the Yankees, Yogi Berra, played with the Johnny Brocks, named after a fine outfielder for the St. Louis Browns.

It was a long hike to Sherman Park from The Hill, where Yogi and I lived. (Outsiders sometimes refer to The Hill as Dago Hill. I guess it's because so many Italian-American families live there.) But we made it for every game.

I had always thought that a scout would be a guy who wore his Sunday suit even on Monday, had a Cadillac four blocks long, smoked a big black cigar and had a pocketful of money to hand out. But Dee looked pretty much like Joe the mechanic, or Gus who took up the collection at eight o'clock Mass.

After the games, Dee would talk to us kids, and he began to spend a lot of time with me. I was a first baseman then, but he told me I should be catching. If you ever wonder how a scout finds a ballplayer, it's that simple. He watches kids play ball.

Today the chances of a good young prospect being overlooked are impossible unless he figures out a way to play ball in complete privacy. Today's scouting is so organized that even the scouts have scouts, known as "bird dogs." A bird dog is usually a high school or college coach or a former ballplayer who sees a lot of sandlot ball. When the bird dog sees a pretty good prospect, he tips off his scout who comes and takes a look or two. Should the boy be signed, the bird dog is paid for his tip—usually on the basis of the higher the boy goes, the more the bird dog gets paid.

My advice to kids who have the dream of someday walking through those clubhouse doors is never be a dogger. The man with the beckoning finger may be watching you that day.

Dee Walsh didn't tell me he was a scout until he beckoned me aside one day.

"Can you work out at Sportsman's Park tomorrow?" Dee asked me. (That's what Busch Stadium was called then.)

Me in a big league park! I shook my head. "Naw, I can't make it," I said. "Got somethin' else to do."

"What's the matter?" he asked gently. "Don't you have the equipment?"

"I got the equipment," I snapped back, but to tell you the truth I didn't even have a Kleenex of my own if my nose began to run.

"Well, bring your shoes and mitt and be out at the park tomorrow at ten," he said. "A fellow will meet you." The way he said it, he sounded so much like Papa John Garagiola that all I could say was, "Okay, Mr. Walsh, I'll be there."

To find baseball equipment on The Hill was going to be a real Sherlock Holmes job. There was no Little League in Italy, so it was hard for Papa Garagiola or Papa Berra to understand why you had to catch a ball, let alone have a glove to catch it with, and why you needed special shoes to run in, especially when you couldn't wear them to church on Sunday.

On The Hill, as in most Little Italy colonies, the Catholic Church was the buzz point. No trouble was so big that Father Palumbo couldn't straighten it out. You were taught early that Saturday is take-a-bath day, get-to-Church-for-Confession day, and help-Mama-fill-out-the-weekly-envelope-to-drop-in-the-basket-at-Mass-on-Sunday day.

All the shopping was done in the neighborhood and in Italian. With the advent of the supermarket, a few of the more daring mamas have gone on expeditions, but mostly it's still to Fassi's or Russo's.

The younger generation has made changes like bringing Hollywood bread to The Hill, but you still see Fazio's bakery truck making the rounds, and the familiar call of *"Andiamo due pane!"* is still heard on The Hill.

Papa saw the paper, but he never read the sports pages. He didn't know third base from the coach's box; in fact, he didn't know there *was* a third base *or* a coach's box. We got the paper because my uncle lived with us, and he liked to read

the weather report. My mother never looked at the downtown store ads, because Gianin would bring the material around. Gianin was a little Jewish dry goods merchant who could speak Italian dialects fluently. He had to be able to understand Lombards, Sicilians, Piedmontese, and the others, and of all the linguists I have heard, he would be my Number One choice, for he had to dicker with these women on their home grounds. All his games were on the road.

Downtown, as far as The Hill mothers and fathers were concerned, was the place you went to take your citizen's papers test. Otherwise, Downtown was as far away as the Duomo in Milan.

The magic words in the neighborhood were Laclede-Christy. Most of the men worked for Christy at either the Manchester Avenue plant or the Kingshighway plant. Papas Garagiola and Berra worked at Kingshighway as laborers—in the words of the song Tennessee Ernie sings, loading sixteen tons. The four-thirty whistle of the nearby Blackmer Post pipe company was the first kind of sign, as far as baseball was concerned, that the kids of The Hill learned.

When the four-thirty whistle blew, it was break up the game and head home for the beer bucket. The kids whose pops worked at the Manchester plant would be first in line at Fassi's for the beer because those workers would be home first. Then Marnati's carry-all truck with benches for seats would pull up with the Kingshighway plant workers. We would try to jockey to get Emil, one of the Fassi boys, to fill our buckets, because he didn't give you all foam, as Papa would say.

Our first ball games were played in the streets, so we did not have much use for the spiked shoes we didn't have. Most of our bats were discarded broken bats that we nailed and taped together. Everybody chipped in to buy a new ball once

or twice a summer. We played mostly softball on the streets. We had a diamond laid out with the bases painted on the street, although we called them bags because that's what France Laux, the Cardinal broadcaster, called the bases at Sportsman's Park.

Painting those bases, we ruined Papa Berra's best paint brush and used up Papa Garagiola's brown paint. For the football season, it meant more ruined brushes and more paint to mark the ten-yard stripes, and Elizabeth Avenue could have been called Zebra Drive.

You couldn't very well tell Papa Garagiola or Papa Berra that there was a chance to make money playing baseball when you were ruining paint brushes and using up paint, so asking for money to buy equipment was out.

The first big league ballplayer anybody talked about in the neighborhood was an infielder with the Pittsburgh Pirates who lived in Blue Ridge (a suburb of The Hill). His name was Jack Juelich. The other big league name we heard was Frank Crespi, but he moved off The Hill before any of us got to know him. Juelich and Crespi were myths to us. Our "live" baseball heroes belonged to the Hawks, a club of about fifty members. Yogi's elder brother Mike was an infielder with that club, and their league was our supply house for broken bats and stray foul balls. We had a regular relay system for retrieving those foul balls. Our whole club shagged the balls.

Every kid on The Hill belonged to a gang or a club. You either belonged or were out of all the action.

We knew of the Joe Medwicks and Terry Moores, and we dreamed of being big leaguers. We would sit on the corner under the lamp post and argue that the Cardinals could beat the Browns, that Harlond Clift was the best third baseman in the American League, and other interesting propositions. We would go to sleep early Saturday night so we could get to the

seven o'clock mass and out to Forest Park early Sunday to watch our "live guys," the Hawks, beat the North St. Louis champs.

As far as we were concerned, baseball equipment like shin guards and a catcher's mitt were just pictures in a catalogue. Rawlings, Wilson and MacGregor, though, were names we could identify much quicker than Longfellow, Einstein or Shakespeare. With me they could put the ballplayers in the Litany of the Saints, but Papa Garagiola couldn't go for it, so asking him for equipment was out. I also struck out if I tried to work it through my mother. She never has figured out this baseball.

She saw her first baseball game only after I had reached the major leagues. The date was September 5, 1946. It stands out so much with me because the people of The Hill sponsored Joe Garagiola Night. It will always be a top thrill to me because that night I saw many people there like Mama and Pop—people who didn't know what baseball was but wanted to be there because "this is one of our boys." It was best expressed by the vegetable peddler who in his best English told me a few days later, "Gioi, you the firsta boy what comes from The Hill, witha name witha ends a, e, i, o, getta name in the paper and no killa somebody."

This Joe Garagiola Night was a big night for Papa John and Mama Garagiola. For Mama, it would be a trip downtown without going to be fingerprinted as an alien. It would be seeing lots of cars and lots of people, and nobody getting married. How could a grown man get money for playing a game? Why do they want to give him an automobile? Why do people pay to see men play? These were just a few of the questions Mama couldn't answer.

My brother Mickey and his wife sat with Pop and Mom. Her first words when she walked into the ball park that night

and saw all the excitement were: "The poor boss, what electric bill he gotta pay."

When the attendance was announced at around 29,000 and Mickey told Mama that each one was at least a dollar, she said the boss could afford to keep the lights on.

But to get back to my treasure hunt for the baseball equipment. If you pooled the resources on The Hill, maybe you could outfit one ballplayer.

Somewhere—but where?—on The Hill were baseball shoes and a catcher's mitt.

Monk Berra (no relation to Yogi, although since his first World Series all the Berras have become relatives) had the only pair of baseball shoes. It was a simple deal. The shoes were 10 C's, but stuff the front with rags and cotton and you could make 5's out of them. Knowing that tomorrow I would be on the field at Sportsman's Park made 'em feel like they were custom made. The catcher's mitt was the problem. None of our guys had one. The only one we knew of belonged to Louie Cassani. He wasn't one of the boys but Father Palumbo said that our Johnny Colombo knew Gino Pariani who knew Louie Cassani. The network began operation and we got the mitt for me.

At ten the next morning I met Joe Sugden for the first time. "You Dee's kid?" he asked and threw out a right hand that looked like a weather vane. Fingers were pointing in every direction. Shaking hands with him felt like grabbing a sack full of peanuts. Joe and Gabby Street are two old catchers that the old-timers say met on the street, shook hands and it took a plumber twenty minutes to get them apart.

"Yes sir, I'm the boy Mr. Walsh sent."

With a shift of his chewing tobacco, his eyes lit up and the face with the lines that looked like they had been carved with baseball spikes broke out in a laugh that's familiar in the

pennant-winning clubhouse. "C'mon, kid, let's get dressed."

Joe Sugden had caught the spitball and was the first catcher to move up close to the hitter. He knew the way to the clubhouse all right.

He took the straight way down from the office, down the back steps, under the stands and then I walked through the Cardinal Clubhouse Doors. I looked around and saw the names . . . Moore . . . Slaughter . . . M. Cooper . . . Medwick . . . I didn't know whether to say three Hail Mary's or just read their names and say pray for us. Joe Sugden took me back to a small room. Later when I got to the big leagues I learned that even this room had a special name. It is called the donkey's room, because all workout and tryout boys are called donkeys.

I put on my first baseball suit. An old pair of Mickey Owen's pants and an old shirt that once was worn by Joe Medwick. Their names were still sewed in there. Joe Sugden showed me how to put on the outer socks because this was the first time I had ever put on a pair of socks that didn't have toes or heels. Then I put on my shoes and grabbed my drug-store mitt.

Joe stopped me. "Those shoes fit you?"

"Yeah, fit me perfect."

He laughed, and now I can see why. They looked like Dutch Boy shoes with the front spikes staring me right in the face.

"What size do you wear?" he asked.

"I dunno. I always wear my brother's old shoes."

"C'mon." He motioned and led me right to Max Lanier's locker. Joe gave me a pair of Max's shoes to put on.

"I can't wear his shoes," I protested.

"Put 'em on, it's okay."

So I did. As soon as I got them on I wanted to take them off and run all the way home to tell the guys on the block that I

had just worn Mickey Owen's pants, Medwick's shirt and Lanier's shoes. (Later on Terry Moore was to give me my first pair of baseball shoes.) Then Joe Sugden took me out on the field for my first workout in a real big league park.

There was one other fellow on the field already, and I thought he was just like me, just another donkey. "Warm that fellow up," Joe told me. I had done this a million times back in the neighborhood without a glove.

"Hand hurt?" Joe hollered after a while.

I didn't have a sponge in the Walgreen glove, and my hand was already swollen twice its size. "Naw, it don't hurt," I called back. How could your hand hurt when you were wearing Mickey Owen's pants, Joe Medwick's shirt and Max Lanier's shoes?

I warmed this fellow up about half an hour, and he quit. "You know that fellow?" Joe asked. "That's Jack Kramer of the Browns. Stayed behind on account of a sore back."

Me warm up Jack Kramer! I was through for that day.

Joe led me back through the clubhouse doors.

Inside the Clubhouse

From that first time with Joe Sugden, I have walked through many a clubhouse door and have modeled quite a few different uniforms. In the minor leagues it was with Springfield, Missouri, in the Western Association, and with Columbus in the America Association. In the big leagues with the St. Louis Cardinals, Pittsburgh Pirates, Chicago Cubs and New York Giants. Those were the home clubhouses I got to know. Of course, I also did time in the visitors' clubhouses in all those leagues.

A clubhouse isn't fancy but the walls hear, the stools see and the boards talk. They all differ, but basically they are all the same . . . a row of lockers . . . a manager's office . . . a training room. Depending on how the team and you are going, the clubhouse can be Heartbreak Ridge or the Street of Dreams.

The Cardinal home team clubhouse now has to rank as the best I have ever been in. It has big lockers and a lounge with telephone, record player and easy chairs. The washrooms are spacious with plenty of washbasins and mirrors.

The visitors' clubhouse at Busch Stadium has been improved considerably, but it is not as plush as the Cardinals': No easy chairs or record player, but there now is the luxury of a locker. What is now the trainer's room used to be the entire dressing room. The comics used to say about the old visitors' clubhouse: "They'll have to paint this before they can condemn it." Lefty Gomez, star Yankee pitcher, once said the showers were so high and he was so small that by the time the hot water got to him, it was cold.

As far as visiting team clubhouses in the big leagues go, I would rank them all fairly even, with the edge to the Milwaukee and Pittsburgh clubhouses. The Dodger clubhouse at Ebbet's Field was always an experience because the walk to it involved going past those fans that made "Ya bum ya" famous. Yes, Virginia, it is different out in Los Angeles.

A big advantage to being the home team, besides the fact you get the last time at bat, is the home-team locker room. A team spends most of the season there, and everything is done to make it comfortable.

The Pittsburgh clubhouse is a roomy one, but in my time it was also the busiest. At times it looked like a Sears, Roebuck sale was going on with power mowers actually on display. Visitors are usually kept out of the clubhouse, but at Pittsburgh when you started talking to someone you didn't know if he was the new third baseman or a salesman for the Encyclopaedia Britannica.

The Giant clubhouse at the Polo Grounds was a contemporary style, split level. Walk down a flight of stairs and you were on the level with the card tables, and off to the side was the manager's office. Down another flight and you were in the locker room. From there, steps led up to the shower room, on still a third level. Card playing was a big thing with the Giants in 1954 when we won the pennant. Gin rummy and hearts were the favorites. "It relaxes while keeping 'em on their

toes," was the defense used whenever card playing was questioned.

The Chicago Cub clubhouse is the most crowded. Your locker is sometimes a nail in the wall. To get to the clubhouse from the field you have to use a long ramp. This ramp or catwalk leading to the clubhouse can make you feel like a Hall of Famer or the condemned man on the long walk to the guillotine, because the rabid Cub fans stand underneath and let you have it, one way or the other. Over seventy-seven games it is really an experience.

The Cardinal clubhouse is a great one for music, with the emphasis on hillbilly records. Max Lanier, a pitcher, was the big hillbilly fan when I was there, and Stan Musial was a great man to beat out the rhythm on coat hangers. Now the Cardinals have their own song writer in catcher Hal Smith. He is the author of such songs as "Sittin', Spittin' and a-Whittlin'," "Churn Full O' Chitlings (and a Belly Full of You)" and "Purt Near but Not Plumb."

Reading material is a big part of the clubhouse. *The Sporting News* is the big favorite, because you can check on what the guy who had the locker next to you is doing with his new club. Comic books rank high. If Yogi Berra can sharpen his eyes on them, they can't be too bad for you. Most players can tell you how Dick Tracy will come out and nobody really cares if Little Orphan Annie is forty-six years old. The Pittsburgh clubhouse has changed, though, and the lockers are now loaded with college magazines and the *Wall Street Journal*. Max Surkont, a pitcher, used to call the locker section where Dick Groat, Jack Shepherd, the O'Brien twins and Laurin Pepper (all college and bonus boys) had their lockers the Gold Coast, while he refers to his row, which at the time included Sid Gordon and Dick Littlefield, much-traveled veterans, as the Bowery.

Routines, moods, and action change with every clubhouse.

Bill Klem, most famous of all umpires, once said there are 154 games in a season and you can find 154 reasons why your team should have won every one of them. Blame luck, the wind, a rock-headed play or the umpire. To this you might add the clubhouse boy who is blamed for almost anything.

Yosh Kawano, Butch Yatkeman, Eddie Logan, Byron Jorgensen ... "What's My Line" would have a hard time figuring out what they do. Japanese rice tycoon the first one? No! Middleweight fighter the second one? No! Irish tenor the next? No! Swedish ski instructor the last one? No! These are clubhouse boys, combination valet, equipment expert, loan company, buffer and the personification of the three famous monkeys.

The truest statement regarding these see no evil, hear no evil and speak no evil boys was made by Mort Cooper, then a star pitcher with the St. Louis Cardinals. One of the cocky rookies was really getting on Butch Yatkeman, letting him know that Butch was the clubhouse boy and he a player. After a while Mort snapped: "Butch was here before you came, and Butch will be here after you're gone."

The clubhouse boys get salaries, but depend heavily on tips, so it's easy to see why the stars are given extra attention, although I have never seen a raw rookie abused. Yosh Kawano, Cub clubhouse boy, made no bones about it. Ralph Kiner was traded to the Cubs on Yosh's birthday in 1953, and Yosh always said that this was the best birthday present he ever received. When big Kiner was traded to Cleveland, Yosh said, "This is the first time a clubhouse boy ever had to take a cut."

Solly Hemus, an infielder, was one to take real advantage of the star treatment. Of course, if there was one ball player who could take advantage of the breaks it would be Hemus.

Solly, dressing next to Stan Musial during spring training, noticed that every day all of Musial's shoes were shined. So

Hemus slipped his shoes into Musial's locker and got them shined every day, courtesy of Stan Musial.

The clubhouse boy has to please twenty-five guys at the same time and is a very important part of the baseball picture. He has to live by the sign that was hung in the Milwaukee visitors' clubhouse by clubhouse boy Tommy Ferguson: "WHAT YOU HEAR HERE, WHAT YOU SEE HERE, AND WHAT YOU SAY HERE MUST STAY HERE."

The trainer's room is usually away from the lockers—except in the Cub clubhouse, where if you're not careful Doc Scheuneman might be rubbing you down when all you want to do is get a sweatshirt from your locker. Everybody collects in the trainer's room or on the table to tell him their troubles.

Sometimes a ballplayer will come up with his own cure, and the trainer might go along with it if only for the psychology involved. The most famous of these home brew cures was the secret snake oil that the ageless Satchel Paige came up with while a member of the St. Louis Browns.

The former trainer of the Cubs, the late Andy Lotshaw, had a favorite story about secret cures. It involved Guy Bush, the Cubs' star pitcher, when he complained about a sore arm. Into his kit Andy went for his sure cure. He rubbed the arm and finally pronounced Bush fit, and he went out and won. After that, it was a ritual for Andy to rub the arm with the secret ointment. It was only after Guy Bush was finished as an active pitcher that Andy revealed his secret. On that first day Andy had run out of linament and grabbed the first bottle of liquid he could get his hands on which happened to be a bottle of Coca-Cola.

Like most trainers, Andy Lotshaw was great on tales about his ability as an athlete. He claimed that as a hitter his eyes were so sharp that he could hit the spitball on the dry side.

Doc Weaver, late trainer of the Cardinals, was a great guy for working on the feet, and he developed the famous Doctor

Weaver's Wonder Walkers, inner soles that many of the ball-players still use. Pepper Martin, the Wild Horse of the Osage, was one of his first customers. How Doc's eyes would light up when he would tell about the great experiment with John Leonard, as Doc called Pepper. He had worked on those inner soles until he knew they were perfect. Before a Sunday double header he gave them to Pepper, who wore them during batting and infield practice. The first time up Pepper topped the ball and was an easy out. The second time up he tapped one right back to the pitcher, easy out. The third time up, in the seventh inning with the bases loaded, he topped the ball again and was thrown out by the pitcher. When he got back to the bench, Pepper took the inner soles out and threw them against the wall hollering, "They make me too high, and I'm hitting over the ball."

Trainers do many things that you would have to call the "extra" that pays off. Doc Weaver would always make sure that a Cardinal victory was more than just another win for the pitcher. Doc would get the last-out ball and paint the line score on it with little figures depicting the highlights of the game. It made the victory more than just another win. Games aren't won on muscle alone.

The trainer is always watching over his boys because he knows you don't have to cure an ailment you can prevent.

"You shouldn't work out in a short-sleeve sweatshirt, Tom. You ought to wear a long-sleeved shirt so you can keep that body heat. When you're sweating, you're heated. Let the cool air hit you, and the chill will tighten those muscles." Said to one, but five guys nonchalantly walk to their lockers for long-sleeved sweatshirts.

"Let me trim those eyelashes, Stan, it will let you see the ball better." (Never heard that one before, thinks the rookie, but it sounds logical.) "The loose lashes won't be irritating your eyes." (That sounds good, thinks another.) "See better,

bound to hit better and you won't be rubbing around there during the game." (I never had that done before, but I'll ask him to trim mine when he's through.)

"Don't just stand there, Hal, sit down. It might be a long night. You know what they always say—Why stand when you can sit, why sit when you can lie down? Know what I do when I go back to the hotel after a long day and lie down to rest? I elevate my feet. Really stirs up the circulation down there and it makes you feel good. Give it a try."

"That's it, keep those nails trimmed. You'll never have an ingrown nail if you keep them trimmed like that. Better yet, you won't have it ripped off by a ball." (This one looks long, and I'm catching tonight, better trim it.)

"Giving those flying feet a grease job, eh, Ken? That's the way to use the foot cream. Petroleum jelly is good too. Get between those toes and you'll never have a blister or a soft corn. Got to keep those wheels spinning."

That is the run of the conversation that you'll hear in the trainer's room, as he looks out for his boys.

What the trainer can't do for you, the team physician can. Treating an athlete is different, because the main thing going for a ballplayer is that he has to play. Every day he doesn't play is gone, and it's a short career at best. The last thing a player wants to hear is that he has to rest his injury. You can appreciate how ticklish the team doctor's job can be.

The late Surgeon General of Baseball, Dr. Robert F. Hyland, was a pro among the pros. It was he, more than anybody else, that brought home the importance of "getting 'em back in the line-up." To him ballplayers' hurts were his hurts, they were deep hurts and sometimes diathermy couldn't get to them nor could surgery. It's a great team in the Hall of Fame, and I'll bet Doctor Hyland is still the first one in the clubhouse when there's an injury.

Practical jokers are a part of every clubhouse. They always

have been and always will be. Walker Cooper has to be right up on top of the modern players' list. If you ever walked into your locker and felt all "knotted up," look for big Coop. That's his favorite, and he can get twenty-five knots into one sweatshirt.

Del Rice, when catching with the Cardinals, got even with Cooper by tying all Coop's clothes in knots. Coop came back at him. When Del went to put his shoes on they wouldn't budge. Cooper had nailed down every pair with a spike that could have held two giant redwoods together.

The late Mel Ott, when managing the New York Giants, went out one night to the preliminary meeting with the umpires and the rival manager, his line-up cards in his right hand pocket. Up at the plate he reaches into his pocket, but no line-up card comes out. From the stands it looks like Manager Ott is really nervous, leaning forward and then backward, now almost on his knees. While the meeting at home plate was still in session, he strode to the dugout. "Cooper," Manager Ott screamed, "you're fined $50 for cutting the bottom out of my pocket."

Ralph Kiner, the great slugger, belongs on the all-time practical jokers' nine. In St. Louis one night he nailed down Trainer Doc Jorgensen's shoes and cut his tie in half. Doc couldn't leave for a while, but the next day he had a new pair of shoes and tie courtesy of Ralph Kiner. Doc probably still doesn't know who took all his bottles and equipment out of his kit and stuffed it with sandwiches. What a surprise it was when one of the players got spiked and Doc ran out on the field, opened his bag, reached for the merthiolate and came out with a braunschweiger sandwich.

Once when the Pirates were having a rough time winning a game, Frankie Frisch, the manager, started a get-tough policy and was slapping fines on everybody.

Elbie Fletcher, the first baseman, got the first prize, a $500

fine. As most ballplayers do when this happens, he headed for the trainer's room to moan.

"What have you got worth $500?" he asked Doc Jorgensen.

"That's about what the diathermy machine would cost," Doc said. Fletcher lugged it out of the trainer's room and put it in his locker.

In came Jeep Handley. "What you got for $250, Doc?"

"That cabinet with the medicine in it should be worth that," answered Doc. Into Handley's locker the cabinet went. This went on until Al Gerheauser came in: "I just got hit with a $50 dandy, so what's left that's worth fifty bucks, Doc?"

"All that's left is the sun lamp, Al." And to his locker the sun lamp went.

Frisch got the last laugh, though, when he collected the fines.

Did you ever try to look through a pair of sun glasses that were coated with zinc oxide? How about putting a thin tissue paper between the ham and cheese so as to give the sandwich more body? Ever smoke a cigar that had cotton soaked in alcohol packed into it?

If Don Gutteridge, later a White Sox coach, never does believe a trainer again you can't blame him. Worried about a condition in his mouth, he sought out Trainer Bob Bauman when both were with the Browns (and on that club you had to make your own excitement). Bauman knew it wasn't serious, but he diagnosed it as a bad case of trench mouth and prescribed a harmless, foul-tasting medicine for two weeks.

Once Johnny Mize had taken an extra hard workout and came into the Giant clubhouse drenched with perspiration. He took off his sweatshirt and went to get a drink of water. Trainer Frank Bowman soaked the sweatshirt with alcohol. When Mize came back, Doc asked him how he felt. "Tired but good," said Mize.

"Better stay away from that hard stuff, though, John. That's what really knocks you," Bowman said in a kindly voice.

"What are you talking about? I was in early last night and only had a couple of beers."

"Oh yeah? It's okay with me but don't kid me, I'll prove it to you."

With that he dropped a match, and the sweatshirt was aflame.

"That's alcohol that you sweated out, John!"

The embarrassed Mize grabbed the shirt and put out the fire.

"Don't say anything about this to anyone, Doc," he pleaded.

Ever wonder what's going on out on the field when the trainer runs out? Well, first he sizes up the injury and minimizes it to the player. If it's serious, he makes the decision and there is no by-play. If it's a minor injury though, look for something funny. Like once in a game with the Phillies, when Solly Hemus was playing with the Cardinals, Solly went down to field a ground ball and it took a bad hop. Down he went in a heap. Out came Doc Weaver and the rest of the team collected around the little scrapper. As he came to his feet, there were smiles that could easily be seen from the stands. I'm sure fans were wondering what's so funny about a guy getting hurt. Here's what happened. Hemus had said, "Doc, use a lot of that red merthiolate, this game might be televised in color."

The clubhouse bulletin board can be a combination of train schedules, court orders and vital statistics. On it you can find anything from what time the train leaves to who was fined for what and thanks for the baby's gift. Somebody has to add something all the time.

On the Cardinal bulletin board, when the notice for the team-picture time was posted, someone added, "Better wait until June 15" (trade date deadline), and the way General Manager Frank Lane was then moving the players, it didn't sound like a bad idea.

There are some serious directives that get on the bulletin board, but these are the least read—too official looking. The player representative usually reads them, and he is forever answering questions about them.

Ever wonder if somebody painted "fighting phrases" on the walls of a clubhouse? In baseball that is rare. I have seen newspaper clippings put on the bulletin board to stir up a team. These are usually statements made about a particular player or the team spirit. The only sign I have ever seen is the one on the wall in the Pittsburgh clubhouse: YOU CAN'T MAKE THE CLUB IN THE TUB.

A lot of conversation in the clubhouse begins and ends with the "swindle sheets" used by the clubhouse boys. These are the lists used to keep track of charges for soft drinks, gum, tobacco, etc. Get involved in a few Coke games and have somebody charge a few to you, and you begin to scream.

A Coke game is the bunting game that the players get into before the regular game. Instead of getting an error when he misses the ball, a player is charged with a Coke. I remember a variation of this game that could be expensive. It was the year that the Detroit Tigers signed catcher Frank "Pig" House to a bonus contract. In addition to a bundle of cash, House was given two automobiles. Joe Ginsberg, then with the Tigers, was in a Coke game during spring training with House. I hollered to Ginsberg, "Pretty fast Coke game with that House in it." He came back with, "Cokes? We play House for automobiles."

Gussie Busch, the owner of the Cardinals, got the same

"Wes Covington. He's a low-ball hitter and likes the ball out over the plate. I will try to get him with curve balls and I think I can change speeds on him. He won't bunt and doesn't hit and run. Play him deep and to pull. Protect the hole in left center field.

"Del Crandall. Likes to hit the fast ball and will pull everything. I think I can change-up on him. When I throw the fast ball it will be in on him. I will try to pitch him right on his belt buckle. He will bunt if he catches the third baseman back. Will try to hit and run at times. Play strictly to pull.

"That's the starting lineup. Watch the hit and run from Logan. Mathews might bunt if they need a baserunner."

After this the pitcher will run down the roster to take up the pinch hitters that are likely to see action against him.

The meeting is usually rounded off by the manager taking charge and reminding his starting line-up about signals and any injuries on the other club. If the pitcher is a weak fielder or might be lax in holding men on base this is discussed. Anything about the other club that might fall into the category of trick plays is discussed, such as "Be careful now of the delayed steal, they like to try it. Watch the second baseman on the bunt situation, they like to try the pick-off play. Be careful when they get a man on second base, see that they don't steal the signs."

I think that sometimes the opposition is discussed too much. You keep pointing out their strong points and trying to find out their weaknesses and you end up making everybody wonder "if he's that good or that tough to pitch to, how come he's only hitting .220?" You might also wonder if a meeting can work to build up tension. We really battled the Brooklyn Dodgers during 1947, 1948 and 1949, and after a series with them, there was a strong emphasis on no let-up against the Phillies. "Don't let up, don't let up, be careful, don't hold this guy cheap and so on." The end result, what-

somebody on first base he will try to go to right field. He will hit and run and will bunt. He doesn't run too much.

"Eddie Mathews. He will chase the bad low ball but can hit the low strike ball a mile. I try to keep the low fast ball out of the strike zone. I can throw him slow curve balls and will try to make him hit my curve ball. If I have to throw my fast ball it will be inside and I'll be throwing for his belt buckle up. He will bunt me especially if they need a base runner. He doesn't steal much but can run. Play him strictly to pull and deep.

"Hank Aaron . . . I'll be moving the ball around and try to get a strike on him by throwing breaking balls away from him. He likes the ball out away from him and if I have to throw my fast ball it will be in real tight. I can change up on him. I think he is a better low-ball hitter. He's a bad-ball swinger and can hit the bad ball. My out pitch will be something besides the fast ball. If I have a good change-up today, that's what it will be. Play him deep and not too far over. He won't pull right down the line. He won't bunt nor does he try to steal too much.

"Joe Adcock. This guy really tries to guess me. A real guess hitter. I like to move the ball around on him and I can change up on him. I can throw my fast ball in on his fist because he comes right into the ball. He likes the ball out over the plate. Play him deep and to pull. He has good power in right center. Doesn't bunt nor does he try to hit and run.

"Andy Pafko. He'll probably play against me. He's a spray hitter to all fields with good power. He's a first-ball hitter and a fast-ball hitter. He will chase the bad curve ball especially when he has two strikes on him. I will try to crowd him with the fast ball and change up on him. With two strikes I'll throw bad curve balls. He won't pull me right down the lines so guard both slots, right center and left center. He bunts for a hit once in a while so be alive.

Rogers Hornsby, the Hall of Famer, has an observation that bears thinking about. About our 1952 Pirate team the Rajah said, "You guys have a fifty-fifty team. You get 'em out in the clubhouse but lose on the field." Very rarely is there a big difference on how to pitch a hitter and very rarely does it end up any other way when a pitcher is stuck than to say, "Crowd him with the fast ball and make him hit the curve ball that is low and away." The magic words, if you want to sound like the expert; high and tight and low and away. A strategy meeting could very well at times be called a meeting of the Society for Advancement of the High Tight and Low Away.

It works like this. You are the home club and have just finished taking batting practice. The whole club is off the field, and the manager hands the starting pitcher the scorecard. Let's say it's the first game against the Braves. Vinegar Bend Mizell is your pitcher.

Vinegar takes the scorecard and begins with the line-up that will start against him. "The first hitter is Schoendienst. He will be batting right-handed against me and is a better high ball hitter batting right-handed. He's a good fast-ball hitter. I will try to keep him from hitting the fast ball. I will try to get him out by throwing him change-ups and making him chase the bad high fast ball. Play him straight away and not too deep. He likes to hit and run once in a while. Doesn't try to bunt too much for a base hit while batting right-handed. He doesn't try to steal too much any more but I know he can run and I'll be watching him.

"Johnny Logan. This guy is really a streak hitter and he has been hitting good his last five games. I think he is a better fast-ball hitter. He's a first-ball hitter. I'll try to make him chase the bad curve ball and make him hit my slow stuff. If I have to throw him the fast ball I'll crowd him with the ball. Play him to pull the ball with nobody on base, but with

type of jockeying while in a pepper game that had Stan Musial as the hitter. It was a custom of Busch and two or three of his associates to work out a bit during spring training. During a Coke game, one of the jockeys hollered to Musial, "Hey, Stan! What do you play Gussie for, breweries?"

The most important thing, in winning or losing a game, that happens in the clubhouse is the pre-game meeting. There are a lot of different thoughts regarding this meeting. Eddie Dyer would have a meeting every day. It was mostly strategy and was held right before the game to be played that day. Marty Marion would have a meeting before every series. Phil Cavaretta, Stan Hack, Fred Haney and Bill Meyer were all about the same—a meeting before the series with the pitcher and catcher holding forth and the rest of the club listening. Leo Durocher had his meeting with the pitcher and catcher, and was the most dramatic. His enthusiasm was contagious.

In 1954 while the Giants were on their way to a pennant, the Milwaukee Braves began to close in. Leo held a meeting and all he kept saying was, "We're in first place, they got to worry. We pick up ground when we get rained out. We're in first place, why worry? Let them worry." It certainly wasn't like Knute Rockne, but when the boys left the clubhouse, they knew they were in first place. They finished there, and a lot of the credit has to go to the pep talk by Durocher.

The main purpose in the clubhouse meeting is to discuss the hitters. Eddie Dyer would have the pitcher take up the hitters and tell the rest of the club how he was going to pitch them and how he wanted them to be played. The secret book on the different clubs doesn't vary, it's the execution that varies. You realize how true this last statement is when you go from a pennant contender, the Cardinals, to a second-division club, the Pirates, which happened to me in 1951.

ever ground was made up against Brooklyn, the Cardinals dropped it to the Phillies.

Another danger is in the so-called "out" pitch discussed in detail by the pitchers. What is a good "out" pitch for one pitcher may be a home run pitch for the other. It is not rare to have a pitcher call a catcher out to the mound and say, "This guy is wearing me out. Bill said he gets him out with a change-up, I think I'll try it." You can realize the danger: here the whole game is riding on this time at bat and your pitcher wants to begin experimenting.

I would say that Howard Pollet, a star National League pitcher and now pitching coach with his first team, the St. Louis Cardinals, held the ideal meeting. He never would say what particular pitch he would throw for the out but would set up his defense and tell where he would throw.

Pollet talking of Peewee Reese, "He'll hit me straight away. I want the left fielder over a bit towards left center, the center fielder shade him a bit towards right . . . the right fielder over towards right center . . . Third baseman give him the line except with two outs and be alive for the bunt . . . I want the shortstop over near the bag—with a man on at first, the second baseman will have to protect the hole between first and second. I'll be pitching my fast ball down and I will change up on him."

There never was any of that "I'm going to curve him and keep it here" or "I'm going to fast ball him there." The reason I liked this meeting so much is that the defense knew where they should be playing and yet Pollet wasn't putting thoughts into another pitcher's head. As I said earlier, I have battled right out on the mound with pitchers who want to try and get him out like so and so is getting him out because he is just wearing me out. Each individual pitcher has to find out for himself. It might end up that he does get the hitter out the way they say, but just because a Pollet got a

Jackie Robinson out on a change of pace doesn't mean that Robinson couldn't hit the change that another pitcher would throw.

When the meeting gets muddled and the wheels really begin to spin, somebody always trys to dazzle the club with grammar. When this happens you can look for somebody to break it up with a crack. It was in a meeting of the Pittsburgh Pirates. They had discussed just about everybody on the Chicago Cub team except traveling secretary Bob Lewis. At this point the player to strategize was Jim Davis, a pitcher. (Jim by reputation was a very weak hitter; a foul ball by him called for a tape measure.) "How's about this Jim Davis, he's a switch hitter, how we gonna pitch him?"

"He ain't no switch hitter," came the answer, "he hits three ways, right-handed, left-handed, and seldom."

It was during one of the meetings that Howard Pollet was conducting in Chicago when the Phillies' catcher came up. Howard had covered the two regular catchers, Andy Seminick and Stan Lopata, but he didn't know too much about Gus Niarhos (hitting .190 at the time).

"I've never pitched against Niarhos before, how should we play him?"

"Easy," came the answer, "just throw him fast balls and bunch him around the mound."

When a manager asks if there are any questions during one of these meetings, you can expect the unexpected. Pepper Martin once broke up a meeting that Ray Blades was having when both were with St. Louis Cardinals. During spring training the Cardinals were working out twice a day while the Yankees across town were working out only once a day. When Ray asked for suggestions, Pepper got up and said he had been noticing that the Yankees were holding only one workout a day and that they had been winning pennants and World Championships so he was wondering if it

wouldn't be wise to follow the Yankees and only have one workout a day.

Blades replied, "No. It's two workouts a day, and the Yankee record should be an incentive for us. You should want to be like the Yankees and work twice as hard on the mistakes and two workouts will do it . . . that's it. . . . Anything further, Pepper?"

"Yeah," said Pepper, "I got a jackass back in Oklahoma, and you can work him from sunup till sundown, and he ain't never going to win the Kentucky Derby."

In another meeting before a crucial series, with Frankie Frisch the manager, it was Pepper again who broke the tension. Frisch was handling the scorecard and ran down the roster of the other team from owner to batboy. All the trick plays were brought up. Watch the wind, be careful of the stands, the grass has just been cut, and on and on to even how many times to use the resin bag. It was a complete coverage from Frankie and one of his longest meetings. Finally to make sure, Frisch asked, "Does anybody have any questions?"

Pepper said, "Yeah, Frank I do."

"What's on your mind, Pepper?"

"Well, Frank, I just don't know what to do. Should I paint the body of my midget racer black and the wheels red, or the wheels black and the body red?"

Dizzy Dean often would take up his own team's line-up and remind his teammates what the great Jerome Herman would do if he worked against them.

Terry Moore, the Cardinal great, says that Bill DeLancey, the Gashouse Gang catcher, fractured Frisch with an answer during a meeting. At a meeting after Cub catcher Gabby Hartnett had won the game for the Cubs with a home run, Frisch said to DeLancey. "Dee, what was the pitch Hartnett hit?"

"How do I know?" DeLancey fired back, "I haven't caught that pitch yet."

In these meetings the pitcher or pitchers who worked the day before are often asked for opinions, especially if a certain hitter on the opposing club is going "red hot." It was on one of these situations that Don Newcombe eased some of the World Series tension for the Brooklyn Dodgers. Newk, if you remember, opened the 1952 series for the Brooks and lost a heart-breaker 1 to 0 when Tommy Henrich hit a home run. From the bench it looked like a change of pace. Nobody was sure, but it was certain that it wasn't his fast ball. In the meeting the next day when the Dodgers got to Henrich, they asked Newcombe, "What did Henrich hit for the homer?"

Newk looked up and said, "A change of space."

Yogi Berra is regarded as the man with the answers because of his knack of cataloging the hitters. During the All-Star game of 1949, it was his humor that came to the front, instead of his memory. The meeting had almost developed into a filibuster as everybody was chipping in on how to get Stan Musial out. After listening for about ten minutes, Yogi simply stated, "You guys are trying to stop Musial in fifteen minutes while the National League ain't stopped him in fifteen years."

The keeper of the clubhouse is each player. He spends more time here than in his own home during baseball season. It's where twenty-five guys battle every day but have to live like one. It's a continually changing scene, the clubhouse, because trades are such an important part of baseball. It is in the clubhouse that trade announcements are usually made.

The big Ralph Kiner trade between the Pirates and Cubs was finally announced in the clubhouse. I was with the Pi-

rates and had reported for the day's game as usual (and in 1953 that took courage) but had a feeling that something unusual was going to happen. We had been hearing rumors, but what really made us feel something was going to happen was the presence of newspapermen in the press box. It was only 11:30 and they were in the press box already. On a normal day most of the writers wouldn't get there until the sixth inning because nothing was going to happen before then anyhow. The Pirates took batting practice at the usual time, and the Cubs would start their batting practice at 12:30. At 12:20 both managers called their teams off the field. I remember the time so well because I remember turning to George Metkovich and saying, "George, remember the time and date, 12:20 on June 14, 1953 . . . this is history. We will see the biggest deal in baseball, with both teams going off the field it must be twenty-five Cubs for twenty-four Pirates plus cash."

Fred Haney was the manager of the Pirates then, and when the whole team was seated in the clubhouse, he said, "We have just made a trade." (This was the biggest understatement since Stan Musial said he thought he could hit.) Sitting on a trunk, I never dreamed I was in on it. I thought I was set for a couple reasons. I had a good year in 1952, hitting .272, twenty-two points higher than I had ever hit, I had played in 112 games and had showed up for 154 (and when you lose 112 like we did showing up was worth something); I had made a lot of luncheons, and I had done the extra things like catching batting practice.

The first player Haney told was Ralph Kiner. "I hate to see you go, but you are the man they wanted. I think it will be better for all concerned. Thanks for everything." Kiner admitted that the deal didn't surprise him too much. The next player was Howard Pollet. Howard knew about it because he was to have pitched the night before but was by-

passed because of the pending deal. George Metkovich, an outfielder, was next. The Catfish knew it because Haney had mentioned the possibility of the deal to him.

I'm sitting back wondering how many are involved. Is it really a twenty-five for twenty-four deal? What are we getting? After all, I knew I had that good year in 1952, and a couple days before I had a meeting with Mr. Rickey to back up my confidence. Mr. Rickey, a very dramatic speaker, had grabbed those bushy eyebrows, looked up to the sky, and said, "By Judas Priest, Joe, we're turning the corner. We're coming out of the wilderness, and you, my boy, figure in my plans."

I could see Haney deliberate and think hard what he was going to say next. A lump almost came to his throat as he spoke softly the next three words, *"Where's the Dago?"* (They hardly ever use your name in the clubhouse.)

I thought he meant Pete Castiglione, the infielder, so I hollered, "Which one, me or Castiglione?" (thinking I knew all the time).

Haney said, "You! You're the one."

"Me, you must be kidding! I figure in the Pirate plans and, besides, my wife did the home stand shopping yesterday."

"No, it's you, Dago. I couldn't tell you anything because I didn't know until this morning. Got anything you want to say?"

"Yeah, if anybody wants to get off this club, rent my apartment. Bill Howerton and Bill McDonald had it before me." (Gene Hermanski, a Cub who was in the deal, took it and lasted about two years.) With that we loaded our stuff, walked through one door and through another, and we were Chicago Cubs. That's a typical day—a Pirate in the morning, a Cub in the afternoon. Confusing? Well, follow it through. Here I was with the Chicago Cubs in Pittsburgh leaving for

New York that night and my family was in Pittsburgh heading back for home in St. Louis until I find a house for them in Chicago. You never know what's going to happen behind those clubhouse doors.

Behind these doors the moods can go from New Year's Eve to a Dead on Arrival morgue scene in a matter of minutes.

They're all clubhouses, from the Cardinal clubhouse that saw and heard the shouts when Slaughter scored the winning run in the 1946 World Series to the clubhouse in Dallas that saw a tough competitor like Phil Cavaretta break down and cry when he was let out as manager of the Chicago Cubs. His only crime—he wanted to win. Go good, and each board seems to sing when it's only squeaking; go bad, and they won't even squeak. They might be the most uncomfortable lockers when you're going good and change to the most comfortable when you're leaving. Get the pink slip and each clothes hook seems to say, "Hang it there, you'll be back." It doesn't take much time to put your equipment in a big league locker, but it's a lifetime taking it out. You get a round-trip ticket, and every player someday has to give up his locker. Be it the square cage with four clothes hooks or a nail in the "donkey's room," it's the big leagues. You have walked through the clubhouse doors to the dugout.

Digging in the Dugout

Once you come out of the clubhouse and into the dugout, you change. You may not be in the line-up, but you're in the game.

Your dugout is literally that, a hole in the wall along the first or third-base side, depending whether you are on the home club or the visiting club. Whether it's at the clay mines back in the neighborhood where you used the frame of an old car or the air-conditioned dugout in Cincinnati, the dugout is where every player better be in that ball game all the time.

Basically, all major league dugouts are the same—a long bench with a drinking fountain, a bat rack, and a rest room (mostly to rest your ears).

It's here that you saw Eddie Dyer jump up on an exciting play and almost knock himself out. The dugout is where Leo Durocher used to turn rag picker and pick up every scrap of paper. Sneak into the Pittsburgh dugout and you would have thought that Bill Meyer was an old wrestler instead of a manager with his contortions and "ugh ughs."

Phil Cavaretta would pop his Wrigley gum because the Wrigley men were popping up. Frisch, watching his Cubs, begged for a sandwich because he couldn't watch this game on an empty stomach.

Ball clubs are always trying to steal signs, because quite obviously you get a big advantage when you know what the other club plans to do. The bunt sign is the first one that you try to steal. It is the easiest to steal, because in certain situations it's a sign that must be given and you concentrate on the sign-giving coach.

Two players are usually in this act. One watches the hitter. The other watches the coach giving the sign (usually the third base coach). The player watching the hitter keeps up a constant report.

"He's looking . . . he's looking . . . he's looking . . . turned away."

The player watching the coach makes a note of what the coach did. The next time a bunt is in order, they follow the same routine. If the coach repeats himself, like going from color to color, and the same thing happens, the two detectives report their findings. The catcher can then pitch out the next time he sees this. If the detective work is correct, the catcher is a smart man.

While you are trying to steal signals, they are fighting to keep you from it. The best way to protect your signs is to instruct your hitters to keep looking at the coach after he has given the sign so that the sign isn't the last thing they see. Another way is to give the sign to the hitter while he is still in the on-deck circle.

I have often said that the 1952 Pirates, which lost 112 games, were the only ball club that I knew that had foolproof signs. Nobody ever got our signs. Many of the clubs thought they had them, but we would miss our own signs so much that they could never prove it.

Fred Haney, then managing at Pittsburgh (before he got his parole to Milwaukee), once gave the steal sign to one of our players three different times in a game with Brooklyn. The first time he gave it, Roy Campanella called for a pitch-out, but nothing happened. With the count even at one strike and one ball (it was easy to get even with our hitters), Haney flashed the steal sign again, and Campy was positive he had the sign. He pitched out again, but our man stayed at first base. Up to two strikes and two balls, Haney tried to start our man again . . . steal sign . . . pitch-out by Campanella . . . our man stays at first base. By this time Campanella was convinced he didn't have our steal sign. Even Haney now wasn't sure he was giving the right sign, so he checked with our man.

"Did you get the steal sign?"

"Yeah, I got it."

"I gave it three times. Why didn't you run?"

"I didn't think you meant it," the guy said.

A noisy bench helps the manager with his signs. The way the manager gives the signs, he needs the help of an active bench. Usually the manager gives the sign to the third-base coach. The other club knows all the signs are coming from the manager, so a pair of eyes are glued on him. The manager, knowing this, often gives the sign to a player on the bench who in turn gives it to the third-base coach. So the more moving around and the more hollering, the more deception. The player that looks like he is getting a nice sun tan on the top step of the dugout, amusing himself by picking up handfuls of dirt, may be the one. Looking at the coach with a handful of dirt is the take sign, looking away, the bunt sign. Throwing a handful of dirt might be the hit and run sign.

The loudest of the bench jockeys might be the sign-giver. The key to a sign might be one word. Any time the sign-giver

uses the first name of the hitter, the third base coach knows that the manager wants the take sign.

"Be ready up there, Stan." (Stan, the key word, means take.)

"Be ready up there," tells the third-base coach that the manager wants the bunt sign (the words "be ready" mean bunt).

"Good hitter, you can do it, let's see you really rip one!" tells the third-base coach that the manager wants the hit and run sign. (The words "good hitter" mean hit and run.)

Let a pitcher tip off what he is throwing, and everybody gets into the act. Certain players on the bench will be assigned to different hitters. On fast balls, the bench man will call this particular player's name. On the curve ball he will say nothing. Everybody on the bench is hollering for decoy, but at the crucial moment only one voice will be heard or not be heard. The hitter has to train himself for your voice. If a fellow has a nickname, it's a breeze with this system. We know that Joe Doakes, for example, is tipping his curve ball. The coach at third base catches it. The coach lets the bench know that Doakes is going to throw a curve. Your man is John Brown. You have made it up between you that you holler his first name on the curve ball and nothing on the fast ball. The rest of the bench jockeys are careful not to foul it up by hollering his first name. Now you are all hollering on the bench as Brown takes his position in the batter's box.

"C'mon, Brownie, give us a start. Get on that base. Make that ball be in there."

Now the coach has flashed the sign. Doakes is going to throw a curve ball. Your job is to keep hollering, but just as soon as the pitcher starts his wind-up everybody stops, and you holler extra loud:

"C'mon, you *John!* Good hitter."

Many ball clubs use the rub-off signs—that is, give the sign and then do something that will take all signals off. This will keep your club from catching repeat signals. Staying with the signs, let us use a rub-off and stay with the dugout, rubbing off talk about signs until later in the book.

A good bench is a noisy one. It's a bench that has a cheerleader. Somebody that is always talking it up. The best one I ever saw was Hank Schenz, who played with the Cubs and Pirates. I saw him over at Pittsburgh. He would do anything —pitch batting practice, catch batting practice, even sweep out the dugout after a heavy rain. He was a good mimic. As Bill Meyer said, "Schenz can do everything but play regular."

A good bench jockey can act, and he can hide and be a ventriloquist on occasion. The Brooklyn Dodgers always had the best bench jockeys when I was in the league. Fellows like Dick Williams, Chris Van Cuyk and Gene Hermanski were the regulars. Don Newcombe does a pretty good job of it right now.

To figure out who the jockeys are is sometimes a tough job for the umpire. Some umpires go by reputation. Umpire Tom Gorman working in Ebbets Field was really getting a going-over from the bench jockeys in a Giant-Dodger game. Having taken enough, he went over to the Dodger bench and roared, "All right, Van Cuyk, get out! You're through."

Nobody on the bench moved.

"C'mon, get going! Van Cuyk, you're through."

And still not one of these angelic faces moved. Gorman then turned to Charlie Dressen, then manager of the Dodgers: "You better get that Van Cuyk out of here."

"If you want to run Van Cuyk," Dressen told him, "you better go to St. Paul, because that's where I sent him yesterday."

Red Jones, an American League umpire, once cleared the

whole White Sox bench for insisting through most of a game that he was a meathead.

The next day, on his way to home plate, he went by the White Sox bench. In unison, the boys hollered: "Oh, Mr. Umpire, you won't have any trouble with us today." Red turned around and told them he was glad to hear that but what made them so sure.

It came in chorus: "We can't call you meathead today because it's Friday."

Bing Miller, now a successful restaurant manager outside Philadelphia, led the White Sox in another performance against the same Red Jones, who had made some calls that had gone against the White Sox the day before.

When the umpires gathered around home plate to exchange line-up cards and go over the ground rules, they were greeted by the White Sox dugout with a male version of the Radio City Rockettes. The White Sox players were in a chorus line, singing a makeshift song that went: "Oh Mr. Umpire, Oh Mr. Umpire . . ."

Bing Miller, a coach then, blasted out with, "Who . . . oh, who . . . was that major league umpire I saw you out with last night?"

To which the chorus came back with: "That was no major league umpire, that was Red Jones."

The good bench jockey is up on all the superstitions, and he knows who is hot and who has just pulled a rock. Loaded with this information, he's ready. You know the superstition about nobody saying anything when a pitcher has a no-hitter going. Maybe nobody on your bench will say anything to the pitcher, but the jocks on the other bench will let that pitcher know. Let someone get a base hit, and the jocks will immediately tell the pitcher that the pressure is off. "There goes your no-hitter," is the cry.

Let the hitter get a home run, and the jock is quick to inform the pitcher that the pressure is really off because there went his no-hitter and his shut-out at the same time. The jockeys will get on the catcher, too. "Another wrong pitch! Atta boy, Joe." Back to the pitcher: "How can you pitch when he keeps calling for the wrong pitch?"

Let a player get close to a record, and the bench jockey will let him know about it. "You got eight straight hits, the record is twelve, think you can make it?" "Better not start pressing now, you're only four hits away. Be sure you get a strike to hit." These are all helpful hints that the bench jockey will pass along. If you listen to him, you'll find yourself called out on strikes.

There are standard gags that are always used, such as telling the catcher that he called for the wrong pitch, or telling an infielder to move around before somebody ties a horse to him. Telling the umpire to punch a hole in that mask or to get new batteries for that ouija board he's using. Hollering to the hitter to pass that *Sporting News* around that he's using for a bat. Asking a catcher having trouble holding on to the ball to send a couple crates along when he's finished boxing them up.

The jockeying gets personal at times, but it rarely gets vicious. To those not in baseball, it might sound that way sometimes, but in the dugout some of the most vicious names are just standard procedure. I was never called Joe or Joey or Mr. Garagiola. It was Dago, Wop, Spaghetti Bender, Ravioli Wrestler or some other descriptive phrase. National origin takes a beating, and that's where the game really shows its Americanism—no discrimination is shown, they get on everybody.

If you're bald, you're Skinhead, Onion Head, Knob Head. You're told to keep your hat on, the glare is too much. Such expressions as Skinhead, Meathead, Hawg Jaw, Cyclops, Whale Belly, Snow Shoes, and Gum Shoes are all regulars.

Before Mr. Warren Giles, president of the National League, put some of his umpires on a diet, a couple of his boys earned the name of Whale Belly. It would make you mad, too, if you didn't know who kept hollering from the bench: "Somebody ought to paint Goodyear across you."

Players wearing glasses get it good. Lee Walls is Captain Midnight. Bill Virdon answers to Cyclops. Clint Courtney is called the sealed-beam catcher.

Think you could recognize this club? The double play combination has the Champ and Juny around second base. Skoonj is in right field. Coconuts is catching. Moony is on first. Zip is at third base. One of the coaches is Banjo Eyes. The manager is Smokey, and the Duke is in center field. To run it down it goes like this:

The Champ ...Pewee Reese Marble champ as a kid.
Juny Junior Gilliam .. Short cut for Junior.
Skoonj Carl Furillo Named after an Italian snail.
Coconuts Rube Walker ... Rube's head is shaped like one.
Moony Gil Hodges Round face.
Zip Don Zimmer ... Take off on Zim.
Banjo Eyes ... Billy Herman ... One look at his eyes.
Smokey Walter Alston ... Got it as a kid.
The Duke Duke Snider Got it as a kid.

From the comedy routine of the bench jockey, it can move to the sober scene when everybody knows this is the end of the line for the "old folks." From laughs it can go to the cold-war stare of the second guess to open war: "If you don't like it, you go out there and play."

Frank Frisch, when manager of the Cubs, waited for Paul Minner, his pitcher, to come into the dugout. Pointing to the bench, he handed him a bat and said, "Go get 'em, kill 'em all." Here's what had happened:

With a one-run lead and two outs, Gil Hodges had hit a ball

that fell for a single when the outfielders played Alphonse and Gaston. On the second pitch, Minner had picked Hodges off first base, but in the chase they hit Gil with the ball and it rolled into the outfield. Hodges scrambled to his feet and tried for third. The throw went past the third baseman, and Hodges tried to score and made it when the throw to the plate was dropped. Six runs followed. You wonder why Manager Frisch gave Minner the bat and his permission to kill 'em all?

When a hitter comes back to the dugout, it often goes like this:

"What was that second pitch he threw you, a knuckler?"

"No, just a good curve ball."

Let the news of a "different" pitch get out, and it spreads in the dugout like wildfire. Let a fast-ball pitcher, for example, get a hitter on a knuckler, and that's all you hear in the dugout. "He got Joe on a knuckler. When did he start throwing a knuckle ball?"

There isn't a suggestion box in the dugout but there might just as well be. The catcher is told he called the wrong pitch when somebody hits one. "What was that? A curve ball! Oh no! You could almost see him looking for it." Most clubs I played with, I didn't get too much of it. My most considerate manager was the late Billy Meyer at Pittsburgh. I guess the fact that he himself was an old catcher accounted for that. He always wanted to know why you did something but let you give your reasons for it. Maybe they weren't always good (and after a home run I wished many times I had another chance to call for a pitch), but if you had a reason, that was good enough for him. He might give you his reasons, and then it was strictly up to you.

Joe Tipton, catching for the White Sox, had the real system. After coming in, following a three-run homer, he was asked, "What was it?"

"A curve ball," answered Tipton.

"What a rock, you could see from here he was looking for it," came the reply.

The next time Tipton went the opposite. The fast ball was hit for the homer. In he came.

"What was it?"

"A curve ball."

"Don't you ever think? The fast ball was the pitch in that spot."

"Well, that's what it was! Ask the pitcher," bellowed Tipton. "So we're both rock heads." Quite a speech for a man getting ready to take a trip.

Bob Muncrief, a much-traveled pitcher, finally hooked up with the Chicago Cubs and Frankie Frisch. In a game against the Pittsburgh Pirates, Ralph Kiner hit a key home run against the back wall in Wrigley Field to tie the game. When Muncrief got to the bench, Frisch asked him what it was. "A doggone good curve ball. He hit a good pitch," said Muncrief.

"Well, just forget about it and throw him fast balls the next time, Rock, and he won't get a loud foul," advised Frisch.

The next time up, with two men on, Kiner hit a fast ball, not only for a home run but *over* the back wall. This shot made the first one look like a bunt.

When he got to the bench, Muncrief looked right at Frisch and said: "Well, brains, he hit yours a whole lot farther than he hit mine."

Managers often express themselves on the bench during the excitement, and the players on the bench sometimes have to run for cover to keep from laughing out loud. In St. Louis, before the new dugouts, there were two rows of benches, and the players had a system to keep from laughing out loud during one of these recitations. The boys in the back row, when the crucial time came, would stuff towels in their mouths to keep from laughing out loud.

Eddie Dyer was as enthusiastic a bench manager as I ever played for. On a double play ball, he would be hollering from the time it left the bat, "Give it to him . . . give it to him . . . give it to him!" And all the time leaning towards the pivot man. When it would be booted, the poetry that followed would have the back row going into the towel routine.

Dyer would play every play, swing at every ball. His coaching really brought out the towels one afternoon in St. Louis. We were playing Brooklyn in 1949 and battling the Dodgers for the pennant. Our left fielder was Enos Slaughter.

Gil Hodges hit a ball down the left field line with the tying run on at first base. Slaughter came over fast and, with that typical Slaughter hustle, really gave it a try. He had a patent on that sliding catch. It was just like he was doing a down-and-up slide into a base. He would cup his hands and catch the ball. This time he missed. When he slid, he landed on the ball and couldn't find it. He was the last guy in the park to realize he was sitting on it. Dyer jumped up on the bench and kept screaming, "Somebody tell him to get off the ball before he hatches it."

One of the most frequently heard statements in the dugout when the hitters are going up and coming back three at a time:

"He doesn't have anything out there." When you hear that look for nothing but goose eggs on the board and a horse collar around the hitters' necks. This is the most famous of the dugout statements, but the hitters have a bunch of old faithfuls. "When did he come up with a knuckle ball?" "That last one was loaded. I know a spitball when I see one." "He hasn't got enough to hit." Usually after one of these statements, the player will sit down and talk it over with the player he sits next to. This is when the fun begins.

Dee Fondy, former National Leaguer, was unsympathetic. We were teammates over at Chicago. In a game against the

Dodgers at Wrigley Field, we had just pulled within two runs when they made a pitching change and brought in Jim Hughes. The tying run was on at first with the other run on at third. A long fly would be great, a base hit terrific—anything but a strike-out or, worse yet, an inning-ending double play. As the hitter, I had worked the count to two and two with both strikes being fouled off on fast balls. The two-ball count had been on curve balls and bad curves at that. This was about the pattern you figured, because Hughes was strictly a fast-ball pitcher. The two-two pitch was outside, a fast ball that missed, and now it was a full count. A walk would put the tying run on at second, and I would be the winning run on at first base. Hughes broke off the best curve I'd seen in a long time, and all I could do was watch it sail by for strike three. I came back to the bench mumbling and groaning and sat down next to Fondy.

"How could he throw that pitch in a spot like that? Strictly a fast-ball pitcher and what a curve he breaks off." That's what I kept saying.

Fondy listened for a while and then in his best Baby Snooks voice said, "Did that big bad man pitching for those big bad Dodgers throw you a curve ball? It isn't nice of Jimsy Wimsy to throw our Joey a curve ball when he has you three and two. . . ."

Walker Cooper can come up with them. His analysis of a pitcher was a dandy. Hoot Rice, then with the Cubs, came back after popping up a pitch and said to Coop: "You caught that guy. He's got pretty good stuff, you know it."

Coop, not too impressed: "Yeah, he's got pretty good stuff. The only trouble is that he drinks it all himself."

Milwaukee in the early spring and late in the season can be a cold spot. It was an early spring game while I was with the Cubs that we were having one of those "bees in the bat handle" nights. On a cold night when you hit one off the handle

or right on the end of the bat, your hands really sting. Ralph Kiner had a couple of dandies the first two times up. He came back to the bench moaning about it. Bill Serena piped up and said, "I'll keep the handle warm for you." So for the next three innings Serena held a bat wrapped in a towel. When it was Kiner's turn to hit, he unwrapped the bat with the warm handle. Everything was fine except that it was the wrong bat.

Ask what a pitcher is getting a certain player out on, and you're liable to get any answer. Listen for a tip as to what the pitcher is doing and you can have 900 different answers. Dusty Rhodes had just gone in to pinch-hit against Stu Miller, then of the Cardinals. Miller is a pitcher of a million different speeds. He had tremendous motion but wasn't overpowering with his fast ball. (Garry Schumacher of the Giants said of Stu Miller's fast ball: "It's the Wells Fargo pitch . . . it comes to you in easy stages.") Rhodes had been watching the ease with which Miller had been getting out the Giant hitters, and Dusty, by no means a modest athlete, said: "I can hit that guy with one arm." So Dusty got his chance and struck out—worse yet, called out. Back on the bench, everybody was waiting for Dusty's philosophical analysis of Miller's pitching. Flinging his bat against the rack he let out with, "Boys, there's the first pitcher I ever saw that changed speeds on his change-up."

It was the same Stu Miller that had Walker Cooper just about asking plate umpire Larry Goetz for an investigation. After Miller floated one of his marshmallow strikes past big Coop, he turned around to Larry and said, "Are you sure? I think he just wound up and held the ball."

George Metkovich, then a Pirate outfielder and at this printing a manager in the Coast League, was another one of the players that had an answer for every pitch. We were playing the Braves in Boston on a cold night (another one of

our many private games that year). Surkont was the Boston pitcher. Late in the game we were hurting for a base hit. Bill Meyer, our manager, looked down the bench and said, "Cat [Metkovich's nickname], grab a bat and hit. You know this Surkont pretty good."

"Yeah I played against him last year out on the Coast," Metkovich said.

So he went up to hit. First pitch was a fast ball for a called strike. Cat backed out, rubbed some dirt on his hands. Next pitch was a fast ball that the Catfish took for strike two. Back out of the batter's box, looked around, and back in. Next pitch a fast ball and called strike three. Metkovich came back to the bench, politely put his bat in the bat rack, and sat down. "He threw me that radio ball," said Metkovich.

"Radio ball?" asked Dick Groat, then a rookie.

Metkovich looked up and said, "You can hear it, but you can't see it."

Habits of the ballplayers and managers differ in the dugouts of the various teams. I have to limit myself to Busch Stadium, Forbes Field, Wrigley Field and the Polo Grounds, but four out of eight is a pretty good sample.

Leo Durocher, for example, was always up and down the dugout. Talking most of the time, keeping the players going and bringing up points of the game. Every scrap on the floor, he would pick it up. Chew a stick of gum, flip the paper on the floor, and Leo would turn from a $50,000 manager to a paper saver. Let things get hot on the field and Leo would be at the water cooler every ten seconds.

Manager Fred Hutchinson is also a pacer. He was a tremendous competitor as a pitcher and it carried over to the executive end. I never played for the Big Bear but have been around him enough to get to know him. He's a groaner. Leonard Koppett of the *New York Post* once described him as "al-

ways looking like his team has just hit into a game-ending triple play." I like to agitate him by describing him as being really happy inside but his face doesn't know it.

Managers Phil Cavaretta, Stan Hack, Eddie Dyer, and Bill Meyer were all pretty much the same as far as walking around the dugout. They would pick the same seat every day to do their sit and moan routine.

It used to be that the one way to tell whether a club was going good or bad was to check the dents in the water cooler. Now the boys let off steam by kicking the protective helmets. This is more dangerous to the innocent bystander because some of their place-kicks make Lou Groza look like he's got ingrown toenails.

In St. Louis, plate umpire Bill Baker ran Solly Hemus, then with the Phillies, out of a ball game. Upon leaving the field Solly went through the Cardinal dugout and there on the top step were twelve plastic helmets. Just a couple of kicks by Hemus and there were enough plastic helmets flying around to make you think it was an invasion from Mars. Later in the same game Ken Boyer of the Cardinals was asked to leave the premises. Boyer made some beautiful boots but fell about ten yards short of the National League record.

Hutchinson, while a pitcher, set the record for the most light bulbs smashed. He smashed forty-five of them in the Detroit runway after being taken out of a game. Eddie Stanky, while managing the Cardinals, lost a TKO to a mayonnaise jar in Cincinnati. One punch and he was cut so bad he couldn't continue the fight.

The most refreshing letting off of steam, though, was the method of Pete Runnels, with the Washington Senators. Runnels, in the middle of a slump, was having his troubles. After the two previous hitters had blooped hits—one a bad hop, the other a hit when the infielder lost the ball in the sun—Runnels

hit a shot on which Kubek of the Yankees made a diving catch. It was a miraculous play.

Runnels calmly went back to the dugout. He didn't kick a thing. He didn't rant and rave. He picked up the water bucket full of water and ice and poured it over his head.

Only in a dugout can you see a water cooler kicked in because of one pitch . . . a favorite bat split because of a called third strike . . . a player challenge another because he thought the ball should have been caught . . . a manager telling a player he's running the club and that's good enough reason for making a move.

Only in a major league dugout can you know how much that hit meant to the kid trying to make the club or to old folks trying to hold on.

Only in a major league dugout can you interpret, "I just didn't have it today" into the sober facts of, "He's through." The laughs are plenty, but there are even more heartaches. The stakes are high in the dugout.

Between the Foul Lines

Baseball is a game played with bat and ball and governed by rules set forth by a committee under the direction of the Commissioner of Baseball. Baseball is a game played by human beings and governed by unwritten laws of survival and self-preservation.

You cross the white lines onto the field of action and find the air thick and tough to breathe. The mound makes you a sitting duck. The ball weighs a ton. The distance to home plate seems to be farther than to the center field flagpole. You are a midget pitching to Superman. The hitter is on top of you, and the double deck stands are tumbling down. Now how do you perform between the foul lines?

The same thick air surrounds the batter's box. The mound is a mountain. You are at the bottom trying to hit uphill. The pitcher is King Kong. The bat should have telephone wires on it, the way it feels. Somebody must have put grease in the resin. Even the spikes are complaining through your shoes; they can't find the right spot in the batter's box.

Now how do you perform between the foul lines? Baseball

is still a game, but not the game of boyhood dreams. Now you have to win. In a dream it's your grand-slam home run that wins it in the bottom of the ninth for your team, or it's the 3-2 curve ball strike-out that gives you the fourth game of your first World Series. There was never any place in your dreams for the knock-down pitch, the slide that breaks up the double play. But in the game that's real. Tip your hand that you don't like it, and you're through.

"You're not going to take it away from me," says the pitcher to himself as he picks out his target high and tight. "You're a good guy, but it takes the edge away from you when you go down."

"He's got a bad right leg," the batter is thinking. "His toughest play is a bunt down the third-base line. It'll make that leg crumple up. He's a nice guy, and he's fighting to hang on. This might be his last start, and he might be through. Bunt down the third base line, and send him a get-well card."

The law of the battleground. You learn the laws in a hurry. Compromise and you are through.

"Hit him hard when you break up the double play, and the next time he'll run out to left field."

Your first swing around the league breaks you in. The club-house, the dugouts, the autographs, are window dressings. It's between the foul lines that counts. The home runs in batting practice get you a few ohs and ahs from the fans and the label of a one-o'clock hitter from the players. There are no one o'clock hitters in baseball's Hall of Fame. You clench your fist and tell yourself that the first punch better get you because you're giving it back. He knocks you down, and you don't like it, but it's you or him. He slides hard on the double play, down you go, but you don't let him beat you getting up. It's you or him. He's going to bowl you over to score that run. Brace yourself, and don't rub when you get up. It's you or him. You can't call for help, and you can't go home. You don't

like it, but it's you or him. Run and you are through. To some the air gets thicker now, the bat isn't long enough, and the pitcher is too close. This is the beginning of the end. Others go down to the dirt but come up with the flashing thought, "I've got to battle back." This is the end of the beginning.

The small and frail depend on their agility. "He hit me when I made the double play going across the bag, so this time I'll make it from behind the bag. I'll get the bag between me and him." But you stay. Run into left field, and you are through.

The big awkward guy comes ready to be hurt. "They might get me this time, but they won't run me out of the ball park." He might be scared, but you'll never know it. He's average, but trouble makes him a Hall of Famer. Run and you are through. Battle back, and they'll say, "Let the big guy sleep. Don't get him mad."

Baseball is a game of size, size of the heart. The little man has the equalizer in the batter's box with the bat and ability to bunt. A six-foot-four Don Newcombe doesn't have the edge on a five-foot-nine Don Blasingame, who can bunt, and run like a deer. A six-foot-four Duke Snider doesn't tower over an Elroy Face, who is five-foot-seven, because the equalizer is uncanny control. The size that counts is the size of the heart. Wear it on your sleeve, and somebody will knock it off.

These are the laws. You live by them and you interpret them the way you know will keep you in baseball. Compromise and you are through.

Tim Thompson, the Kansas City catcher, was having trouble getting his pitcher, Virgil Trucks, to agree to a signal. Billy Klaus, then a Red Sox infielder, was the batter. "Don't you know what Trucks wants to throw?" Billy said to the catcher.

"No, I don't know what he wants to throw," said Thompson.

"Give him the knock-down sign. That's what he wants to do, knock me down," said Billy Klaus.

Thompson gave the sign. Trucks nodded. Trucks threw. Klaus went down. Klaus got up. The game went on.

I have heard this pitch called many things—the bean ball, the knock-down, the duster, the brush-back, and the low-bridge pitch. I think the best name for it is the one that Mr. Branch Rickey gives it. Mr. Rickey calls it the "purpose pitch."

At the end of the 1951 season at Pittsburgh, Mr. Rickey held a fall camp for his "cream of the crop" rookies. In this camp were sixty-five of the "can't miss" boys in the Pirate organization—to name a few, Bob Friend, Ronnie Kline, Vern Law and Bob Skinner. It was here that I heard of this pitch. His description was both flowery and logical. "When you throw it, let it serve a purpose!" shouted Mr. Rickey as he ended his speech. (The purpose, I guess, is to separate the head from the shoulders.)

Almost no pitcher will deliberately throw to hurt anyone. He uses this weapon as a means of survival, to take the edge away from the hitter. He uses it in retaliation against opposing pitchers' throwing at his players. So it is a "purpose pitch." It delivers a message.

In 1943, my first full year in professional baseball, I was with the Columbus Red Birds of the American Association as a seventeen-year-old boy. We were playing the Toledo Mud Hens (then a farm club of the St. Louis Browns), and my first time up I had hit a two-run triple off a left-hander named Bill Seinsoth (who later went to the big leagues with the Browns).

The next time at bat I had to go down. I hit the next ball hard but foul, and the next pitch had me looking at the stars again. I finally hit a fly ball to the center fielder. When I came

back to the bench, I sat down between our manager, Nick Cullop, and our first-string catcher, the veteran Tommy Heath. "Man, he's wild now, isn't he?" I remarked. "He didn't seem that wild my first time up."

Nick and Tommy broke out laughing, and then they let me in on the big secret. Mr. Seinsoth's control was as sharp as ever.

I saw this scene re-enacted in 1952. I was then with the Pittsburgh Pirates, my first full year there after being traded from the St. Louis Cardinals. In Pittsburgh that was the year of the Great Experiment. It was the ninth year of Mr. Rickey's five-year plan, which was known as Operation Peach Fuzz, but we were usually called the Singer Midgets and the Rickey Dinks.

With all our inexperienced players, we got off to a slow start. We lost ten out of the first fourteen and then had a slump. In July our pitching and hitting slumped together, and we had a long losing streak. We got a break in August. One of our pitchers went home, and we were rained out of five games. The thing that really hurt us that year was the terrible finish. We ended up losing 112 games out of 154. So that meant we won forty-two—not in a row, but we won them.

We had just finished a home stand, and we opened in Cincinnati. Bubba Church was pitching for the Redlegs with a two-run lead going into the sixth. Gus Bell, then with us at Pittsburgh, hit a home run on the first pitch. Ralph Kiner hit a home run on a two-ball, no-strike pitch to tie the game, and I came up and hit the first pitch for a home run to break the tie.

Bobby Del Greco, one of our young outfielders, was the next hitter. On the first pitch down he goes. Up he comes. Next pitch and down he goes. On the two-two pitch he flied out to the left-fielder. When Del Greco came back to the bench he sat down next to Clyde McCullough, then a fifteen-

year man in the big leagues. Bobby said, "Man, he's wild! I thought he was supposed to have pretty good control."

McCullough, the philosopher, looked at Bobby and in his best southern drawl said, "Son, when the three previous hitters have hit the ball out of the park, go up there and go down before you see the whites of his eyes."

The big bombers hit the ball out of the park, and the BB shooters get knocked down. A Duke Snider and a Gil Hodges hit home runs, but a Junior Gilliam gets knocked down. A Mickey Mantle and a Yogi Berra hit home runs, and a Bobby Richardson gets knocked down. I followed Gus Bell and Ralph Kiner when I was at Pittsburgh, and I spent a lot of time in a horizontal position. And I, like a lot of players in those shoes, wondered why they throw at a confirmed .250 hitter. The pitcher is steaming, though, and he isn't going to take any more chances. You happen to be the man with the opportunity to get hit or go down.

Buddy Blattner, another ballplayer turned broadcaster, was on the 1947 New York Giants, which set the record for most home runs hit by a team, 221 (tied in 1956 by Cincinnati). In the Giant line-up, Bud followed such heavy artillery as Willard Marshall, Sid Gordon, Johnny Mize and Walker Cooper. During one of these bombing sessions, Gordon, Mize and Cooper hit home runs on five pitches. Here comes our hero, knowing what to expect. First pitch, here it comes—and down he goes. Up he comes, and down he goes. After his routine out, Blattner took his seat on the bench. Big Walker Cooper looked at him and said, "I'll say one thing, Blattner—they really respect you."

You improvise on the unwritten rules and you interpret, but you stand up and get counted. Run and you are through. 1949 was a great year for battles between the Pittsburgh Pirates and the St. Louis Cardinals. I was then with the Cardinals.

The double play combination that year for Pittsburgh was Danny Murtaugh at second and Stan Rojek at shortstop. During a game in St. Louis, I walked first time up and, in trying to break up a double play, I hit Rojek pretty hard. He said something and I said something, but no fireworks. Second time up, same thing. This time Rojek's diction had improved and so had mine. I didn't think I could live up to his descriptive adjectives, and I don't think he could stand the heat where I told him to go and how to get there. But still no fireworks.

The third time up I get a base on balls, and here I am on first again. (When I joined Murtaugh a few seasons later at Pittsburgh, I learned that although they had a chance to tie a double-play record, they had worked it out that the pivot man was going to get me first and then try for the double play.) Well, here comes a ground ball on one hop to Murtaugh at second base. The cooperative Murtaugh waited until I got about ten steps from the bag and then flipped the ball to Rojek, and he's waiting for me. Rojek jumped straight up for the pivot, and came right down on my leg. I gave him a kick with my free leg and there was more descriptive language. He had accomplished it, though, as I was roughed up pretty good. But there was more to come.

Ken Johnson was our pitcher, a left-hander all the way. If the strike zone had been high and outside, he would have been great. He was used by Manager Eddie Dyer to mop up games. Rojek, the first hitter, always crowded the plate. The first pitch Johnson threw beaned him. As he went down, the Pittsburgh club came after me. I'll say this for the late Bill Meyer, the Pirate manager, he was the first to challenge me, even though there was about forty years' difference in our ages. There was some shoving and brushing and a lot of words but no battles. Rojek said later that he lost the ball, but that meant nothing. I was marked.

The next trip into Pittsburgh, I knew I was marked. There

are two ways to get to the visitors' dugout in Forbes Field—
around the first base stands or a short cut through the Pirate
dugout. I wasn't about to strain relations just to save a few
steps. I took the long way. The stands were packed, and the
minute I stepped on the field the boos began. I was walking
with Howard Pollet and talking as usual and didn't realize
the boos were for me. I didn't know until they announced the
line-up that the boos were for me and that I was not the peo-
ple's choice.

As soon as I took my position behind the plate, the Pirate
dugout, led by Dixie Walker, made the fans sound like angels.
Dixie had a piercing voice that reached farther than his vo-
cabulary, which was advanced. The first time up I made a
routine out, after being knocked down once by pitcher Rip
Sewell.

I didn't realize it then, but it turned out the first knock-
down was a calling card by Rip telling me that he would be
back.

Jocko Conlan was the umpire behind the plate. Sewell
came up to hit. I thought the second pitch was a strike and
said to Jocko: "Where was the pitch?"

Before Conlan could say anything, Sewell turned around
and said to me: "Why don't you let him umpire, Bush?" (an
expression used by players meaning Bush Leaguer, the lowest
form of baseball life). "The ball was low," continued Sewell.

"Who's asking you? Why don't you just hit?" was my reply
to him.

"You punk, you've been a bush Dago ever since you came
into the league."

"Maybe I have, but I'm not an old goat like you."

"Keep popping off, and I'll stick one in your ear," Rip con-
tinued.

"With the garbage you throw, you couldn't hurt me if you
hit me." (I later realized that was the wrong thing to say.)

The next time I came up, the low bridge went down and it

was a good one—bat one way, cap another, and me down. I got up and said nothing but knew he meant business. I planted my feet in the batter's box, but not for long. The next pitch really upended me. That was two knockdowns. (Run and you are through.)

I had seen our third baseman, Whitey Kurowski, retaliate on a pitcher with a bunt down the first base line, the idea being that the first baseman would field the ball, and the pitcher would cover the bag and you could walk up his back. That's what I decided to do. A perfect bunt.

Ed Stevens, the Pirate first baseman, fielded the bunt, and Sewell started for the bag. After taking two steps towards the bag, he turned and came straight for me. He threw a football block into me, knocking me into the Pirate dugout. When I had stopped rolling, all I could see were Pirate uniforms and spikes.

I later saw Rip Sewell in Deland, Florida, at a Pirate camp and Murtaugh re-introduced us. "Joe, you know Rip. Rip, you know Joe. Now I don't know if you want to talk or fight." We shook hands. It was the law between the foul lines, survival. It is no disgrace to be beaten, but compromise and you are through.

Jimmy Dykes says they are much politer in the American League about the knockdown. He says that in the American League, just *after* a fast ball leaves his hand, the pitcher yells, "Look out!"

In this Emily Post group of pitchers you have to put Harry Brecheen, the Cat, at the top of the list. This little fellow was one of the great competitors, and he used everything he could muster to beat you. He was small in size, five-foot-six and 155 pounds, but the tougher the spot the more heart he showed. The Cat was always taking the edge away from the hitters. He was a polite one, though, and you could hear him holler "Look out!" as you were picking yourself up off the ground.

Even a loud foul off him was an invitation. On the next pitch you got the R.S.V.P.

The Cat was hooked up with Monte Kennedy of the Giants in a real duel until Mize hit a 3-2 curve ball on the roof for the tie-breaking run. "He'll never hit another curve ball off me for a home run," stormed the Cat as he came into the dugout. The next time up, Johnny worked the count to two strikes and one ball when he was plunked with a curve ball. He had to leave the game, and the Giants were without his big bat for the rest of the game.

As soon as Mize was hit, Mel Ott, then Giant manager, called Kennedy. "Monte, the next time that little so-and-so comes up there, I want you to hit him right on the knee. Right on the knee. If you don't, it's going to cost you fifty dollars."

Kennedy pleaded with Ott. "Don't hold me to it, Skip. I'll try, but my control ain't that good. If I hit him, it will be the first time I ever hit anything I aimed for."

"You better hit him," came the answer.

Brecheen steps into the box. On the first pitch Kennedy fires a fast ball and hits the Cat right on the knee. Kennedy was so happy that he jumps up and down on the mound, yelling: "I saved fifty bucks! I hit him." The Cat knows the Giants are retaliating, and he won't even rub to give the Giants the satisfaction that they hurt him. He took about ten steps and went down in a heap.

The legs are the toughest part of the body to get out of the way when the baseball is coming at you, but the real danger pitch is the one behind the hitter. The natural tendency of the hitter is to back away, and if the ball is behind him, he backs into the pitch. Jocko Conlan, National League umpire tells how a control pitcher is sometimes used to give the batter the message.

It was while Jocko was in the American Association as a player. They were involved in a knockdown contest, and it

took four pitches before Jocko was conked on the elbow. Joe Hauser, home-run king of the Minneapolis Millers, was the first baseman. "How about that guy throwing at me? Even on three and nothing he throws at me," said Jocko to Hauser, who was always a target. Joe turned to Jocko and said: "Quit moaning, when they want to get me, they take out pitchers like that and put in somebody who can throw harder with control."

Sal Maglie wasn't called the barber because of his ability with a comb and scissors. Durocher was supposed to have hung the nickname on him when he said that Maglie looked like the barber in the fourth chair. When you bat against Maglie, you have a different reason for calling him the barber. The Barber reminds you of the story told about the hitter who told a knockdown artist that he would knock down his own mother on Mother's Day. "I would," replied the pitcher, "if she was crowding the plate."

Sal Maglie isn't anti-social, but very seldom did you see him fraternizing. Why? "I don't want to get to know the other guys too well. I might like them, and then I might not want to throw at them."

Pressure is defined as the state of being pressed—harassment, oppression, a state of trouble or embarrassment. This is the climatic condition between the foul lines. The players define it like this:

"It's here that you rise to the occasion."

"Here is where you separate the men from the boys."

"Between the foul lines the boys are changed into men."

"Now we'll separate the sheep from the goats."

"Never mind the lip service, show me when you cross the white lines."

Walter Shannon, an executive of the St. Louis Cardinals, illustrates it with a tryout camp experience. The strapping boy said he was a pitcher. On the sidelines he had fair ability—a

fair fast ball, no curve, but pretty good control. The last two can be taught, but the first (the fast ball) has to be a gift along with the greatest gift, which is an intangible, competitive fire. In the game the kid showed nothing. Two or three more tries and still nothing. So the boy was told that he didn't have major league potential. He just did not have a good enough fast ball. "Find something else to do."

"I know I ain't throwing hard here," the boy said, "but you ought to see me fire that ball behind my garage in the alley."

The breathing was easier in the alley. All major league scouts would be almost infallible if they could see inside the boy. . . .

Catch a hot hand and get a base hit in the right spot, and you're tabbed a money player. Make the play in the jam, and you're known as a guy with average ability but one who doesn't scare.

Compromise, and you lose it. You are through. I don't know of any ballplayer who doesn't feel it. They all have a way of hiding it. "Bravery is the capacity to perform properly even when scared half to death," said General Omar Bradley. "If you're scared, just holler and you'll find it ain't so lonesome out there," said Joe Sugden. They were both talking about it.

In a big game, a World Series or a key pennant game, I was always hoping the first ball would be a pop foul. A foul tip off the mask would help. Football players need the first contact. Human beings run on flesh and blood, not batteries. It's natural to feel it. But you hide it. Show it, and you are through.

Most ballplayers are loud. I always feel that's a way they hide it. Others use silence to hide it. He's mean on that mound. He won't talk before a game. The loud ones hide it behind an air of confidence. The silent ones won't let you inside the shell. Then the battle is on. Tip your hand, and you are through.

But the idea is to win the game, and it takes a team to win.

It's pitching, hitting and defense that wins. Any two can win. All three make you unbeatable. The underlying factor is the team. Team is defined as a group of persons associated in some joint action. The purpose in baseball is to win. To win you need nine individuals working together, each of whom has a feeling for the fine line between self-preservation and sacrifice to the team.

Between the foul lines is a world in which the highest laws of civilization and the most fundamental laws of the jungle apply. Each player is alone, and they are all working together.

The catcher signals the pitch. The shortstop or second baseman picks it up and relays it to the infield and outfield. Watch that shortstop or second baseman next time. When he raises his glove to his face, he's flashing a sign to the infield. Mouth closed might mean a fast ball, open a curve ball. Then there will be a prearranged sign with the outfielders. One method is to show them the glove. When he sees it, the outfielder knows it's a curve ball. When the infielder shields his glove, the outfielder knows it's a fast ball. How can he give a clear signal with a natural move? He can hold his glove out in front and pound it. You've see infielders do this. To you it's nothing. The outfielder sees no glove, so it's a fast ball.

Let a smart base runner get on second, and the counter-intelligence system goes into action. He watches the catcher give signs, making a note of how he starts, the second sign, the last sign and what digit was repeated most often, any one of which can be the key. When the runner comes to the bench, he reports his observations. When the next base runner gets to second, he compares this information with what he sees. Catchers fight this by using switches that change signs from pitch to pitch. Infielders keep smart base runners on the move, even though there is no chance for a pick-off play. Peewee Reese was a good man to keep moving when he was on at second base.

Sometimes the best of teammates play like they were trying to lose. Players come and go, but regulars like Alphonse and Gaston last forever. Two ballplayers are under a fly ball, and either can make the catch, and the ball falls safe. Leo Durocher once introduced teammates Willie Mays and Don Mueller very formally on the bench. As Walker Cooper once said on a windy day, "The fly balls are too high to handle."

The Top Banana in the cast between the foul lines has to be the take-charge guy. He is the must guy. Trades are made for his type. We can't win without one. We lose because we don't have one. What is a take-charge guy? I say that some players that are typed "take-charge" are a creation of the fellow that wrote the so-called "book" on baseball. Dig a little deeper, and he's the same guy that says a good little man can't beat a good big man. He probably never bet against the Yankees or Notre Dame either.

Most spitfire type players are tagged "take-charge" guys . . . a lot of spitfire ballplayers make up for lack of talent by determination and holler. What makes "take-charge" is the determination, *not* the holler.

All the hollering in the infield can't stop a run from scoring. The pitcher isn't looking for a pep talk when there's a bunt situation with men on first and second; he wants to know whether to throw to third base or first base. He needs help. His back is to the play. The real take-charge guy will call this play. The holler guy will clam up because he's afraid if he yells the wrong base the manager might give it to him. If the play is made, he'll holler the number of outs to everybody in the ball park. Holler guys are good for a ball club. You need them. They make you look wide awake. But a good little guy *can* beat a good big man, and not all holler guys are take-charge guys.

Maybe the holler guy runs in on every pitch, but he says nothing of value to the pitcher. Give me the quiet take-charge guy who makes the plays and comes in when the game is at

stake. He might just say, "Bear down and make him hit the ball. I'll make the play for you." Then the pitcher knows he is not alone. The mound becomes a mountain.

There are a lot of ways take-charge players show it, but it's not easy to hear it. To take charge might mean to make maybe a "useless" shoestring catch. Jim Busby crashed into a wall making the last out in the top of the ninth even though his club was trailing 15 to 1. How many players that night wondered, "Was I putting out as much as Busby today?" Taking charge might be the tag play at the plate when you are trailing by ten runs and, as catcher, you block the plate and the runner bowls you over. You might have sidestepped him. Or it might be taking the shortstop out of the double play when your team is out of the game. You could have gone through the motions of sliding.

Name some names . . . sure . . . Alvin Dark. I saw him and heard him get on a Giant pitcher while the team was coming down the stretch for the 1954 pennant. It shook up the whole ball club. This pitcher had just given up a three-run homer to the opposing pitcher. He came to the bench and said he didn't want to throw the pitch the catcher had called for. Alvin Dark heard him and let him have it. He didn't wait for Manager Durocher or any of Leo's coaches. "We're trying to win a pennant, and if you don't want to throw a pitch, don't throw it. If you don't want to pitch, get out. But don't alibi, just bear down." The pitcher came back with shutout innings and a victory. Alvin Dark isn't the spitfire type, and that wasn't a display of temper, but of competitive fire.

"Hello," was a major speech for Joe Dimaggio, but the Yankees followed the Yankee Clipper. Charlie Gehringer, the great Detroit Tiger second baseman, was known as the Mechanical Man. You don't holler your way into the Hall of Fame.

I saw Terry Moore grab a pitcher by his throat and shake

him when he was throwing excuses and alibis instead of good stuff. All Terry Moore told him was: "Do what you said you were going to do, and the rest of us will make our plays." In a tough spot Terry might say to a hitter, "Bear down, kid, and get a piece of the ball." Something would rub off on the kid. Harry Brecheen would never win the Emily Post Award for Etiquette on the Mound, but he won four games in the World Series. The infield of Whitey Kurowski at third, Marty Marion at shortstop, Red Schoendienst at second base, and Stan Musial at first base would never win a hog-calling contest but it won a world championship.

Between the foul lines your time is measured. You guard it, you hoard it, and you protect it, but you lose it. Time robs you of the downhill spring in your legs. Your wrists become handcuffed. The lights are no longer bright enough, and day games after night games make your bones ache. You're not old in age, but baseball time loses you. Victories and base hits are the candles on your baseball birthday cake.

Baseball is a game played with a bat and a ball and governed by rules . . . baseball is a drama with an endless run and an ever-changing cast. It has to be. From the legend of a Babe Ruth, there came a kid out of Commerce, Oklahoma —Mickey Mantle. From the legend of a Walter Johnson came a pitcher named Robin Roberts.

Now for you it's over. You move on. You lived your boyhood dream. Memories stamp the dream as false. The grand-slammer is now a squeeze bunt in a winning game. The no-hitter is now a successful pick-off play that won for you. You crossed the foul lines, and you are different. You breathed the thick air, and you lived and battled with the chosen 400 between the foul lines.

The Meeting on the Summit

"There's a lot of brains out there now. Give me a load of rocks just like that, same size. I want to build a patio. What a rock garden!"

That's the way the bench jockeys greet any meeting on the mound between catcher and pitcher and the infielders. And the fan in the stands wonders what the catcher is always talking to the pitcher about.

The answer varies because the pitchers vary. There are guys like Howard Pollet for whom the mound was just sixty feet, six inches from greatness. There are guys like Sal Maglie who patrol it as their own, knowing that only time has a license to take it away. There are the Red Barretts who think the mound is a stage and the hitters are puppets on strings. There are the Harry Brecheens who consider the sixty feet, six inches a fair distance for the duel, and it's you or him. You chose the bat; he chose the ball. This is the mound. Sixty feet six inches from home plate, made of dirt, in the middle of which is a rectangular slab of rubber. On it stand men with feet of steel or clay.

What goes on out there? Sometimes the pitcher stands accused because the catcher said he let up on a pitch. Sometimes the catcher has to give a true answer to the manager's question, "Does he have it any more?" A sore-arm Johnny Beazley (Cardinals) or Bill MacDonald (Pirates) tells you. "I can't throw any more." A Warren Hacker (Cubs) calls you out with the bases loaded and Duke Snider hitting to ask if you know where he can get some shotgun shells. Jim Wilson of the White Sox says he'd like to come in to relieve some day, in a jam-packed ball park, with the bases loaded and uncork his first warm-up pitch so wild that it hits the screen on the fly, just to hear the fans roar.

It's a hot day in St. Louis, about 95 in the shade. A real close game, your club is leading. Your pitcher has had to battle all day. Now it's the top of the ninth. The first hitter bunts one down the third-base line. Over your pitcher goes, makes a bare-hand pickup, fires it hard and just gets the man at first. Now the sweat really pours out of him. The next hitter runs the count to 2 and 2 and then tops the ball towards first base. In comes the first baseman, over goes the pitcher and, grabbing a quick toss with a sudden burst of speed, nips the base runner. Two out, one more to go. Protecting a one-run lead, every pitch a pressure pitch. Ball two, strike two! Now a couple of foul balls. The next pitch just misses, and it's three balls and two strikes. Three more foul balls. Now the pitch just misses—ball four, and the tying run walks. Time is called, and out comes the manager for a strategy meeting. The sweating pitcher waits for the manager. He has just raced to the third base-line . . . made the play . . . came back to cover first . . . made the play . . . went to three balls two strikes . . . just missed and walked his man . . . it's 95 in the shade. The manager asks, "What's the matter . . . tired?" That's the strategy meeting. One of these days, the pitcher will flip. Instead of reassuring

the manager, he will say, "Sure, I'm tired. Take me out of here."

The character in the lead role is always the pitcher. The lines and the moods change. On the summit you meet the diplomat, the comedian, the growler, the Shakespearean actor, the accused, or the accuser. The props are the same for all, a rubber slab twenty-four inches by six inches on a hill fifteen inches above the base line paths, and a resin bag.

The mound is ruled by the law of the jungle. Beat or be beaten. The pitcher's weapons are cunning, finesse, intense concentration, and confidence. His tools are his pitches, be it a fast ball, curve ball, or the jet age "slip pitch." He has to get one man, the batter. He has the help of eight other players, but the pitcher has the ball. The pitcher's biggest help comes from his catcher who "suggests" what pitch to throw. The catcher bases his suggestion on the situation, the stuff the pitcher now has, and a defense predetermined in the clubhouse meeting. I use the word "suggest," because the pitcher always has the right to shake off a sign. He must throw the ball that he has the most confidence in. The catcher, unless he is working on a specific weakness, governs his calls by two basic principles. Late in the game, from the seventh inning on, he trys to work his pitcher low, since a low pitch is least likely to be hit out of the park. The second is the cardinal rule of calling pitches: if the game is in balance and this is a game situation pitch, the pitcher must throw his best pitch regardless of the hitter's strength. For example, if your pitcher is a fast low-ball pitcher and the hitter is a good low-ball hitter, then it's strength against strength, and your pitcher's fast ball goes against the hitter's ability to hit it. A Bill Meyer would holler, "Don't let him beat you with a cantaloupe!"

The catcher learns to adjust to the moods of a pitcher— and to the varying personalities of pitchers. "I'll make him

hit into a double play," a Howard Pollet tells the catcher, but the catcher might be greeted with, "Just catch, I'll pitch," as Yankee Vic Raschi said to Yogi Berra. The same intense concentration and confidence expressed by two different personalities.

The mound has been the birthplace of philosophers. "Confidence is the secret of any endeavor, the backbone of baseball," said Lindy McDaniel when a twenty-one-year-old pitcher for the St. Louis Cardinals. "How do you get control as a pitcher? Not by saying, 'I've got to be careful not to pitch this hitter high,' but by saying, 'I've got to pitch this fella low.' If you even think you might pitch up when you know you've got to pitch down, that's fear, and it's fear that beats you more often than the pressure of the other club's bats."

Every meeting on the summit is different. Once you're met by a growl, the next time you learn a lesson in positive thinking. Maybe today it's your turn to be in on an invention. Murry Dickson, my battery mate with St. Louis and Pittsburgh, would be number one in this group. He has enough pitches to make a catcher want to take off his shoes and use his toes to help flash the signs. He used to say he had only six pitches, but I've caught a fast ball, a slider, a sinker, a screwball, a knuckle ball, a curve ball, and a change of pace—plus the two extras he got by slowing up on his fast ball and his curve ball. His assortment was varied still more by the angle from which he threw his pitches—overhand, three quarters, side arm and even submarine. This last one was a new one that he showed me when I was with the Giants and he was with the Phillies. With two strikes, he threw me a curve ball with an underhand motion that seemed to come up and in to me. I swung and missed, striking out. When I came into the bench, Leo Durocher asked me what it was. I told him "A roundhouse American Legion submarine curve

ball." Leo had never heard of it, but Tom Edison Dickson had just thrown it.

Carl Furillo of the Dodgers is a leading member of the "What was that pitch?" club. Dickson always had a set idea of what he would throw. In one game he threw Furillo eight straight curve balls on a three-ball, two-strike count. Carl kept fouling them off. I thought it was time to switch. (I had thought so earlier, but Dickson kept coming back to the curve.) After he had shaken me off and come back to the curve ball sign again, Furillo backed out of the box, and I said to Carl, "What do you think you are going to get?" Confidently and quickly he said, "Another curve." "Right," I told him, "but neither one of us knows from what angle." Murry slowed up on an overhand curve ball and struck him out. Furillo turned to me and asked the familiar question, "What was that?"

Good pitching is explained in many ways. Vinegar Bend Mizell of the St. Louis Cardinals, after an amazing strike-out record in the Cuban Winter League, explained it this way: "Shucks, those guys couldn't understand the language I was pitchin' to 'em in. That's why I struck out so many."

Casey Stengel, explaining Satchel Paige, said that he threw the ball as far from the bat and as close to the plate as possible.

In one of these meetings on the mound Lefty Gomez, the great left-hander of the Yankees, was in a bases-loaded situation. Frank Crosetti, the shortstop, walked over and said, "C'mon, Lefty, bear down, the bases are loaded!" "I know they're loaded," Gomez said. "Did you think I thought they gave me an extra infield?"

Gomez once engineered an odd play, especially for the dignified Yankees, that grew out of the fact his teammate, the late Tony Lazzeri, had been getting a good deal of publicity on what a smart ball player he was and how he never

made a mistake in judgment. One morning the newspaper story was about how Lazzeri always knew what to do with the ball. In the middle of the game that afternoon, the Yankees and Gomez were in a bases-loaded situation with nobody out. Lazzeri, the second baseman, was in on the grass ready to make a play at the plate if the ball were hit to him. Gomez pitched, and the ball was hit right back to him. Instead of firing to the plate for the force-out and double play to first base, Lefty wheeled and threw to Lazzeri. Completely dumfounded, Lazzeri caught the ball and held it, and everybody was safe. Calling time, Lazzeri tore to the mound. "What did you throw it to me for?" he screamed. Lefty grinned at him. "I've been reading in the papers how smart you are and how you always know what to do with the ball. Well, I wanted to see what you would do with that one."

Even toward the end of his great career, Gomez would send his catcher scurrying back to the plate with a smile on his face. Bill Dickey once ran out to the mound for a conference when it appeared that the hop was off Lefty's fast ball. "Lefty, you better throw harder," Dickey told him.

"Throw harder?" Gomez said. "I'm throwing twice as hard as I ever did . . . it's just not getting there as fast."

Bob Lewis, a very funny man in addition to being the traveling secretary for the Chicago Cubs, qualifies Larry French, Cub pitching great, as another pitcher with the ready answer. Bob tells this as he heard it from Andy Lotshaw, the late trainer of the Cubs.

French had pitched a game that he won but wondered how. The Cubs won 3-2, but the Pirates left thirteen men on base. In the clubhouse French summed it up this way: "When I looked around, I didn't know whether I was pitching for the whites or the grays."

"Did you see the last sign?" These are the most frequently used words in the meeting on the summit. When a battery

sign is missed, the catcher calls a conference for good reasons. First, a missed sign can mean injury to the catcher. If he signals for a curve ball, the catcher starts leaning and shifting with the expected pitch as soon as the pitcher releases it. A right-handed pitcher against a right-handed hitter would have the catcher shifting towards first base on a curve ball. If the fast ball is thrown instead, it takes a mad grab by the catcher, maybe even with the bare hand, to get the ball. Second, a cross-up often ends with the runners advancing regardless of how much effort the catcher puts out. This defensive lapse is a gift to the opposition, and an old saying in baseball goes: "Give them only three outs, make them earn their runs, and you'll have a good chance of winning."

Roy Campanella of the Dodgers was the hitter, and I was catching Bob Rush, when we were both with the Cubs. Rush had trouble seeing the battery signs, especially on overcast days. He had already crossed me up three times, and I was running out after every cross-up.

"I know why you're going out there," Campy told me. "I caught him in the All-Star game, and he crossed me up five times in two innings. So you go out and talk all you want. I hope it helps."

Mike Ryba, the one-man team and now a scout for the Cardinals, recalls the first game that Paul Dean pitched in the big leagues. Ryba was the catcher.

"We used basically simple signs, one finger for the fast ball, two fingers for the curve, and three fingers for the change of pace. The first inning was kind of long, but we got out of it all right. Paul didn't have too much. In the middle of the second, he called me out to the mound.

" 'What's the matter, Paul?'

" 'Mike,' he said, 'call for that two-finger ball more. I can get more on it.'

"Then I realized that Paul had been gripping the ball with the number of fingers I put down. On the one-finger sign, which called for the fast ball, he had been throwing a one-finger pitch."

I once had trouble getting the sign to a young pitcher who was well known for being something less than a mental giant. In fact, Mr. Rickey once said that he had good potential except that his arm was twenty years ahead of his brain. We were playing the Cardinals, and they got the bases loaded with the winning run on first base and Musial at bat.

In the pre-game meeting this boy had said he wanted to throw fast balls inside to Musial. I didn't agree with this because I didn't think this pitcher was fast enough to get them by Musial, but a catcher can only suggest, and the pitcher has the final say-so. The first two times Musial had come to bat, the strategy had worked. We took roll calls to see if everybody was still there, because they were vicious line drives, but still outs.

Now, with Musial up again, I give the sign for the fast ball. The pitcher shook me off. I went to the curve ball signal. He shook off the curve ball sign. There was only one sign left, the change of pace sign, and he shook it off, too.

I said to the plate umpire, "This guy is thinking out there." He was employing a strategy in baseball that is called "shaking the catcher around"—that is, shake off all the signs and come back to the original sign. A pitcher does that to confuse the hitter as to what the pitcher is going to throw. Anyhow, here's a pitcher making $6,000 a year going to confuse a man that owns a Hall of Fame batting average, two restaurants, and two Cadillacs. But I go along with this strategy. I motion for the original sign, the fast ball. Again the shake-off. The curve ball sign. Shook me off. I put down the change of pace sign, and he shakes me off again. So I

call time and run out for the meeting on the summit. "You said in the meeting you wanted Musial to hit fast balls. I gave you that sign and every other one. You shook me off. What do you want to do?"

My pitcher looked up at me and said, "Nothing, I want to hold the ball as long as I can."

In a similar situation, Lefty Gomez, pitching against Jimmy Foxx, kept shaking the catcher around. Finally Dickey walked out and hollered, "You're going to have to throw something. Why don't you pitch?"

"Let's wait a while," Gomez said, "Maybe he'll get a long-distance phone call."

Often, in a tough spot like that, the real mission of the catcher is to ease the tension. I remember one time at the Polo Grounds, Johnny Klippstein, then with the Cubs, came in as a relief pitcher with the bases loaded and one out. Manager Durocher of the Giants countered with his best pinch-hitter, Dusty Rhodes.

The first two pitches were wide, and Johnny was behind the hitter. I called time and walked about three quarters of the way out to the mound and said, "C'mon John, make him hit." (A typically brilliant suggestion.) The next pitch Dusty fouled off and then took another ball. With the count three balls and one strike, I called time and went out to the mound.

I handed the ball to Klippstein and said, "John, if you make him hit the ball to you and if you throw it to me, I promise you I'll throw it to first base for the double-play, and that'll get me about ten votes for next year's All-Star game."

I walked away before he had a chance to say anything. Well, it happened. Dusty hit a curve ball right back to Klippstein—to home for one, to first for the double play. Klippstein told me: "Joe, I thought you'd flipped your lid

when you told me what you did." It broke the tension, and that's a pretty important job when you're catching.

Bobby Bragan, when managing the Pirates, used to call meetings on the summit to break the tension. One day when they were losing to Brooklyn, Bobby called the players in.

"Shall I let him stay in, Dale?" (of Dale Long, first baseman).

"Yeah, I would, Skipper."

"How about you, Curt?" (Curt Roberts, second baseman).

"I think I'd leave him in."

"Dick?" (Dick Groat, shortstop).

"I'd go with him a little longer."

The 20,000 people in the Ebbets Field stands and now Frank Dascoli, the plate umpire, are wondering what's going on and are getting impatient. But Bobby still hasn't polled Frank Thomas at third and Jack Shepard, the catcher. Frank says leave him in.

"C'mon, let's play ball," Dascoli snaps.

"How about it, Jack, does he still have his stuff?"

"Let him stay in," Jack says.

Now Bragan turns to Dascoli. "How about it, Frank? Should I let him in, or bring in a new pitcher?"

Flabbergasted, Dascoli roars back. "That's your job, not mine."

By this time, the players are smiling, and the tension is broken. No pitching change, but new players resume the game.

There are some tip-offs that pitchers give that cause a catcher to run out to the mound. Injury or an expression of pain will always bring that catcher out. Every catcher would like to see the pitcher go all the way and win, but the catcher has to think of winning the game. When a pitcher stays in a game and he's not at his best, he is hurting the ball club's chances. The mound is no place for martyrs. Some-

times little things a pitcher does are tip-offs that something's wrong. Some pitchers take longer between pitches as they tire. They go to the resin bag more. Other pitchers make unnecessary throws to first base. Some tiring pitchers find fault with the ball—none of the balls feel right and they keep asking for new ones. Pitchers who never bother to look at the outfield in the early innings will take a great interest in how they are playing in the seventh, eighth, and ninth innings. Any one of these can call for a conference. A catcher learns the characteristics of each pitcher.

It's tough for a catcher in these meetings to answer the manager's question: "How about it? Does he have anything?" You don't want to hurt anybody's feelings, yet you have to win. You have to tell the truth because the manager is leaving it up to you. Here's the tired, sweating pitcher standing right next to you. He's been bearing down all the way. He's pitched his heart out, but you know he doesn't have it any more. When you see the manager start from the dugout, you begin preparing your speech. "How about it? Does he have anything?" asks the manager.

"I'll tell you, he had a real good curve ball, but it's really been hot out here. He had a tough inning in the fourth, and he really had to battle them. This is his game, and he deserves to win. That heat really takes it out of you," the catcher says. This conversation goes on until the manager realizes that the catcher is saying, "No, he doesn't have it."

Howard Pollet was a pitcher who knew when he had lost his stuff. Preacher Roe, former Dodger star, was another. It was during one of his tougher games that Preach ran into trouble and had to bear down on every pitch. He had pitched out of a bases-loaded jam in the seventh, and here in the eighth he walked the first man. Out came Manager Alston. "How do you feel, Preach?" he asked.

"I'll tell you, Skipper, I got good stamina. I got good

wind, and the heat ain't got me, but I just don't have a good fast ball."

Pitchers often tell you they are pacing themselves, and their act is so good that you sometimes believe it. After the pitcher's best pitch has been hit very hard, the catcher walks out to the mound. "I'm pacing myself," says the pitcher, "so I'll have something on the ball when I need it."

Clyde Sukeforth tells about Harry Taylor, then with Brooklyn, in the 1947 World Series. The first four men to face him got on base. Coach Sukey raced to the mound. "What's the matter?" Sukey asked him.

"Nothing at all, I'm fine."

Sukey looked around and said, "Okay, you're fine, but those guys on the bases . . . what about them?"

"Oh, those guys! I'm just pacing myself."

"Well," said Sukey, "go in the clubhouse and pace the floor."

Runs control the mood of the mound. Get a couple runs ahead, and the quips are fast. I was never in a dull meeting on the mound when we were ahead.

Fred Hutchinson, one of the real tough competitors as a pitcher and as a manager, while trying to protect a two-run Cardinal lead, came out for the third time in one inning to make a pitching change against Milwaukee. The tying runs were on and the lead run was represented by Eddie Mathews at the plate. As he got to the mound, stern-faced, he was met by his infielders. "Here I am again, boys—brains is really moving 'em like checkers today."

Managers are asked sometimes how to pitch certain hitters even by veteran pitchers who should know what to do. Lou Boudreau, when manager of the Cleveland Indians called in Red Embree, a right-handed sinker ball pitcher. Embree got to the mound and asked Boudreau if he could pitch Ted Williams low. "Yeah, you can pitch him low, but

as soon as you throw the ball run and hide behind second base."

The meeting of the summit has become such a part of baseball that managers now have signs to the infielders indicating that they start a conference. Former Cardinal managers Eddie Stanky and Harry Walker would signal when they wanted more time for the relief pitcher to warm up. An infielder, upon getting the signal from the bench, would run over and talk to the pitcher and say, "This is your old friend, Joe, coming out to talk to you because the manager would like for me to visit you." Having consumed as much time as possible, he would go back to his position, and then the manager would come strolling out. After a long discussion, the change is made with the relief pitcher fully warmed up.

Even so, sometimes a relief pitcher just doesn't get warmed up enough and then further histrionics are necessary to give him more time. Eddie Miksis claims the greatest acting he has ever seen was a performance by Peewee Reese. In a game at Ebbets Field, the Dodgers made a quick move and Clyde King was called in to relieve. As soon as he got to the mound, King told Dressen, the manager, he needed a few more warm-up tosses before he could be ready. For what seemed to be a strategy conference, Dressen walked over to Reese and told Peewee to try and stall until King could get ready.

When the umpire called play ball, Reese got something in his eye. He called time and walked over to Billy Cox at third and asked him to get the speck out of his eye. Reese's performance was so good that King, who was supposed to be throwing hard, came over to see how Cox was making out in getting the speck out of Reese's eye.

CHAPTER ◆ *SIX*

The Bullpen

There has been a lot of speculation about how the bullpen got its name. It is generally believed that the term originated because pitchers early in the century used to warm up against the Bull Durham signs that were fixtures in most parks. But Lee Allen, writing in the *Sporting News* of May 16, 1956, says that the term was in use before the Bull Durham signs went up. It was during the 1909 season, Lee reports, that Blackwells' Durham Tobacco Co. bought advertising space on outfield fences all over the country and offered a prize of $50 to each hitter who hit the bull.

However, the area in foul territory beyond first and third bases was referred to as the bullpen in the *Cincinnati Enquirer* on May 7, 1877. In those days, the price of admission to the grandstand was pegged at 50 cents, but some major league clubs (to quote the *Enquirer*) admitted "late comers for ten cents or three for a quarter, herding them in like bulls within a rope area in foul territory, adjoining the outfield." The bullpen at the Cincinnati grounds, the *Enquirer* commented, had lost its usefulness.

Even though the area may have been first called the bull-pen because of the "three for a quarter" crowd, as Lee Allen's research indicates, it would be my guess that the term came into use with its present meaning in the days of the Bull Durham signs.

However it got its name, every manager will tell you this: "I can't win without a bullpen."

Some say the bullpen is the land of the misfits, the rest home for the sore-arm pitcher, the terminal for the old-timer waiting for the bus back to the minor leagues, or the hide-out of the manager's friend who is counting the days until he is eligible for the baseball pension plan. It is for the pitcher whose curve ball hangs and who is referred to as the janitor, or mop-up man. It is behind the lines for the shell-shocked. The bullpen is the slums of baseball. The high-rent district belongs to the Big Four Starters of the pitching staff.

The basic layout of the bullpen is the same—any spot in the ballpark where the crew's out of the way and can get up to play catch when and if they are needed. The popula-tion of the bullpen usually consists of three pitchers—a long man, a short man and the mop-up man. (Sometimes a fourth pitcher is in the crew—a spot starter who is used in relief.) Depending on the roster, there is a catcher and either the fifth outfielder or the utility infielder who doubles in brass as a warm-up catcher. Recently, more and more pitching coaches have also taken up residence in the bullpen.

With the coming of the Jim Konstantys, Joe Pages, Ted Wilkses, Elroy Faces and other great specialists, the bullpen has taken on some respectability and even glamour. Birdie Tebbetts says that the relief pitcher is the one man on a team that can make a manager look like a genius.

The long man is usually a starter who has been in a pitch-ing slump and is trying to untrack himself. He is trying to pitch his way out of the bullpen back to the Big Four. The

manager uses him in the early innings, usually in a losing game, hoping he can finish the game. The real hope is that somewhere along the line, while holding the other team close enough to pick up the win, he will regain the confidence and touch that was lost. The long man is usually more of a transient than a permanent guest.

He is usually replaced by a young pitcher in need of seasoning. It takes a real con artist to keep this fellow happy. The young ambitious pitcher looks upon the bullpen as a dog house. The question in his mind is, "What did I do or what did I say to have him send me down here?" The trick is to swing his thinking around to: "Will I get another start if I look good in relief?"

The short man is the star of the housing project. He is the man the manager depends on in the late innings to nail down a victory or hold the other club. All pennant-winning teams have had good short men—Joe Page, Joe Black, Hugh Casey, Al Brazle, Jim Konstanty, Jim Hughes, Clem Labine, Elroy Face, etc. The short man may go a week without pitching and then pitch every day in the heat of a pennant race.

The mop-up man is the ugly duckling of the crew. Many times a decision has to be made on this individual—whether to keep him on the roster or not. Meanwhile, he is used to mop up a lost cause and be of some value to the club. His contribution often is to absorb a shellacking that saves another pitcher for the next day's game.

Many times, though, a mop-up man battles his way up to the Big Four. Used infrequently and never knowing when the mop-up call will come, he must be ready to give all he's got every chance he gets. If he looks good, even in a losing game, the question always comes up: "Would he be that good if the game meant something?" Therein lies his hope. Maybe he gets a chance in a closer game. If he passes this

test, he may be cast in the role of the short man to nail a game down. The next step up is to be used as a starter in spots. Al Lopez says that a good relief pitcher should have speed, control and ice water in his veins. Tom Ferrick, the pitching coach, once described the perfect relief pitcher as a left-hander all the way—a comic-book reader with no imagination and all his brains beat out. This type knows no fear. All he wants is the ball and to throw strikes. Everybody agrees that the main asset is lack of fear.

Ted Wilks was a mainstay in the Cardinal bullpen. His temperament was perfect, his makeup ideal—strong, durable, without fear. His only words when he came into a tough situation were: "Use the second sign." (Meaning that of all the finger signals I flashed only the second sign counted—one finger for a fast ball, two for a curve, and three for a change of pace.) Then he would rear back and throw. His fast ball was his money pitch, and many was the time he threw it right into a hitter's power and struck him out. The hitters knew it was his bread and butter pitch, but they had to beat him with the bat. He never walked himself into trouble, and he never thought himself into trouble. He threw strikes and knew no fear. Jim Konstanty, who could dazzle you with footwork, is rare. Most good bullpen men are Powder River boys. Rear back and let'er go.

As a relief pitcher, Wilks was born on a train. Eddie Dyer, then our manager with the Cardinals, talked for hours to Wilks about how valuable he could be to the team as a relief pitcher. But the glamour was with the starters, argued Wilks, and so was the money. The bullpen was the tenement district of baseball. "Do as I ask you, and I'll get you the money," pleaded Dyer. So Wilks tried it and saved a few games and got the feeling that the fans and players were depending on him. He began to like the idea of being a relief man. Being nicknamed The Cork (because he was the

stopper) appealed to him. Like all good relief pitchers, his attitude became, "Don't worry, just give me that ball."

Larry Goetz, the great National League umpire, will always remember a dramatic save of a game by Wilks. The Cardinals were playing the Dodgers at Ebbets Field in Brooklyn, which was a very cozy park—like pitching in a telephone booth. The bases were loaded with two outs, and Duke Snider was the hitter. The tying run was at third and the winning run at second.

In comes Wilks, with the have-no-fear-I'm-here look on his face. As I met him on the mound, he gave me his usual speech, "Use the second sign."

Duke Snider was a good fast ball hitter, so I flashed the curve ball sign. Wilks fired a fast ball right down the middle that Snider missed swinging. Set for a curve, I just barely got my glove on it to keep it from going back to the screen. I went out to the mound. "I got it, I just forgot," he said before I could ask the question.

Seeing how good Wilks's fast ball was on the first pitch, I signaled for his fast ball. In came the best curve ball you ever saw. Snider swung and missed. Again I was lucky to keep the tying run from scoring. I call time and out I go to the mound. "You got the signs?" "Yeah." . . . "You crossed me up twice." "I did?" "Yeah—second sign now, one is a fast ball, two a curve and three the change up." "Okay I got 'em."

Thinking we've got Snider in the hole, maybe he'll chase a bad curve ball in the dirt, I signal for the curve ball low. In comes a fast ball right down the middle. Snider took it for strike three and I took it off the chest protector. Retrieving the ball, I tagged Snider for the third out, and that ended the game.

Larry Goetz turned to me and said, "I knew you guys had him, because none of us back here knew what was coming."

There was the great relief pitcher in action. Throw strikes

with something on the ball. Ted Wilks pitched to Snider like there were only two men in the whole ballpark, Snider and Wilks. It was a personal duel.

The old pitcher knows how many warm-up pitches he needs to get ready. The young pitcher usually feels he needs just one more. It was said of Ellis Kinder that he could shake hands and be ready. Ready or not, the time comes to take the long walk in from the bullpen. The trouble is there waiting for you. The ones that get the death-row feeling don't make it. It takes a comic book reader with his brains beat out, Tom Ferrick said. Or it takes a man like Wilks going in for his personal duel with the hitter.

Conditioning a relief pitcher is a different job from that of getting a starting pitcher ready. The starter knows that his turn comes up every four or five days, rarely in between. The bullpen crew is on call every day or night. Running to strengthen the legs is important to the bullpen pitcher, but he can't run as much before a game because he might be used. On the other hand, he can't lay back saving himself because if the starting staff goes good it could be several days before he is used. The way many pitching coaches solve this is to run all the pitchers a certain amount every day. This is done by getting a pitcher started and then throwing the ball, much like a football forward pass. The coach shortens the distance for the bullpen men.

Running is one of the most important phases of staying in condition, but all pitchers hate it. From the bullpen has come the strongest argument against it. When Tom Ferrick wanted Art Fowler to run more, Fowler said: "If running is so important, Jesse Owens would be a twenty-game winner."

The perfect bullpen location, as far as the players are concerned, is any spot where the manager can't see you, is away from the crowd, and has a snack bar and bathroom facilities.

Unfortunately, there is no such spot in either major league.

Getting decent protection from the crowd is the most important factor as far as the bullpen crew is concerned. Fans seem to have a hard spot in their hearts for the bullpen. There is a famous story about John King, who showed up one day carrying a large package. When the game was about to start, he took the package over near the bleachers, opened it and took out about fifty hunks of raw meat. Tossing the meat up to the fans, he hollered: "You wolves been howling for blood all year. Maybe this'll shut you up."

The Polo Grounds, former home of the Giants, used to be the worst for the bullpen. It was merely a bench in far-off left center field (so far away, you were always an out behind, like seeing a re-created game), and the fans were right on top of you. To sit through a double-header out there was equivalent to thirty days on bread and water in a zoo. The fans were all advocates of the spitball . . . with or without the ball. The last year the Giants were there, an awning was put over the bench which shielded the crew from the sun and the fan-made monsoon.

Ebbets Field wasn't much better. The visitors' bullpen was a bench right next to the reserved seats in the left field corner. The cash customers felt they were entitled to pet the animals. Although they did obey the Do Not Feed the Animals sign, the fans would usually pet you with empty or half-filled paper cups and hot dog buns. With the coming of the protective plastic helmets, they would play tunes on the helmets with marbles. You felt like a part of the Ebbets Field Swiss Bell Ringers. It was in this bullpen that Sam Narron, the Pirate coach, suffered a serious eye injury caused by a fire cracker that exploded in front of him. It took this accident to get the bullpen bench protected from the sun and the fans.

Clyde McCullough, veteran of many a bullpen, was in the Ebbets Field bullpen, taking abuse from a big fat fan. For the first four innings Clyde took it. Then the fat man shouted: "When you going to quit, McCullough, and give a young fellow a chance?" Mac got up and said: "You be quiet, or I'll shove an apple in your mouth and put you in the middle of the dining room table."

Danny Murtaugh, later a manager, in subdued tones once said to his heckler, "Can I tell you something?"

"Sure, I'll listen."

"When I was a youngster, I lived on a farm. We had a jackass on that farm that just wouldn't do anything. One day I really gave that jackass a beating. My father heard the jackass hollering and came to his rescue. Then he turned on me and gave me a good lacing for what I had done. His last words were: 'Someday that jackass is going to haunt you.' And, you know, *up till now I never did believe him!*"

Most bullpens now have at least an awning up to protect the players. At Wrigley Field in Chicago and Connie Mack Stadium in Philadelphia the players are protected from the fans by walls that rise away from the fans. The wall isn't too high in Chicago, but the fans seem well behaved. In Philadelphia, the wall comes so close to the foul line that just by standing still you are crowded. The left-hander always warms up closest to the foul lines, and the right-hander takes his chances with scraping his knuckles along the wall.

Sitting close to the fans has worked to the advantage of the bullpen crew, though, as many a business deal or profitable contact has been made. Autographed baseballs have been turned into shoes, suits, or luggage at wholesale. In addition to a place to warm up players, especially pitchers, it is also a place for meeting people, making wholesale deals, eating peanuts, trading insults with the fans and players, sec-

ond-guessing the manager, and picking all kinds of all-star teams, like the all-ugly team, all-screwball team, all-stack-blowing team, or all-American-football team that played major league baseball.

I once helped pick an all-star team of the best fighters in a brawl. We put Gil Hodges and Ted Klusewski at first base with Dale Long in reserve. Johnny Temple was at second, with Johnny Logan at shortstop and Don Hoak at third. Pete Whisenant, Moose Moryn and Del Ennis were in the outfield. Stan Lopata would be the catcher. Picking a team of this kind sets off a rhubarb. The question comes up, "How can you keep Furillo off? He can take care of any of the guys you named." From here the argument goes to who is the strongest guy in the league.

Another great all-star team that is argued over in the bullpen is the major league football team. Catchers could be Charlie Berry, Red Wilson or Vic Janowicz; first baseman, Ted Klusewski; second base, Frankie Frisch; shortstop, Alvin Dark, and third base, Jackie Robinson. Utility men could be Bill Skowron and Carroll Hardy. The outfield is loaded with former football greats—Jackie Jensen, Bob Cerv, Sam Chapman and Eric Tipton. The pitchers are Allie Reynolds, Paul Giel, Bob Friend, and Laurin Pepper.

An all-star basketball team might include Gene Conley, Dick Groat, the O'Brien twins, Joe Adcock, Del Rice, and Dick Rickets.

Who is the fastest runner in the league? Who is the fastest runner in the big leagues? These two questions come up in every bullpen. The Philadelphia Phillies crew once had a track meet in the bullpen. It was limited, because of the space, to two events—the running broad jump and the standing broad jump. The big bullpen question in Wrigley Field in Chicago was always, "Could you drive a golf ball over the

center field scoreboard from home plate?" Sam Snead once did it, but I don't know of any ballplayer who has done it, although a few have snuck out there and tried.

Nate Levin, a Chicago hardware man, was a number-one friend of the bullpen crews. For years he always came by with peanuts and learned to flip them in when the coast was clear. In the Polo Grounds, a cab driver always supplied pitching coach Frank Shellenback with cigars. In Forbes Field a woman fan would bake cakes for the crew. Ordinary fans find ways to get hot dogs and hamburgers in to the bullpen.

A rookie pitcher with the Washington Senators, with his team trailing by seven runs, had only two thoughts in his mind: get the game over, and I'm hungry. Feeling certain that he would never be called into the game, he managed to smuggle in a hot dog dripping with mustard. A quick call to the bullpen came when the Yankees exploded with another big rally. "C'mon kid get hot!" Quickly he put the hot dog into his hip pocket and started throwing rapid-fire to get ready. In another minute, he was called into the game. At the mound he asked for instructions. "There are no outs, the bases are loaded. Coming up are Lazzeri, Gehrig and Ruth." The rookie said, "Here, hold my hot dog—I won't be here long."

Sometimes the first sign a relief pitcher gets from the catcher is to wipe the mustard off his mouth.

The Polo Grounds bullpen was so open that the players occasionally had to make a trip to the clubhouse. Those who went had to bring back the groceries. A group huddled together in the Milwaukee bullpen means the peace pipe is being passed. In the Philadelphia bullpen, the player in the corner is sneaking a smoke. Practical jokers help pass the time in the bullpen. Ralph Kiner, while playing left field for the Cubs, made the mistake of flipping his glove into the bull-

pen when Walker Cooper was there. Time had to be called while Kiner shook out grass, sticks, gum, chewing tobacco, and peanut shells that were expertly and compactly stuffed into each finger.

Some players have been known to try to catch forty winks in the bullpen, and that can be dangerous. The Philadelphia visitors' pen is nicely situated by the standards of the players, away from the fans when you are sitting and always out of the line of vision of the manager. The crew will let you alone long enough to doze off, and then it begins—hot foot, glove stuffed, jacket turned inside out, wad of tobacco in the pocket of your glove, shoe laces cut almost in half, etc. One pitching coach was padlocked by his belt to the iron grill-work. Water dripping is a common practice. Putting lighted cigarette butts in belt loops caused so many burned uniforms on one team that a clubhouse meeting had to be called.

There is usually a captain of the pen. Although he is not necessarily a leader on the field, he is the leader in the agitating, practical jokes, and bullpen awards. Sibby Sisti, a utility infielder, was the captain of the crew in Milwaukee. The first year the Braves were in Milwaukee, the team was always getting some kind of award or presents, which usually did not include the "scrubinis" and the bullpen crew. They instituted their own awards. Once you got in the game for any reason, pinch running included, you were disqualified from the voting. The voting was limited to bona fide "scrubinis." Such deeds as bringing the cigarettes, going to the clubhouse for the chewing tobacco, and stuffing a glove without being caught would make you eligible for an award, which ran anywhere from personally autographed bubble gum card pictures of the crew to an autographed broken bat.

Frank Smith, a relief pitcher who gained fame with the Cincinnati Reds, was another crew captain. Perhaps his best stunt involved the organist at Crosley Field, who would play

a fight song when the starting line-up ran from the dugout to take positions. Usually Smith and his boys would walk slowly to the bullpen in left field before the game started. One day Smith got his crew poised on the top step of the dugout. On a signal by Smith, they all broke into a sprint towards the diamond. The organist took it as his cue and broke into the fight song. As the music blared out, Smith and his men stopped, made a left turn and headed for the bullpen. After pulling this trick three days in a row, Smith and his bullpen crew could claim the distinction of being the only crew in the major leagues to go to the bullpen with a fight song.

Their manager's strategy comes in for a real raking from the crew. Would you bunt? Would you steal? Would you let him hit and run? The young pitcher is reminded that it was a curve ball Furillo hit with the count 3 and 2. If the young catcher is in the bullpen, he is constantly being asked, "What would you call for in this spot?" Innings are replayed and future plays are planned. Any play discussed usually touches off a rhubarb. It's all part of bullpen life.

Del Wilber, a teammate of mine on the St. Louis Cardinals, would be my number-one bullpen philosopher. He always came up with interesting subjects that would keep you hopping for nine innings. Does the right-handed hitter actually lose a step to the left-handed hitter going to first base? Is the National League a right-handed hitter's league? What is a perfect line-up? What do you mean when you say that a ballplayer is gutless? Why not try to steal even though trailing by a big score? Any of these questions is good for a debate that will make the United Nations look like a meeting of the local PTA.

Whatever else they're doing, though, the bullpen crew is always in the game. A good bullpen always has an espionage system going. The opposing shortstop might be too obvious with his signs to the outfield on what pitch is going to be

thrown. Since the bullpen crew has the same vantage point as the defensive outfielders, they sometimes can steal the signs and relay them to their own hitters. The infielder moves to his right for the curve ball, but stands still when it is a fast ball. If this is confirmed, as the sign, the bullpen man who appears to be just sitting and swinging both legs is signaling the fast ball, one leg swinging a curve ball. The hitter can pick up the sign easily.

The visitors' bullpen in St. Louis is along the right field line. The screen in St. Louis is 310 feet from home plate. The Brooklyn Dodgers would place a man with a white towel on the edge of the bench nearest home plate. From the bullpen, they could judge quicker whether a fly ball was going to be caught or hit the screen. If it was a hit off the screen, the man with the towel would make an exaggerated swipe to his face. The base runner would see the towel and dig for second without hesitation. Then he would pick up the third-base coach who would signal whether to stay at second or come on over. In this way the Dodgers got a good many doubles out of singles and triples out of two-base hits.

The next time the ball goes near the bullpen, watch the action. If one of their own outfielders is in the field, up they get to let him know whether he is near the wall and can make the play or not. On a base hit, they tell their outfielder where to throw. For an opposing outfielder, nobody moves. I can still see Don Thompson, an outfielder with the Dodgers, trying to fight his way through our (Cardinals) bullpen to try to catch a foul fly ball. Nobody moved, and he couldn't reach the ball. Had we got out of the way, he would have had a good chance to make the play. The Dodgers argued interference, but no one had done anything. We didn't even move.

The biggest complaint about bullpens from the physical viewpoint is the location of the bullpen mound. In most ball parks the pitcher must warm up with his back to the infield.

If there is any wind, the pitcher warming up is getting the opposite effect from it than that of the pitcher in the game. In many parks there is no bullpen mound, and he is warming up off a slab of rubber.

Most bullpens have telephone connections with the dugout. In the bullpens that don't have a phone (Pittsburgh and Cincy) the manager plays charades in getting his men warmed up. Stan Hack, when managing the Cubs, would, for example, signal for Hal Jeffcoat by making like Atlas, flexing his muscles to indicate Jeffcoat's great strength. For Johnny Klippstein, Hack would give a scissor's clipping motion with his hands, indicating Klipp.

For any pitcher that wears glasses the sign is the peering look. A knuckle ball pitcher is called by a fluttering motion.

The bullpen is the originating studio of the pretend radio broadcast. The last year I was in Chicago, Johnny Klippstein was my partner. These broadcasts had many sponsors and always featured interviews. Don Drysdale was the phantom broadcaster in the Dodgers' bullpen at Ebbets Field. Clem Labine, the ace of the Dodger crew, was his assistant. The Dodger broadcasts were sponsored by a water softener concern that is endorsed by Lew Burdette. ("You can't throw a good spitball with hard water.")

When one of the fellow bullpen members got up to throw, Drysdale would say: "Got the glasses on him, Clem?" "Yeah, it looks like a right-hander getting up." "It is a right-hander all right. We'll have to wait and see his number before we can tell you who he is."

Sometimes it would go like this: "Here is Garagiola hitting now—I mean he's in the batter's box, fans. Last year he had a good year, led the league in stolen match books, second in stolen towels, and finished in a tie for the wholesaling crown."

My partner once was that great catcher of many a Na-

tional League campaign, Clyde McCullough. We were both with the Pittsburgh Pirates then. It was the first night the Pirates wore the plastic helmets that are so common now. When we came on the field, we were called everything from coal miners to space cadets. We were in last place, and the questions asked most that night was: "Who's going to throw at .210 hitters?" With all this I decided on an interview.

"Clyde, do you think these hats have the future that is predicted for them?"

"I sure do."

"Clyde, do you endorse these hats?"

"I sure do."

"Clyde, do you think these hats would be better if we had some chlorophyll in them?"

"No, I think they would be better if we had some ballplayers in them."

The laugh is louder, the needle is sharper, and activity is the byword of the bullpen. "A comic book reader with his brains beat out," is the way the bench jockeys put it. "I can't win without a bullpen," is the way the manager puts it.

The Loners

It was a close play at third base. The famous umpire Bill Guthrie deliberated a moment.

"What is he? What is he?" the third baseman demanded.

"He ain't nothin' till I say so," Guthrie replied, and thereby stated the code of all good umpires.

Once Larry Goetz, one of the most respected umpires, was having lunch in a hotel dining room with Warren Giles, his boss, and Waite Hoyt, then a broadcaster. Goetz put on his glasses to read the menu.

"You got a lot of nerve putting on cheaters to see something with the league president sitting right here," needled Hoyt.

"I got a lot of nerve," Goetz told him, "or I wouldn't be in this business."

Once it was said about umpiring that you can't beat the hours, but now you have to beat everything. Every move is a challenge. Nobody can move until the umpire says so, but every move he makes can touch off an explosion.

You look at the qualifications of a major league umpire, and

you know that Larry Goetz was right. Before they are hired, all umpires are checked thoroughly by professional investigators. The National League has set five standards he must meet. Written, they are five . . . in carrying them out, they seem like five times five times five. . . .

1. A record of unquestioned integrity
2. Courage
3. Knowledge of the rules
4. The right temperament and disposition
5. Health and appearance

Every game he works challenges every one of those standards. The umpire behind the plate may well make 275 calls a game. The base umpires may make ten or more each. An average umpire must make some 10,000 decisions a season, taking his turn behind the plate and on the bases. With these decisions, the umpires are carrying the hopes of millions of fans and about 250 players, managers and owners in each league. One wrong decision can cost a game, and a lost game often means a lost pennant.

The manager has twenty-five players to deal with. Add eight managers and at least sixteen coaches and multiply by eight, and you have the cannon barrel that the umpire is looking down. Yet over 154 games, the umpire must forget personalities. Forgive and forget. Every game is a new game, every pitch a big one. And he gets the free help of both benches, especially the catchers. Let him lose his temper, and he's through. Or let him get pushed around, and he's through. Once he is on the field, everybody is against him except his buddy umpires. Every fan in the stands has the right to boo him and to join in that old American chorus: "Kill the umpire!"

The umpire is a loner. It has to be that way.

He rarely stays at the same hotel as the players. Off the field, he is rarely seen in the vicinity of players or club

officials, some of whom once were his close friends. When you see an umpire off the field, he is usually with a buddy umpire or an old friend outside of baseball.

The chances are, if you are an average fan, you wouldn't recognize an umpire off the field anyway. Gone is the sober blue suit of his trade. His dress goes from the conservative businessman look of a Babe Pinelli to the fashion plate with Windsor knot of a Jocko Conlan. Ken Burkhardt, Frank Secory or Vinnie Smith can easily be mistaken for the major league players they once were. Bill Jackowski could be a house detective, Augie Donatelli a rough-featured contractor waiting to meet a fellow builder, Frank Dascoli a restaurant proprietor, and Hal Dixon a big rawhide in town to buy some farm equipment.

The usual procedure is for four umpires to travel as a team. From game to game, they work clockwise around the diamond. Today's plate umpire is tomorrow's third base umpire, and today's first base umpire is tomorrow's plate umpire, etc.

Their working day starts an hour and fifteen minutes before game time, when the third base umpire takes a seat in the stands to enforce rules against fraternizing between opposing players and managers. He also sees that the rule against playing pepper games (bunting the ball to a row of players) toward the stands is observed, and he keeps his eyes open for anything that might be detrimental to the game. All umpires are in uniform at least fifteen minutes before the start of the game.

The third base umpire usually carries the bag of official game balls to home plate. The plate umpire for the day has already rubbed up about four dozen balls with a special mud that the league buys. The mud takes the shine off the new balls without making them dirty. (The salesman for this mud is a former major leaguer, Lena Blackburn.)

The toughest job to work, of course, is behind the plate

where there are more decisions to make. In the American League the umpire works directly behind the catcher, looking over his head. In the National League, he works inside— for a left-handed hitter, to the right of the catcher and over his right shoulder, and to the left of the catcher for a right-handed hitter. Each league argues that its system is best. The National League claims better calls on the inside and outside pitches.

In his position the umpire is like a catcher without a glove. The other equipment used by both is about the same. The shin guards of the umpire are not as big as the catchers, because the umpire must wear them under his pants legs. The shoes an umpire wears behind the plate have an extra heavy piece of leather on top of the shoe with a steel plate on the toe, but this is no guarantee against painful injury.

George Magerkurth was a veteran umpire when I broke into the big leagues in 1946, and he was always complaining, "My bunions really hurt today." As a twenty-year-old rookie, I hadn't yet learned to hold the mask in one hand when a foul ball was hit, then find the ball and flip the mask in the opposite direction, which is the right way to chase foul balls. All I knew was that if the ball was hit, I was allowed to try and catch it. Foul ball . . . flip goes my mask, and away I'd go. Nine times out of ten the foul ball was against the screen, and there was no need for the chase. Umpire Magerkurth kept mumbling something about the mask. "Hold the mask, my feet . . ." Every time I would flip the mask, he would try to catch it to keep it from hitting him on his bunions. In the seventh inning I made a direct hit. When I got back to the plate, Mage was really moaning, and he let me have it. "Listen, the next time you hit me on my bunions, you're out of here. My feet are sore, and my fingers are sore from trying to catch that mask. You better hold that thing, or you're gone."

The chest protector the umpire wears is quite a bit differ-

ent from the one worn by the catcher. It is a snug fit with more protection around the shoulders. Most National League umpires use the inside protector instead of the outside balloon type used for the most part in the American League. Tradition is a big factor here. The National League goes along with the thinking of the great National League umpire the late Bill Klem, originator of the inside protector. (He once told Augie Donatelli, then umpiring in the minor leagues, that if he wanted to go to the major leagues he ought to get rid of that balloon protector.) The American League umpires follow the great American League umpire, Tom Connolly. The inflated protector fits snugly under the chin. By automatically making the umpire hold his hands behind his back to keep a tight fit, this form of protector automatically keeps his hands out of danger. With the inside protector, the umpire is always using the catcher as a shield for his hands and arms.

Both methods of umpiring, inside by the National, directly behind the catcher by the American League, and both protectors, inside by National League and balloon-type by the American League, are only as good as the man who takes the position and wears the protector.

The umpire's mask is usually much heavier than the catcher's. Most umpires use a bar mask (three iron bars across the front) in preference to the wire mask, because it gives them better vision. You could never convince the players of this on certain days.

Birdie Tebbetts was asked to leave the game one day for merely asking the umpire to look through the open spaces of the mask, not through the iron.

Dewey Williams, a catcher with the Cubs, had just lost an argument to umpire Beans Reardon, when he said, "Beansie, can I ask you one question? How do you get that square head of yours in that round mask?"

Next catcher, please.

The umpire has to buy his own equipment, except the lightweight summer suits which are furnished by the league office. With the shin guards, chest protector, and mask he needs two other pieces of equipment, the indicator and the whisk broom.

The indicator is a little gadget with two manually operated dial wheels. To indicate a strike, the umpire must push the wheel away from him, to indicate a ball he gives it a toward-me motion. During the game the umpire is constantly looking at his indicator, checking against the scoreboard. The bench jockeys accuse the umpire of having a ouija board sometimes instead of an indicator. The two danger plays for losing the count are the wild pitch and the foul tip. On a wild pitch when there is a possible play at the plate, it is an easy thing to forget to record the count.

The whisk broom is more valuable to both the umpire and the ballplayer than you might think. The umpire uses it to dust off home plate and let off some steam. This maneuver gives the umpire a chance to get away from the player so as not to hear anything that will force him to run a man out. He is there to call the plays, not to run players, managers, or coaches out of the game.

Bill Stewart was very proud of his whisk broom. "Sixteen years, been using the same one," he claimed. It looked it too.

The player closest to the plate umpire is the catcher—in position, in job, and in equipment. Most catchers are "umpires." When I was in the National League, Jocko Conlan once rated catchers as the worst umpires in this order: Smoky Burgess, first; Andy Seminick, second, and Joe Garagiola, third.

"When you first came into the league," Conlan once told Seminick, "you were a lousy catcher and a lousy umpire. You're a good catcher now, but your umpiring is worse."

To get ready for a call, the umpire sets himself carefully. First setting himself inside (in the National League), he stands

so his eyes are even with the top of the strike zone. He knows at least that his eye level is the top of the strike zone. He still has to worry about the lower part of the strike zone but his position has already eliminated a big area of doubt.

Behind the plate there are several extra tough decisions. The high outside corner fast ball is the toughest pitch to call. It is the perfect pitch for the pitcher, and he is frequently trying to hit that corner. The umpire is working "inside," therefore has to shift with the pitch. It is often a borderline call.

Cal Hubbard used to tell the hitters, "Boys, I'm one of those umpires that can make a mistake on the close ones. So if it's close, you better hit it."

The steal of home is a tough play for the plate umpire because it involves so many decisions. The umpire must watch the ball and call it a ball or a strike. He must see that there is no catcher's interference with the hitter or hitter interference with the catcher. He must make sure that the pitcher doesn't balk, and he must call the runner safe or out. All this in about three seconds, the time it takes that runner to come roaring down from third. Lose sight of any of these factors, and the umpire can have one of those situations.

The late Bill Meyer, my manager at Pittsburgh, used to have a pet play that he worked successfully in the minor leagues. With the bases loaded and a count of 3 and 1 strike or even 3 and 2, the runner would start for home. The instructions were to start slow so the pitcher would think it was an easy out. The gamble was that the pitcher would forget the count and try to get this easy out by throwing the ball outside to the catcher who would make an easy tag for the out. If the umpire forgot the count too, you can see how embarrassing it would be to rule out, and then have to change to safe because the last pitch was ball four, forcing in the run.

The half-swing is another tough play for the plate umpire, because he is usually partly screened by the catcher. If the

plate umpire sees it, he calls it without help. Once he has to call another umpire for a decision, every half-swing will bring a plea from one bench or the other that he ask for help. The plate umpire usually has a signal with the first base umpire for a right-hand hitter and the third base umpire for a left-hand hitter. Right hand to the chest or thumb-up means "Yes, he swung."

The foul tip into the dirt is tough for the plate umpire to see, because he is behind the play and it is hard to tell whether the catcher caught or trapped the ball.

Umpiring on the bases is more peaceful, although the unexpected is always happening. Take a look at the third base umpire, and he will be straddling the foul line most of the game. He has one base to cover, one line to watch. The biggest bugaboo for the base umpires is the trapped ball in the outfield, or the apparent home run just into the stands. This is a danger play, because of the possibility of a double decision with one umpire ruling out, the other ruling safe. Teamwork, as you can imagine, is of the utmost importance on this play. A base runner moving on a safe signal given by one umpire is out according to the infielder who was watching the out sign of another umpire.

Ron Northey was once tagged out at the plate when he came jogging in thinking his ball was a home run. An umpire had given him the home run sign. The protest was upheld and the game replayed from that point. Gus Bell once "caught" a fly ball and let two Cardinal runners score before he finally threw the ball in to get Joe Frazier trying to score from first. Gus had seen Babe Pinelli rule out from third base, but Bill Stewart at second base had called it a trap play. Stewart's decision stood.

Al Barlick once ruled a diving attempt by Andy Pafko a trapped ball, and there was no doubt to anyone what the ruling was. But Pafko was so sure that he had made a fair catch that he ran to Barlick to argue that he had caught it.

Meanwhile, Rocky Nelson, the batter, was circling the bases with the shortest inside-the-park home run that ever won a game.

In 1952 the Pittsburgh Pirates had one of those clubs that, if there was to be a new way to lose games, we would find it. Augie Donatelli was working first base in a game against the Brooklyn Dodgers. Our first baseman was George "Catfish" Metkovich. It was one of those days at first base that would have made Pearl Harbor seem like a church picnic. Line drives were flying by the Cat's head and through his legs from the first batter on. A grass-cutter hit by Duke Snider ricocheted off Metkovich's shins and went into right field for a single.

The Catfish looked at Donatelli and yelled, "For Cripes sake, Augie, don't just stand there. Get a glove and help me out."

Beans Reardon got caught in a switch while umpiring at third base. Richie Ashburn slid into third, and Billy Cox, Dodger third baseman, made the tag. Reardon yelled "safe" but raised his hand in the "out" sign. Naturally, a rhubarb. Finally, Judge, Jury and Prosecutor Reardon said to Ashburn: "You heard me call you safe, didn't you? But I gave the out sign," said Beans, "and as far as 30,000 people are concerned you're out. So you're out."

Luke Sewell, former major league manager, claims that Bill Terry was the smartest first baseman he ever saw for a reason that few people know about.

"In the 1933 World Series," says Luke, "Terry took two legitimate hits away from the Washington club because he knew the habits of the first base umpire. This umpire would watch the bag to see when the runner's foot touched it. He never looked at the ball, but listened for it to hit the glove. The sound of the ball hitting the glove determined his decision. Twice Terry slapped his glove with his bare hand before the

ball got there. It sounded like the ball was beating the runner, and the runners who were safe were called out."

Larry Goetz tells this one on himself. "Johnny Moore is the hitter, Sam Leslie is the first baseman. The shortstop fields the ball and starts to throw to first. I turned to watch the play at first. When the runner is about two steps from the bag, Leslie pounded his hand in the mitt. I motioned out, and Moore comes charging right at me. I'm wondering what he's mad about, since he rarely makes a beef. All he said was, 'Larry, I feel I have a right to argue. Leslie doesn't have the ball. They made the play at third base instead.'"

I did not have the good fortune of knowing the man considered the greatest umpire of them all, the late Bill Klem. He has become a legend. His drawing of the line with his foot and telling a player not to come any farther is a scene re-enacted whenever the talk gets around to umpires. It was his way of saying, "That's enough. Cross this line and you're through."

It is where to draw the imaginary line that is the toughest job for the umpires. "How far do I let them go? How much of this do I hear? Do I bite my tongue?"

In his instructions to umpires, President Giles gives two fundamentals in six words:

Quick to Think
Slow to Anger.

Bill Klem was both. One day to the surprise of all fans and players, Klem threw Pie Traynor the great third baseman, out of a game. To see Traynor argue was a rarity, and he was a man who never used bad language on the field. To believe that he had said something to cause an ejection was almost impossible. After the game the newspapermen had to get the answer. "What did he say?" a reporter asked Klem.

"He wasn't feeling well," Klem said calmly.

"He looked okay before the game," a reporter countered.

"Well," Bill shrugged, "that's what he told me. He said he was sick of my stupid decisions."

Bobby Thompson, the miracle homer man, once mentioned to Augie Donatelli that he was the only umpire that had ever thrown him out of a game.

"My honor was at stake," Augie said.

"Your honor! I'll bet you don't even remember what happened."

"Yes I do. I called a strike on you, and you called me a _____ _____ _____ _____ _____."

"That's right," said Bobby "but why did you kick me out for that? Nobody heard it but you and me and the catcher."

"I know, Bobby," Augie said, "but I didn't want that catcher going through life thinking that I was a _____ _____ _____ _____ _____."

Never show an umpire up is one of the first instructions given to the young ballplayer, especially a catcher. This means never turn around and jaw with the umpire. If as a catcher you think a call is a strike, make your beef but keep looking out towards the outfield. In this way the fans don't know what's going on and won't be riled up against the umpire. When you're hitting, never indicate to the umpire (and the fans) where you thought the ball was and why it should have been called a ball. If you're a pitcher, don't stare in at the umpire.

Frankie Robinson, the Cincinnati slugger, once got an early shower. Larry Goetz was behind the plate and had called a strike on Robinson, who turned and stared at Goetz.

"What are you looking at? Get in there and hit. What are you looking at?"

"Nothing," said Robinson, "when I look at you I ain't looking at nothing."

Umpire Babe Pinelli says that there are three kinds of kickers among the players—the chronic kicker, the from-the-

heart-kicker, and the alibi kicker. To the chronic kicker, according to Pinelli, the other fellow is always out, and no strike is ever a good one. The guy who kicks from the heart only squawks once or twice a year. When he does, you know it's because he feels he really has a beef. The alibi kicker tries to take the heat off himself. He squawks on that third strike right down the middle.

Pinelli believes that umpires can be classified too. The first category of umpires, says Pinelli, is the one with a chip on his shoulder—always threatening to throw somebody out of the game and never giving the player a chance to let off steam. The second type of umpire is the one who works from the heart but doesn't have enough ability to be a really good one. This umpire, says Pinelli, answers protests with, "I'm doing the best I can."

Clyde McCullough, the Cub catcher, told of the time he was behind the plate in a sandlot game. Here comes a ball right down the middle. The hitter, a giant of a guy, took it and Clyde thought it would be strike three. He didn't hear anything from the umpire. Just then the big guy turns around and asks, "What is it? What's the call?"

"Two," squeaked the umpire.

"Two . . . two what?"

"Too close to tell."

The third type of umpire is the one baseball needs and, for the most part, baseball has. This umpire lets the player blow off steam and gives him an answer without getting antagonistic. He commands the respect of the players. As Larry Goetz said, "I don't care if they like me, as long as they respect me."

With Beans Reardon you were allowed to let off steam. If you got a little too excited and maybe a cuss word crept in, he wouldn't bounce you. He would come back with his own barrage.

Ford Frick, then president of the National League, once called Beans in on the carpet for cussing out ballplayers. "They cuss me out. Why shouldn't I cuss 'em back?" Beans replied.

"Put them out of the game," was the advice given by Mr. Frick.

"If I did that," Beans protested, "I'd have to sit up half the night making out reports. It's easier just to cuss 'em right back."

Among the most famous of the umpire-and-manager debates were those between Beans Reardon and Frankie Frisch. To be catching when Reardon was behind the plate and Frisch was coaching at third base was a front row seat to a great performance.

In Pittsburgh, while Frisch was managing, he and Reardon were having one of those days. Two or three decisions had gone against Frisch, and he thought his club was being hurt. Then came a close play at third. In those days there were only three umpires in a ball game and the man behind the plate had to hustle down to make the call at third. Up went Beansie's right arm, and another Frisch man had bit the dust. Well, now it started. Frisch, coaching at third, really lit into Beans. After Frisch had let off his steam, Reardon stopped him cold. "I know it's hot out here. You're having a rough day, and you want me to kick you out. Well, I don't care what you say—you're staying. If I have to stay, you stay." Frisch went back to the coach's box.

The third out was made, and now the clubs were changing sides. To get from third base to the Pittsburgh dugout, Frisch had to walk by home plate. He stopped. "Beansie, boy, I'm going into the cool of the dugout. I want to enjoy myself. Have you got a cigar?"

"A cigar . . . a cigar? What would I be doing with a cigar?"

That was the opening Frisch hoped for. "You called that

last play like a cigar store Indian, and I thought sure you would have one."

Jimmy Dykes also has to go down as one who always had a word or a thousand words for the men in blue. In a game against the Cardinals, Jimmy was coaching third for Cincinnati and was acting manager, since Birdie Tebbetts had already been excused by the umpires. A rhubarb came up, and Jimmy was right in the middle of it. With three umpires gathered around him, Dykes stated his case in vain. As he started back to the dugout, he spotted the fourth and senior member of the umpiring crew, Jocko Conlan, and appealed to him.

"Jimmy," answered Jocko, "I don't even know what this is all about."

"Join those three over there, they don't know what it's all about either." Exit Jimmy Dykes.

It isn't the name-calling or the shouting contests that make the sharpest points on the field. It's often the soft squelch heard by only a few.

George Strickland took a pitch low—at least he thought it was low, but then he heard, "Strike two!" He stepped out of the batter's box and started for the dugout.

"Hey! where you going? It's only strike two," said the umpire.

"I know," said Strickland. "I brought the wrong club, and I'm going back to get a wedge."

Ken Burkhardt got his baptism early in his big league umpiring career from catcher Ed Bailey of the Cincinnati Reds. After hearing Ken call the first pitch a ball, Bailey philosophized, "Well, you won't have that perfect night tonight."

Dusty Boggess always had his Texas wit to top a situation. Clyde McCullough, Cub catcher, was the hitter.

"Strike three!" Dusty proclaimed.

"You missed it," said Mac quietly, walking away. "That was a ball."

"You know, Mac, for twenty years as a player I thought that was a ball, too, but it's a strike, so I went to umpiring."

John Fitzpatrick, coach with the Milwaukee Braves under Fred Haney, tells about an umpire that left him speechless. He was in the Dodger organization, managing Newport News in the Piedmont League. The opposing pitcher, according to Fitz, had balked. Fitz tried to convince the ump to call it. "It isn't a balk," the umpire told him.

"Well," pleaded Fitz, "that move is at least half a balk."

"I'll buy that," said the ump, "and I'll send your runner halfway to second."

Nick Altrock, coaching for the Washington Senators, always had an answer for the umpires. The late Bill McGowan told this one. Several calls had gone against Washington, and Altrock had discussed each one with McGowan. In the sixth inning a foul ball was hit into the stands. McGowan looked back and saw a woman being carried out on a stretcher. He asked Altrock, coaching at third, if the ball had hit her.

In a voice loud enough to be heard in the next county, Nick yelled, "No! You called that last one right, and she fainted."

The benches are constant sources of irritation for the umpires. I have heard more than one umpire say that a guy playing has a legitimate beef, "but I ain't taking nothing from that loud-mouth on the bench who plays once a year and is on the club because he's got a good pair of lungs." It is like the sniper you can't see. The umpire can't know the voices of all the players. Besides, the players disguise them. In some dugouts, like St. Louis, a bench jockey can hide under the bench. You can hear him, but can't see him. If the umpire tries to find him, he is accused of having rabbit ears. Looking into the dugout after a good needle has been given, the umpire sees a picture that could go on a Christmas card—twenty-five grown men looking like twenty-five angelic choirboys.

If it is his team that is doing the jockeying, the catcher re-

mains silent. If it's the opposition, he repeats the phrases to make sure the umpire doesn't miss any.

Clearing the bench is a drastic move. When it is necessary, it clearly indicates, says Larry Goetz, that the manager has lost control over his players. Goetz believes that managers should be ejected before players. "People come to see the players. Nobody ever bought a ticket to see a manager. If you put a manager out while his team is winning, it really doesn't matter. And if you put him out while his team is losing, it often strengthens the club."

Among the many complaints against umpires is that they let some players get away with things they won't take from others.

Johnny Temple, the Cincinnati second baseman tells about one of his very first times at bat. "Larry Goetz called a strike on me, and I let him have it good," says Temple, "and he told me I was out of the game. That really burned me up and I asked him why he let other ballplayers argue but throws me out. Goetz answered, 'I don't mind it when the lions and tigers get on me, but when the nits and gnats get on me, it's too much.'"

A good umpire umpires the ball, not the player. The umpire doesn't care if a black arm throws it to a Catholic catcher to fool a Jewish hitter. The strike zone "is that zone over home plate which is between the batter's armpits and the top of his knees when he assumes his natural stance." With every hitter the strike zone may change, but never because of his record, disposition, previous experience, race, religion, or color.

Quick to think. Slow to anger. The mechanics of umpiring can be learned and is the easy part of the job. The umpire's approach to the game, his poise and his understanding of human nature are the important things. If any of these are lacking, he might as well buy a ticket and sit in the stands.

The umpire must draw the line at the right time so the word spreads around the league, "Leave him alone, he's a good umpire." If he draws the line too soon, he becomes a chip-on-the-shoulder, rabbit-eared umpire. If he draws it too late, he is known as a guy you can push around. It's a tough climb for the young umpire in the big leagues, a day-by-day, decision-by-decision climb, judged by all the players and the grapevine. The big league umpire reputation is made in about three years. All the plays are covered by then, and the umpire's reaction is well tested. The umpire can gain the respect of the minor league player in a year, but the major leaguer waits. The major leaguer weighs and waits, for he must help the umpire draw his line.

President Giles of the National League believes that five years' umpiring experience in the minor leagues is needed to season a major league umpire. In that time, every play in the book should have happened and every situation possible have been covered. *Baseball Register* also shows that most major league umpires were professional players, at least in the minor leagues.

Almost every umpire will come up with the same answer when you ask, "What makes a guy want to become an umpire?" They will tell you they love baseball and want to stay in it. The former major leaguer, the minor leaguer who never had that "cup of coffee" in the major leagues, and the fellow who didn't have the ability to play but wanted to cross those white lines—they're the ones who take the blue suit and a lonely life of abuse.

The pay is pretty good. The rookie umpire gets $7,000 his first year, about $2,500 a year on the expense account, and at least $50,000 worth of advice. The National League allows the umpire $20 a day expenses, out of which come his hotel, food and incidentals. The salary goes up to $16,000 and, in some cases, higher. The umpires have their own pension fund.

However, it's not all gravy. He buys four uniforms, two for behind the plate and two for on the bases, at between $75 and $100 each. They last about three years. (The lightweight uniforms are furnished by the league.) Other equipment expense runs like this:

Mask	$11.00
Shinguards	10.00
4 caps, $3.50 each	14.00
6 Black Ties, $3.50 each	14.00
6 to 8 White Shirts, $3.50 each	28.00
Shoes (behind the plate)	22.00 to 27.00 a pair
Shoes (on the bases)	18.00 to 25.00 a pair
Socks, $2.00 pr.	24.00 (buy 'em by the dozen)
4 suits long underwear, $3.50 each	14.00
Ball and strike indicator	1.00
Chest Protector	27.00
Whisk Broom	1.25

So it costs you $500 or so before you walk on the field.

One of the big items of expense for the umpires is the baggage tips. When a cab load of umpires pulls up, the bellboys get busy somewhere else. Each umpire has at least two bags, one with his umpiring gear in it, the other with his street clothes. Almost for survival the umpire becomes a good tipper. It comes to about $7 per city, twice a week, or $14 a week in tips.

My former roommate with the Cardinals, Ken Burkhardt, turned to umpiring. As a pitcher he had limited ability but unlimited determination.

"I was released by Oakland of the Pacific Coast league and took a job in a tool and die factory for $2 an hour," Burkie told me. "Good pay, but I wasn't happy. I wanted to get back into baseball. I wrote George Barr (former National League umpire in charge of umpire recruitment) for his honest opinion as to whether I was too old to make it back to the big leagues as an umpire. I was thirty-five years old then."

Burkie started in the minor leagues, and from 1952 to 1957 every play in the book must have happened as he saw baseball all over again, through the eyes of an umpire. One night he came out of the Class D Sanford, Florida, park and found sand in the crankcase of his car, and he knows what it's like to be escorted from the park under police protection. But he made it back to the major leagues, because that's where he wants to be.

At the Polo Grounds, one of the first places he visited upon his return to this country, General MacArthur stated: "It is wonderful to be here, to be able to hear the baseball against the bat, ball against glove, the call of the vendor, and be able to boo the umpire."

For many years Dolly Stark was a top umpire in the National League. His reason for retiring was this: "I'm sick of being in a public profession in which the greatest compliment I can receive is the silence of the crowd," he said. "An umpire can work a perfect game, call every play right and get by without one beef and not one fan can tell you his name ten minutes after the game. Or an umpire can work a perfect game and be in a rhubarb even though it be an unjust squawk and everybody in the park will know his name." That's the way Dolly Stark felt, and he quit.

Ban Johnson, the pioneer American League president, had this definition of an umpire: "A good umpire is the umpire you don't even notice. He's there all afternoon but when the game is over, you don't remember his name."

The umpire is a loner. It has to be that way.

CHAPTER ◆ *EIGHT*

The Heartline

She gets him back after the game.

While he is on the field, he belongs to the club. At some ball parks she sits by herself. (At Wrigley Field the wives of the players are scattered through the stands on the theory that it isn't good for the ball club to have them watch the games together.) At most others she sits in a special section with the other baseball wives. (At Busch Stadium, the Cardinal wives sit in Section P, overlooking the Cardinals' dugout.) She is in the stands, because he is on the field. Whatever he may be to the other people out to see the game—star, regular, bench strength, fading hanger-on, rookie, a hero on a bubble-gum card, or the bum who kicked the game away—to her he is a man with wants and hurts, fears and anxieties.

You should be able to recognize baseball wives easily, because, though I say it with prejudice, they are the most beautiful of any group of women. They are a real cross section of American girls, from the high school sweetheart of Stan Musial to the starlet wife of Andy Carey. Nurses, dancers, musicians, secretaries, schoolteachers, athletes and, especially

since the ball clubs have been doing a lot of flying, a good many airline hostesses—they have all traded in what they were for the title, Mrs. Baseball Player. As such, they take on the status of their husbands—star, regular, bench strength, hanger-on, or rookie. As the player goes, so goes his wife.

Whatever her status, being a baseball wife makes her a member of a society with certain rules she has to live up to. Though these rules are not written anywhere, she reads them. Though never spoken, she hears them. Though never taught, she learns them. Breaking these rules can affect what happens between the foul lines. By observing these rules, Mrs. Baseball Player becomes a member of the ball club, without even taking batting practice.

The rules would go something like this:

"Say about other players only what you want to hear about your own."

"Don't let the ups and downs of your husband's career, or the way he is going on the field at any given time, affect your behavior."

"No error is funny, because your guy has 154 games a year in which to duplicate it and maybe make a worse one."

"Fans may upset you, but as long as he is on the field, he belongs to the club and the game, not to you."

"Trades are made by the front office. Though good friends are leaving, the merits of the trade belong in the front office. No trade is ever approved by *Good Housekeeping*."

The life of the wife of the twenty-game winner, or the .300 hitter, is the happy one. The paydays have been healthy and regular for a long time, her husband plays every game, and every night seems like Academy Award night. The biggest question may be deciding what products we endorse this month. These wives of the stars become the natural leaders of the baseball wives' society. They must be careful not to form a tight clique, or the ball club could find itself in a struggle

between the high rent district and the middle class instead of one for the pennant.

Most of the wives of the stars are as good for the ball club in their way as their husbands. It is these wives who get the birthday parties going, the wedding presents chosen, and the baby showers organized. Though the name Stan Musial always rings a true bell, it must have rung louder and truer to Tom Glaviano, then a rookie with the Cardinals, when his wife told him that Lil Musial organized the baby shower for little Tommy. Many a lonesome rookie wife gets the telephone invitation from the star's wife to come on over and play cards while the boys are on the road. She puts down the phone and makes the silent promise: "If I am ever in a position to do that, I will."

The majority of the baseball wives are in the category of the journeyman ballplayer, or bench strength. Mrs. Baseball Player's husband is, most likely, a well-known player who has been on several clubs and does not play every day. He could be the star on the downhill ride, or the promising youngster who never quite made it to the top.

This baseball wife finds the going toughest. Can it be that the manager doesn't realize what a great player my husband is? How can he play that dumbo instead of my husband? How can he play that inexperienced kid instead of my husband? How can he play that old man instead of my husband?

Every game is a grab bag for her, because she never knows when he will be playing. When he does play his one game in a week and has a bad night, she shares his mood with him and knows what went wrong and why. When he plays that game and has a good night, she joins the celebration, and she knew it all the time. The key base on balls as a pinch-hitter takes on the importance of a grand slam home run. Even a hard-hit foul ball becomes a cause for some cheerfulness.

To the baseball wife in this category, the two most im-

portant dates are May 15 and June 15, and neither one commemorates a birthday or an anniversary. May 15, the first survival, is the official date for the roster cutdown. ("We made it!") June 15 is the last day for trades, the second survival. Once by this date, you send out the laundry and it's okay to pay next month's rent. ("We will probably stay all year now.")

For the veteran hanging on, baseball seems to be a game that's always played at midnight. The park is never as bright. Each pitch takes longer to make. Each time at bat is a production. The scales are tilting. You try to hold on to it, but you know you got a round-trip ticket to the big leagues when you came. You know that your base hits are fewer, and that your birth certificate is the first thing they talk about in the executive meetings. You've gone from a complete ballplayer to a one-third player. If you pinch-hit safely, you need a rookie's legs to run for you. As a relief pitcher you can't go every day, and they save you for one man. It's tough to hold a winning hand when the odds are 425 to 1. Though all this is felt and known by those who wear spikes and swing bats, it is just as well known and keenly felt by those who wear pancake make-up and fingernail polish.

The most feared, yet the most expected, event is the notice of the unconditional release. This is the return half of the round-trip ticket. When it happens, the front office tells the press that now you have a chance to make a deal for yourself, but you know that most clubs have passed you up or you would have been traded or sold. Knowing the unconditional release may come any day, Mrs. Baseball Player watches the game from her regular seat in the wives' section. The friendly smile is that of a .300 hitter or a twenty-game winner. . . . Don't let the ups and downs of your husband's career influence your behavior.

For the rookie breaking into the big leagues, every game is

played under a bright sun with the flags waving and the Star-Spangled Banner playing between innings. It's the Mardi Gras and the home-town carnival all wrapped up in one, with every ride on the merry-go-round a cinch grab of the brass ring. For his wife it is the same merry-go-round whether she is from the big city or from where the city-limit signs are back to back. In this strange land of headlines and box scores the young wife tries to be the perfect wife. Whether she is a newlywed or a minor-league-trained veteran, the new life adds, multiplies, and divides into the first chance to make the big leagues.

The first big date in the rookie wife's career is when she goes North to the club's home city. Maybe she is a big-city girl who makes her own plane reservations and travels with a poodle, or maybe she is a Spanish-speaking rookie's wife who has to make it North without being able to speak any English except: "Fairgrounds Hotel . . . ham and eggs, please . . . Husband here in one week. . . ." Either way, she's a major leaguer for the first time. The next big date is May 15, which is cutdown date. (Only the supreme egotists among the rookies even think about being included in any trades, so he and his wife are not much concerned with June 15, trade deadline.) The first year is a tough one. First, it is living out of an anxiety-filled suitcase in Florida and then it's trying to find and make a home away from home with only a temporary card in the sorority.

For some, finding a home and getting settled, knowing you might have to pull up and do it all over almost any day, is a challenge, an experience to take in stride. To others, it's like always being in enemy territory, camping out. Still others are just plain homesick.

"For the first month I was in Los Angeles, I cried every day about wanting to go home," Joan Hodges told Milton Gross of the New York *Post* after the Dodgers had been moved out of

Brooklyn. Even though she was the wife of a regular, a star, she was going through her rookie year as far as changing homes was concerned. She had met Gil in Brooklyn while he was with the Brooklyn Dodgers, and there had been no moving around, never a hunt for the new friends. Road trips passed easily because she was home, her family close by, a telephone call away.

"Long Beach didn't seem home to me, not when I couldn't call our family doctor if the children got sick or if my family couldn't come when they were needed," she told Milt. "I felt all alone and when Gil would come home with troubles of his own, I didn't help by adding what I thought were mine."

When Joan Hodges realized that she was hurting Gil on the field, she punched through, and I can't help but be a rooter of hers. I believe what Milt Gross wrote: "Each of us is affected by the stresses and strains not only of his own business but what happens at home, whether it's one of the kids who fell out of a tree and broke his arm or a wife with the miseries."

"My wife can ride with the mood," Larry Jackson once said. "She can pump my heels when I'm going bad without the rah rah. If I need it, she can really put the needle in to let the air out of my balloon."

There are some wives who would make the frontier women of old look like they had tired blood. Into spring training they drive with a carload of kids. Then drive the big trip North and have the house all set up by the time husband ballplayer gets there. Virginia Munger, wife of pitcher George Munger, would be the leader of my wagon train. Her motto was, "Never mind the mule being blind, load the wagon and yank the line." She would organize the wives' automobile caravan back north. And plan everything—what time they left and where they would stop along the road.

The big job of Mrs. Baseball Player is being housewife and mother in a life that is more topsy-turvy than most. The base-

ball wife has to be a combination cook, waitress, house detective, and secretary with an "Open 24 Hours a Day" sign hung around her neck.

For the greater part of the week, the schedule calls for night games, which means Daddy gets home late for a snack during the post mortem. The usual time, win or lose, that you rest your case is about one o'clock, two hours after the game. Her day ends the same time as her husband's, but it's up with the children in the morning to be house detective and cook. During the morning hours, she must keep it quiet so he can get his proper rest. (There are no coffee breaks or snooze periods between the foul lines. Or, as Frank Lane has put it, spectators are not allowed in the batter's box.) So it's breakfast for the kids at eight, and about ten or ten-thirty it's breakfast for the champion. (If there are any telephone calls, she is the secretary.) At noontime, the kids want lunch, but daddy just ate breakfast so he skips it now. If he is a regular, he eats about four in the afternoon. If he's an infielder or outfielder, she can fix the same supper for all. But if he's a pitcher and he's scheduled to work that night, she will probably come up with a small steak and salad for him and hamburger hash for the rest. Pitchers, more than others, have a set routine as far as what they do on the day they pitch. With some it's a set time for the main meal and a nap after, with others it's a nap before the meal. There are only so many starts and so many pitches in an arm, and he must guard his time in the big leagues. Fred Haney, a great manager, says, "You don't play baseball, you work at baseball." The true baseball wife knows that baseball is not a game when your paycheck depends on your man's ability to perform.

Once the player is off to the ball park, it's suppertime for the kids. Once that is out of the way, there are two routes to go. If it's out to the park, she either gets the kids ready to go with her or she waits for the baby-sitter. The latter is more

usual, because it gets late before the game is over. The regular wives make it to the park more often than the pitcher's wife, who usually goes out only when her husband is scheduled to work. Other nights she follows the club by radio or television. In any case, time at the ball park is largely determined by the number and age of the children.

The routine changes for a day game. With starting time usually at one-thirty, there is just time for breakfast before the man leaves. On Sunday, it's always a day game, and to many it is the big rush-rush act of the week. Get the kids dressed, off to church, breakfast for Daddy . . . see you after the game. A double header means the next meal might be at nine o'clock that evening. If the kids go to the game, and day games they usually do, the concession stands take care of lunch. After the game is the big meal. A victory will make an old shoe taste like a filet mignon, but when you are knocked out in the first inning or your error let the winning run score, a filet will taste like it has been breaded with Bon Ami.

The baseball wife must also be a secretary and public relations director. She has to handle the local program chairman who promises, "We'll give him a good meal, if he will talk to the church meeting," and she has to be nice to the salesman who wants to sell him part of an oil well or a body-building gym set that will guarantee the Hall of Fame.

The moods get long and the tempers short in the life of a baseball family. The wife must slip in and out of these moods. After the first year, she takes a more professional view of the game of baseball. The rah-rah talk after a tough loss is replaced by the idea that if you lose today, you win tomorrow and try to win the next day. Meanwhile, her housewife duties become a breeze, she learns to make friends faster than Dale Carnegie, she answers the interviewers as if she wrote the last

Stengel speech, and she organizes and moves quicker than any teamster. She has to.

After Lew Burdette won three games in the 1957 World Series, cars, banquets, parades were his. Proudest among his many admirers was his wife. You can bet, though, that Lew knew who the real hero was when he learned the story of the eye injury his youngster suffered during the Series. "I knew he had enough to worry about with the Yankees, and we were already doing all we could," Mrs. Burdette said, explaining why she handled the emergency without his knowledge. It may have been the biggest single contribution to the Milwaukee victory.

Once when the Peewee Reeses' daughter Barbara was very ill, Mrs. Reese didn't tell her husband about it. "What good could it do? What could he do? Besides we were doing all that could be done," was her explanation for a solitary battle. Mrs. Baseball Player knows that it's easier to think about curve balls and double plays when there are no family crises to worry about.

Wins, losses, runs, and hits are important when you work at baseball, but the baseball wife is interested in baseball mainly because baseball happens to be her husband's way of paying the bills around the house. Baseball becomes her life and her job, too.

There is the standard story about the veteran who comes home from the park all smiles and says, "Go ahead, ask me what I did today. Go ahead, ask me. . . ." Smiling, Mrs. Baseball Player says, "What did you do today, honey?" Puffing a bit, "We won 5 to 4, I went to bat four times, got four hits, two home runs, a double and a single, drove in three runs and scored the other two."

The next day without waiting for the cue, she comes with it again: "What did you do today, honey?" "Listen," he tells

her, "you do the cooking, and I'll take care of the baseball in this family."

The jockeying improves as the baseball years go on. Fern Furillo, wife of Carl of Dodger fame, was having lunch out one day with her husband. They both chose corned beef and cabbage, but a big side order of carrots was also brought in.

"Carrots are good for your eyes, aren't they honey?" said Fern as she dumped a big pile on his plate where she figured they would do the family the most good.

Without breaking stride, Carl said, "They might be good for my eyes, but they won't straighten out the curve ball."

Diet is important to the player, especially if he has a tendency to overweight. Bob Bauman, the great trainer, goes directly to the wives for help. Without the player's knowledge, the diet is set. Between meals eating is out because she says so. He may complain, but she has the answer.

At times she must play trainer. There just isn't enough time at the ball park to treat all injuries. No injury is a trivial one, and once in that game you are expected to put out to full capacity. The visit with friends or the night out has to be given up to stay home applying hot towels. Don Newcombe's wife spent the day and night before a World Series game applying hot packs to an ailing arm.

One of the first things said by almost every injured player is, "Call my wife." When I suffered a serious injury in 1950 in a collision with Jackie Robinson, I could think only of my wife. She was at the park, but at the time we were expecting our first child. All I could think about was her falling in the excitement and injuring herself. But the "colony" chipped in. Lil Musial took hold of Audrie and accompanied her down the steps to the clubhouse.

While broadcasting in Ebbets Field, I saw a rookie pitcher, Tom LaSorda, get spiked covering home plate. While the trainer was working on him, I took a look at the wives' section.

Though I had never met Mrs. LaSorda, I could pick her out. The hands twisting the handkerchief and the face trying to hold back the tears could only belong to Mrs. LaSorda. To the rest of us as fans, the injury didn't appear to be serious. To her, it was his first chance to make a major league pitching staff. "He's waited a long time to get here. Will this be his last chance? If he's out too long, they may not start him again." Your time is measured. The biggest worries of the baseball family are injuries, physical deterioration, and trades that change your whole life.

The day I was traded from the St. Louis Cardinals to the Pittsburgh Pirates in 1951 was the day that the foundation for my newly-bought house was poured. Red Schoendienst went from the Cardinals to the Giants the day after he bought a new house. There is no protection, even though you ask. Bill Sarni of the Cardinals asked Frank Lane, then general manager, what his prospects were and was told he was in St. Louis to stay. The day after construction was started on his new house, he was traded to the Giants. The "can't turn down trade" shows up, and you are gone.

In 1951, after my first trade, I reported to the Pittsburgh club, and my wife stayed in St. Louis the rest of the summer. I was fortunate in that I was able to visit my family when we played the Cardinals.

In 1952 my family moved with me from St. Louis (my winter home) to Pittsburgh. Luckily we stayed all year, and I needed my family that year. Remember, it was the ninth year of Mr. Rickey's five-year plan, and we lost 112 games out of 154. I needed the comforts of home.

"Trading is rough on a man's family," said Dick Littlefield, one of the most traded players of big league history. In February of 1952, Dick went downtown to get a railroad ticket from Detroit (his home) to Burbank, California, the spring training site of the St. Louis Browns, to which he had been

traded from the Chicago White Sox two months earlier. On his way to the railroad station he stopped at his sister-in-law's house and learned from her radio that he had just been traded to the Detroit Tigers. Had he left a day earlier, he would have spent half the spring trying to get to the right club, since the Detroit team trained in Florida.

When he was traded to Pittsburgh, Dick and Mrs. Little-field found and rented a house and stocked it with groceries. They put their daughter in school and settled back. The next day, he was traded to the St. Louis Cardinals, and the little girl had only one day in her new school.

"I got the family to St. Louis where we stayed in the hotel a week before I found a house," Dick tells the story. "I was in the house about ten days when Frank Lane traded me to the Giants. With two months' rent down the drain, I went from St. Louis to New York, while my family went home to Detroit."

Usually there is someone in the front office who helps the new player and his wife find a good place to live. In St. Louis, Mary Murphy, the official housemother of all St. Louis Cardinal rookies, does it. "This isn't the type neighborhood for your family," she says. Or, "I saw this house myself and it looks nice, go see it." These are familiar phrases from Miss Murphy. The interim is usually spent at a hotel near the park, where the players get special rates.

At the ball park, the conversation between the wives runs anywhere from a visit to the dentist by a youngster to a new recipe for meat balls with seams. Their pet peeve is the loud-mouth fan who thinks his wisecracks make him Joe E. Lewis and Jack E. Leonard in one. He is a nuisance to all but especially to the baseball wife. If he is not talking about her husband, he is talking about a friend's husband. Some of these fan comedians purposely sit near the wives to taunt them, but

they ignore them. (Fans may upset her, but as long as he is on the field he belongs to the club.) These fan comedians who don't soon become discouraged by being ignored are usually ushered away.

Many a baseball wife has had fun with the ballpark Romeo who uses statistics and his vast knowledge of baseball for an intro. During an especially rough time for me in the 1948 season in St. Louis, my wife, then my fiancée, was sitting next to one of these statistical Rubirosas. "That Garagiola stinks," he kept saying. Audrie would ask why. The reasons I was a bum flowed out of him. All this while, he was operating. As soon as the game was over, he turned confidently to my fiancée and said, "I sure enjoyed sitting next to you. Will you join me for a drink?"

"I can't," she told him. "I have to meet my fiancé, but why don't you come with me? You know him—Joe Garagiola."

Many wives were not baseball fans before they met their husbands. You frequently hear a player say, "My wife didn't know anything about baseball until I married her." Now you find that she is talking intelligently about hit and run plays and about hitting behind the runner. The day of the wife walking into the nothing-nothing game in the sixth inning and saying, "Oh good! We haven't missed a thing" is over.

The wife of pitcher Ned Garver would sit in the stands and keep careful statistics on her scorecard. Every home game he pitched, she would keep score and make notes, what kind of pitch the batter hit, the count when he hit it, and where he hit it. The wife of Clem Dreisewerd, a left-handed pitcher, could put on a catcher's mitt and put him through his paces.

Marv Grissom, the fine relief pitcher, once held the upper hand over what and how much his wife could say, but he had the shield of an umpire going for him. In 1939, while playing semi-pro ball in his home town of Red Bluff, California, he

was picking up extra money umpiring around town. One of the games he worked was a ladies' softball game. In the sixth inning, with a chance to go ahead, the best-looking player came to bat. "I couldn't help her, though," Marv recalls. "She took three pitches, and on the last one I called strike three. She turned around and really gave me a blast. I finally said, 'Listen, meet me after the game. I'll buy you a Coke, and you can really tell me all about it.' She met me, and I lost the argument, but I won a wife."

Wives aren't as superstitious as you might expect. Or maybe they fear that by telling about their superstitions they will break magic. Mrs. Bob Friend, though, made no bones about hers. "When he wins, I wear the same dress until he loses. Then I won't wear that dress again when he pitches." Nancy Kiner, Ralph's wife, always wore her lucky earrings to the games. They were gold number 4's, Ralph's uniform number. Mrs. Alex Grammas passed out candy on a night the Cardinals won. She had to bring the same kind of candy until they lost, and it was a week before the spell was broken. Same seats, same inning for the hot dogs or Cokes, same lucky pencil—these are a few of the favorite lucky doings in the baseball wives' section.

Luck is the residue of design, says Mr. Branch Rickey. This quite possibly is true, but the baseball wife wants to help all she can any way she can. She is a big factor in her husband's career. There are some players who played beyond the licensed time because of a helpful wife. There are some players who left part of the time unused because she couldn't meet the standards required. It's the player's day in the sun, and she is glad to watch, but it's the time when the lights go dim that she wants to share.

EDITOR'S NOTE: We asked Joe Garagiola's wife, Audrie, what it is like to be Mrs. Baseball Player. At the time, she was

the organist at Busch Stadium, a job she took on about the time Joe became a broadcaster. This is what she told us:

For the last four seasons I have watched the Cardinals from the organ booth, high atop Busch Stadium, where the pigeons fly, the breezes blow, and the game of baseball once again seems like a game. To most people that's all baseball ever is, just a game. The sun shines, the music plays, the fans cheer, and everybody has a good time at the old ball park. Now I play the music, I cheer and applaud. I'm a fan.

But once I watched the Cardinals play from Section P of the grandstand. You know it's a funny thing. The field looks just as bright, the grass just as green, and the seats are just as comfortable, but it's a different game that you see.

Base hits, home runs, errors are part of the game. Sure they are. So he struck out with the bases loaded, and they lost the game. So it could happen to anybody! . . . But you know it's going to be a long ride home, because you can't tell him that. You can't tell him it doesn't make any difference, it's only one game. He knows nobody gets a hit every time up. But he also knows that they lost the game because he didn't get a hit that time up. So it's a long ride home, and your dinner doesn't taste too good that night. But the next day he feels better and he knows he'll get four for four, and maybe he does and the team wins the game. That night the leftovers taste better than the $4.50 steak.

"Did I tell you that Mary Ann tied a string to her loose tooth? Joey started the second grade today, and when he left for school this morning. . . ." This is the kind of conversation you might hear in Section P, for players' wives don't talk about baseball at the ballgames. They talk about their homes, their children, or a new dish they tried for dinner that evening. But ballplayers' wives think about baseball. If her husband is the pitcher, she might be laughing and telling the girls about some funny thing their baby did that day, but you can

bet the palms of her hands are damp when there's two men on and nobody out. If you watch closely, you'll see her take it with every base hit those lucky guys get off of him.

Maybe she didn't go to the game tonight. The baby is cutting a new tooth, and she didn't want to leave him so she listens to the game on the radio. It's been a close game. Now it's the ninth inning. The score is three to two, favor of the Cardinals, but now the tying run is on first base with two outs. The announcer's voice rises in excitement. "There's a drive, deep into left center field, the tying run is rounding third. It's going to be close. HERE COMES THE THROW . . . HE SLIDES . . . HE'S OUT ! ! ! CARDINALS WIN ! ! ! CARDINALS WIN ! ! ! But wait a minute, folks, the catcher is hurt on that play, he hasn't gotten up yet, here comes the trainer running out to take a look. . . ." Her husband is the catcher, and she'll hold her breath with an ear glued to that radio until . . . "He's okay, he's up on his feet now and he's walking off the field under his own power."

This baseball is many things to a ballplayer's wife, but certainly it is never dull. You are never quite sure just where you will live. In fact you are never sure you will finish a season in the same town in which you start it. Trades are a part of baseball. Everyone in baseball realizes it, yet you are never really prepared when it happens.

I remember the time in 1953 when we were with the Pittsburgh Pirates. After much difficulty we had succeeded in finding an apartment, moved in, and were just about getting settled. One evening we were having three of the ballplayers, whose wives had not yet arrived in town, over for a dinner of genuine Dutch-Italian spaghetti and meat balls. Around noon I went out to do my shopping, returning in time to switch on the radio and hear the starting line-ups being announced. It was the Pittsburgh Pirates versus the Chicago Cubs. When I heard Bob Prince, the Pittsburgh announcer,

say the Cubs battery would be Bob Rush and Joe Garagiola I was certain that Bob had made a mistake. Then I heard him announce Ralph Kiner in left field for the Cubs. He must be flipping his lid. Joe Garagiola catching for the Cubs and Ralph Kiner playing left field for the Cubs! But there it was, the big trade had been consummated just before game time. We were now Cubs.

Joe had tried to call me before the game started but I was out shopping. The state of confusion that followed was something to behold . . . from a safe distance. The Cubs left that night for New York, and the players involved in the trade wouldn't have to report to the Cubs in New York until game time the next day. That gave us an extra six hours. We must have set some kind of a record stuffing suitcases and trunks, getting plane and train tickets, and making arrangements to get our car driven home. We traded apartments with one of the players from Chicago (Gene Hermanski), but since the Cubs were just starting on a three-week road trip, it seemed useless to go to Chicago. So when the dust settled around four A.M. the next day, our two-year-old son and I took off from Pittsburgh for St. Louis, Joe was heading for New York, and all our worldly goods were en route to Chicago.

But that's baseball and nobody knows it better than the ballplayer's wife. Though it is sometimes nerve-racking, sometimes heartbreaking, I'm sure there isn't one baseball wife who would rather be anything else. Sure she's proud of him when he has a good day, but she's proud of him if he has a bad one, too, because being up there in the big leagues makes him a pretty special kind of a guy.

The Social Security Numbers

I. *Of Scouts, General Managers, Schedule Makers, Groundskeepers, and Others Behind the Scenes*

The only numbers some baseball people have are social security numbers. They are the men and women you get to know only when you have gone through the clubhouse doors. They are a real and big part of baseball, but they never have a "day" at the ball park, and their names might as well be written on a snowbank. Baseball is a game played with twenty-five men on each side, but it takes more than 400 people to put on a major league game. So let's take a look behind the scenes. Baseball games begin when the umpire says play ball. Baseball begins with the scouts.

There never has been a day for Tom Greenwade, who discovered Mickey Mantle, and Joe Mathes is a social security number except to the pennant winning players he signed. But Frank Lane, the dynamic general manager who has an opinion on everything, believes that the scout represents at

least sixty per cent of the success of a ballplayer—and, there-fore, the club. The ball club supplies forty per cent by a sympathetic front office, proper coaching and handling by the manager and coaches, and the attention of the other men that make up baseball—the trainer, team physician, club-house attendant, etc. The sixty per cent begins with an intangible. Can he run fast? Can he throw hard? Can he hit with power? These can be spotted. Does he have the in-tangible?

Burleigh Grimes, one of the all-time greats, says that he could scout with 100 per cent accuracy if he could see a youngster and look into his heart. "That's what you've got to know about a boy and that's what it often takes longest to learn. There's no substitute for heart," is the way Burleigh puts it.

Scouting means dealing with the human equation. There are many former major leaguers scouting, but being a major league player does not automatically qualify you as a scout. A baseball scout has to be a man of patience with the detec-tive abilities of Sherlock Holmes and the persuasive powers of a super-salesman.

Every scout, as I said earlier, has his own private network of assistants, called "bird dogs." One could be the high school coach, another the gas station attendant who manages a semi-pro team on Sunday, a third the retired country banker who likes to watch sandlot baseball. Upon spotting a likely prospect, the bird dog notifies the scout and gives him a schedule of where and when the "find" will be playing. The scout comes in to take a look. At first he may be the only scout on the scene, but the word usually spreads. Next game more scouts are looking, but the original "bird dog" usually gives his scout an in. Now the patient, sympathetic scout follows the kid all the way. Through school, through amateur games, practically living with him for the word of assurance

that he'll sign with him. Then comes the time for the signing. (No boy can sign a professional contract until his high school class has graduated.) The heartbreak clause in the oral agreement is often invoked when the kid signs with another scout who offers more money.

Get down to the final moments, and the scouts develop new talents for any situation. Walter Shannon, Cardinal supervisor, tells how he was once drying dishes and talking to the mother of a boy while another scout was out back chopping wood and talking to the father. Who signs the boy? Usually the scout with the biggest money offer.

Most scouts agree that the toughest part of scouting isn't finding the talent, it's signing it. Lenny Merullo, now a scout, says that sometimes the parents are the toughest of all to sell. They can make it or break it. "I remember how I signed Moe Drabowsky. Moe, his mother, father, sister, and I flew to Chicago to sign the contract on the boy's twenty-first birthday. I knew the White Sox would be trying to get him, too. So I told the cab driver at the airport to swing out to Comiskey Park. This way we had to go through the worst part of town, the stockyards, and slums. Moe's folks were horrified at the thought that their boy would have to be driving through this every day. Then we took the scenic route to Wrigley Field, along the lakefront. That eight-dollar cab fare was a good investment."

No two scouts operate alike. Every sandlot game is an opportunity to find a player. Tryout camps have turned up many players. Some scouts concentrate on discovering raw talent. Some super-scouts, the aristocracy of scouting, watch only major league games and recommend possible trades. If a big bonus is involved in signing a young player, the super-scout is usually called in to pass final judgment.

Frank Lane puts scouts into the following categories: The Yes-and-No Scout; Good Old Days; Quantity; The Loner;

Eavesdropper; Diplomat; Figure Filbert, and the Scout With Nerve.

The Yes-and-No Scout finds his man with qualifications. His find can hit like Babe Ruth (hit with power); throw like Willie Mays (good arm); and run like a scared jackrabbit (fast). "Of course," he adds, "I didn't see him hit too many curve balls." If the phenom flops, there's his out. If it's a pitcher, Mr. Yes-and-No gets off the hook with the mystery pitch of baseball, the "other pitch." Let the boy get hit hard, and he says: "He's got good stuff and his curve ball will get him by, but I told you he needed the other pitch to make his regular stuff look good." The rap goes to the organization for not teaching him the other pitch.

Frank Lane's other name for the Quantity scout is Joe Volume. He signs most anybody on the theory that in quantity there is bound to be some quality. One of his finds, he'll say, is the best of the lot. Lane will ask if he means the best of a good lot or the best of a bad lot.

The Loner is a good scout. He doesn't want any help and expects a blast when the phenom doesn't work out. He sees the ballplayer, makes up his mind, brings him in, and makes his recommendation. Then he has to be convinced that the boy doesn't have it. He is a good scout because he has ability and courage. "Three out of five times I go along with the Loner," Lane says.

The Diplomat spots his man and then double-checks him with the other players. Teammates know a player best as to his "heart." The diplomat is friendly with all. By asking about every player, he gets the information on the one he's looking over and then proceeds to scout the ability. He talks to so many players that even his own organization doesn't know who he's scouting until he brings his man in.

The Eavesdropper has to be a good actor with rabbit ears. While reading the paper, he hears the pitcher and catcher

put the rap on the shortstop. He asks a few questions, but mostly he listens. It's the hard way, and often he is the victim of fake conversations held within earshot. The Mickey Mantle he is trying to find turns out to be the house detective.

Figure Filbert is the Univac of scouting. He gets all the figures on a boy, and then he is sure that this is it even though the boy doesn't look like he can do it physically. Filbert's theory is that figures can't lie. The trouble is he doesn't weigh such things as differences in age, types of competition and other factors. The kid hit .786 in twenty games with forty-two home runs, and he's got to be good. The kid might be twenty-three years old and playing against Little Leaguers, but "on paper he can't miss."

Good Old Days according to Lane is the guy who never heard of the big bonus. When he recommends a boy for a $10,000 bonus, you can assume it is safe to go up to $100,000.

The Scout With Nerve is the best. He can spot a kid and, though there may be an apparent weakness, he can tell how far this boy can go. He weighs everything and then makes his recommendation. He doesn't go for quantity and he's not a Yes-and-No guy. The pet expression is, "He can learn to do the other things. He's worth every dime of it."

Concluding his observations on scouts, Frank Lane says, "I'd rather have two good scouts than two minor league farm clubs. Good scouts can dig up talent; ball clubs are not hard to find."

Scouting is not simply finding raw talent. Evaluating raw talent is the hardest of the scouting jobs. The trend now is to wait and become a bidder in the auction for the boy. Though a scout may be looking at raw talent for the first time he may already know that the beginning price is $50,000 or $75,000.

Tryout camps are still the best single bet for future major league talent. It is the best way to get the prospects with the

least amount of cash outlay. The player attending the tryout camp is looking for the opportunity. Go to him, and you are paying a cover charge. Although it is often more discouraging than looking for that needle in a haystack, the tryout camps have produced the likes of Harvey Haddix and Red Schoen- dienst. Attendance at a tryout camp immediately stamps the boy with having the important ingredient—desire. You need not be reassured that "he came to play." What else did he come for if he didn't come to play?

There are other advantages to the tryout camp. The prospect is in your back yard, and he shouldn't get away. It brings qualified judges to the rural areas and the crowded tenement districts.

To judge his speed, a batter is asked to run as hard and as fast as possible to second on the last swing at bat. But how would you judge a player who, after his last swing, tore right across the pitcher's mound to get to second? A prospect did that and then told Walter Shannon: "That was the fastest way I know to second."

Tryout camps are open to all within a given age limit. Shannon tells the story of the big tall boy who came to tryout camp. He was playing first base in a high hat and a swallow- tail coat. "I'm not just satisfied to be a major league player," he explained, "I want to be a baseball clown like Al Schacht."

Joe Labate, the Phillie scout, once asked a boy who claimed to be a pitcher about the apparent nothingness of his pitches. "How long have you been pitching, son?"

"All day, sir," the boy said.

Classifying youngsters is sometimes a big problem. Cardi- nal scout Buddy Lewis said to a boy: "I know you're a pretty good ballplayer, but what's your best position?"

"Well, sorta stooped over like this."

Players are asked to report to the tryout camp with gloves and shoes and uniform if possible. Sometimes a boy adds his

own equipment. Tony Kaufmann tells about the Madison Avenue boy who came with uniform, glove, shoes, and a brief case. In it was a two-tone bat that came apart to fit in the brief case. "Sure we let him hit with it," Kaufmann says, "but he was more screwed up than that bat, and we couldn't sign him."

Determination is hard to discover in a youngster, but Cardinal scout Joe Monahan tells about a youngster who was told he just didn't have it and that he need not come back the next day. But the next day he was back, and once again he was told he couldn't make it. The next day he was back and again Monahan cornered him. "Son, you were cut twice. Why are you back?" "That wasn't me," the kid says. "Those were my brothers you cropped." "You're the third brother we're cutting," Monahan told him.

Frank Lane's favorite is about another youngster who showed up three days in a row and was cut every day. The fourth day he came in under an assumed name and a painted mustache.

Though it is assumed that every boy at a tryout camp is an aspiring big leaguer, that need not be the case. "I remember a real good-looking third baseman that really caught our eye," Walter Shannon recalls, "He could do everything. The third and last day we pulled him aside to talk contract to him, but he explained he was a Catholic priest who had taken a bunch of kids over and while there thought he would just fool around to see if he could still play."

Charlie Grimm got a laugh while conducting a camp during the war. "I am 4F," said the kid, "and I can hit like Ted Williams, throw harder than Dizzy Dean and play the outfield better than Joe DiMaggio, and if you need me I can coach too."

"You're nuts," said Grimm.

"Sure—that's why I'm 4F."

Casey Stengel was once stopped cold at a tryout camp. In one of the sessions Casey called for the kid wearing the shin guards to get behind the plate to see what he could do.

"But I'm no catcher," the youngster answered, "I'm an infielder."

"An infielder? Whatta you doing with the shin guards on?" Casey asked.

"Well, I'm a little weak on ground balls."

Scouting a minor league is a big part of scouting. A scout will trail a ball club to watch a man under game conditions. A deal will many times hinge on his report. He can't tip his hand or the price goes up. Habits are noted, results under certain conditions are noted. Everything is added up. Everybody knows he is in the park, and his biggest job is not to tip his hand.

Minor league managers in a sense are all scouts as they are required to make reports on the opposition to the parent club. Since scouting is just one of many jobs, they make short and sweet reports. Typical is this classic: "Good stuff, good control, screwy. Eliminate head, cinch 20-game winner."

Birdie Tebbetts, while managing Indianapolis, gave Gabe Paul such short, accurate scouting reports that he later got the manager's job at Cincinnati under Paul. In giving his report on a pitcher: "This boy is wild low, doesn't have enough stuff to be wild high."

Once when Burleigh Grimes was managing in the major leagues, he sent a young pitcher back to the minors. A few days later the manager of the minor league team wired Grimes: "Your pitcher too green." Grimes wired back: "Paint him red and send him to Elmira."

The most famous of the short scouting reports, which has become a byword, is attributed to Spanish-speaking Mike Gonzalez. Asked for a report on a ballplayer, Gonzalez wired back: "Good field, no hit."

The general manager or the president of the club has to okay the big bonus. The free prospect is no risk. It's the big money that makes the general manager the watchdog. The standings of the parent club are his box score as far as the fans are concerned. The black ink on the ledgers is the tote board as far as the owners are concerned. When the club is winning, it's because the manager and players are doing a great job. Praises do not come his way. When the club is losing, the cry goes up for better players. The telephone is his bat, and he can take more than three swings. The men in his organization are his lifeline. His toughest job is to get a good organization around him. He is a broker in human beings.

The highest recognition a general manager can get is to be called a good baseball man. What makes a good baseball man? Mr. Branch Rickey says it takes three things.

1. To be able to estimate a player's ability accurately on a given amount of "look."

2. The ability to digest and evaluate scouts' reports and make decisions from them.

3. To be a good team balancer.

Mr. Rickey singles out the late Ed Barrow as an example of a good baseball man. "Many men," continues Mr. Rickey, "can scout an individual player; others can scout a whole team as a unit. Barrow could do both. Not many men can."

Every year a ballplayer must sign a contract after negotiations with the general manager. Baseball is one business where you get paid this year because of what you did last year. Contracts are usually sent out by registered mail and must, by baseball rule, be in the mail, in most cases, by February 1.

Techniques of general managers and presidents differ. My business dealings with the Cardinals were with a sympathetic Sam Breadon and with a cold but fair Fred Saigh.

At Pittsburgh signing a contract with Mr. Branch Rickey was like being in on the signing of the Declaration of Independence while taking a course in human behavior. Wid Mathews was my general manager at Chicago, and contract negotiation was a sparring match without gloves.

"Why do you think you deserve more money?" is the question they all ask in different ways. Once, after three days, I gave Mr. Rickey this answer: "Because my name is Joe Garagiola, and I did the best I could the days I played and was ready to play the days I wasn't in the game. I have a wife and family, and we could use the money."

He grabbed his bushy eyebrows and looked to the ceiling, then pounded his fist on the table and roared: "Would you put that in writing?" I did and to this day that argument is still on file.

Mr. Rickey could shoot holes in any argument that involved figures, runs driven in, and so many games saved. Figures meant nothing to him. He evaluated players in his own way. A contract session with him was a chance for a debate. His creed in these sessions was set forth in a framed saying he had on the wall over his desk. The inscription read:

> He that will not reason is a bigot
> He that cannot reason is a fool, and
> He that dares not reason is a slave.

Ballplayers would compare notes as to how the sessions with Mr. Rickey went. Gene Hermanski and Chuck Connors (now a TV star) tried to double-team him one year over at Brooklyn. On the flip of the coin, Hermanski went first. After an hour or so he came out and Connors asked how it went. "I didn't sign. Everything was going along pretty good, I thought. I know he is a pretty religious man, so I was ready. He asked me if I smoked and I said not too much. That was okay. He asked me if I went out with women, I said not too

much. That was okay. Then he asked me if I drank and I said a little now and then, and that's when he hit the ceiling."

Connors went in. The same questions came. "Do you smoke?"

"No, Mr. Rickey."

"Do you go out with women?"

"No, Mr. Rickey."

"Do you drink?"

Connors slammed his fist on the desk and shouted, "If I have to drink to stay in your organization, I'm leaving!"

Connors signed at good terms. "It was easy to figure out Mr. Rickey's thinking about contracts," he says. "He had both players and money—and just didn't like to see the two of them mix."

Preacher Roe, the great Dodger star, is an admirer of Mr. Rickey's abilities at a contract session. It was during a hold-out. After one of the pow-wows, Mr. Rickey suggested that Preach go home and consider his final offer. "By the way," Mr. Rickey said, "I've got two hunting dogs I'd like you to have. I know you like to hunt."

Preach took them, and they were the best dogs he ever had. "One day while I was having a real good hunt, I got to thinking, you know he can't be too bad a guy, giving me these dogs. So when I got back, I signed the contract. The day I put it in the mail, those two dogs took off across the field, and I haven't seen 'em since."

The great National League star, Pete Reiser, told about the Dodger rookie who, after a good year, went in to talk contract with Mr. Rickey. They couldn't get together at all. Finally Mr. Rickey said, "Boy, you want too much. I can't give you that much. You just can't hit a happy medium."

"Oh yeah!" the rookie came back, "Tell me who throws that. I bet I hit him good."

The easiest contract I ever signed was in 1951. I thought it would be the toughest, because in 1950 I suffered an injury in June and it kept me out the rest of the year. I expected a cut in pay and hoped to make it as small a slice as possible. The president of the Cardinals, Fred Saigh, called and said he wanted to see me. "Joe, it was unfortunate what happened last year. I would like to give you more money, but I can't. I am offering you the same contract. Get off to a good start, and I'll call you in the first chance you give me to do so."

Bill Veeck as a general manager once devised a system to break contract stalemates. Both he and the player would write down a fair figure. The agreement being that if the player's was the lowest, they would split the difference.

Ballplayers have their own ways to get across the idea that the money offered isn't enough. Chuck Connors once sent back his contract with a note written to Bavasi in red ink. It read: "You want my blood, please send contract with more money as you can see I . . . am running . . . out of . . . blo . . ."

Rocky Nelson, the much-traveled major leaguer and a big hero in Montreal, had just led the International League in six departments. When his contract came, it was for the same amount as the previous year. He noted that the envelope was addressed to Robert Nelson. His given name is Glenn. He circled the name and sent the contract back unsigned. Another came, same mistake, same procedure by Rocky. The third came, same amount, same name, and a sharp note wanting to know why in all courtesy he hadn't even sent a note with the rejected contracts. "The money," wrote Rocky, "isn't flattering, but the wrong name on the envelope is a real insult."

While general manager at Cleveland, Hank Greenberg got an answer in the mail that really stunned him. After receiving

an unsigned contract, Greenberg immediately sent a wire to the player: "In your haste to accept the terms you forgot to sign the contract." The player came back with this note: "In your haste to give me a raise, you put in the wrong figure."

If they are all like me, very few ballplayers have ever read a contract in its entirety. There are two lines the ball-players look at, where do I play and how much do I get.

For as long as I can remember, the Cardinals have had Miss Murphy in charge of preparing contracts. It was always Miss Murphy who would type in the figure agreed upon and she'd be the second person to wish you a good season.

Once a contract is signed, there is no comparing salaries with other players. This is an unwritten law respected by all. Dissension could easily start with the feeling that he's getting more than me when I am doing more than him.

The only advice I got upon being subpoenaed before a Congressional committee was to tell the truth. When asked to state how much I made, I told the truth. Upon returning to Chicago, I was told I had made a big mistake because two players had already been in demanding more money on the strength of what I was being paid.

The worst feature of contract negotiation is that in the discussion all the negative aspects of the player's ability are brought out. You sometimes get the feeling that you are lucky to even be offered a contract, and then when you sign it, the general manager tells the press that your club has a chance to win the pennant because you are such a key man. The player that is trying to sign and the one signed become two different guys.

Trades and contracts are the showcase of the general manager. It is in these two phases of the game that his name is most often mentioned. See two general managers sitting together, and the trade winds start to blow.

The trades you don't make are the best ones, the general managers will tell you. Values fluctuate from week to week, year to year. The throw-in of a year ago can't be had at any price today.

Statistics are kept on all players. Scouting reports are constantly coming in. Frank Lane and Bing Devine are among the general managers that subscribe to out-of-town papers to help keep a finger on the pulse of other teams. Frequent telephone calls add to the information stockpile. The calls range from calling minor league managers to asking neighbors of ballplayers about personal habits. Every factor is weighed, but the risk rate is high.

No deal is made with the idea of stealing a player. Deals are made to fill particular needs. Because of circumstances and situations the fans can't see, a deal will sometimes look lopsided. The bad ones are remembered longer than the good ones.

A deal can start with a vague hint or it can start with a telephone call making an outright offer. Frank Lane engineered a deal while in a hotel room for three days, talking trans-oceanic to Hank Greenberg in Rome.

Pat Harmon, sports editor of the Cincinnati *Post*, once wrote how general manager Gabe Paul of the Cincinnati Reds goaded Frank Lane, then general manager of the Cardinals, into a deal. Both Lane and Paul were to be among the speakers at a dinner in Dayton. Up to that time Paul had made eighty-nine phone calls in eighty-nine days without concluding a trade. That night he said to his audience, "We have here a man who has fallen in love with his own players. Frank Lane is so much in love with his players that he refuses to part with them, even though he has had many chances." As Paul spoke, a phonograph record in the wings softly played, "Falling in Love with Love."

Lane jumped up to speak. As he passed Paul he said, "Before I go back to St. Louis tonight, we'll have a deal." It was Brooks Lawrence for Jackie Collum.

But Lane had been eying Collum, and it took more than music and a dare to make the deal.

"Front office interference" is a phrase that upsets more fans than any other phrase in baseball. The general manager ought to leave the field manager alone, say the baseball fans. But it is not, and it cannot be, that way. The manager and general manager may not always be in agreement, but they must be working it out together. The manager is usually hand picked by the general manager for qualities that the general manager thinks will get the best out of the material he gives his man to work with. They must be together. Game strategy is up to the manager, but there are times when he cannot see the forest for the trees.

Frank Lane's pet example involves the Cardinals of 1956 and an outfielder. "Do you figure on using ———— next year?" he asked Fred Hutchinson.

"No, get rid of him."

"How can I if you don't play him? You got him on the bench, playing Sauer (forty years old) in his place. If the other club feels you think Sauer is better than ————, how can I trade him?"

Hutch saw the point, played ———— the last month, and the following winter Lane traded him. There's the case for "front office interference."

A general manager in baseball today has a very definite voice in the selection of coaches by his manager. It used to be a buddy-buddy system. Players used to make agreements among themselves that whoever got to the big leagues first as a manager would name the other a coach. Now the hiring of a coach is done with a specific duty in mind and often after much deliberation.

Coaches can be placed in the categories of assistant manager, middleman, and journeyman. The assistant manager coach is one who has complete charge of a particular phase of the team action, usually pitching. For many years Jim Turner had control of the New York Yankee pitching staff, and it was mainly on his recommendation that Casey Stengel made his moves. The middleman is usually closest to the manager and will be at his side most of the time off the field. He knows baseball, but his greatest asset is that he knows how to make friends and influence people. He is the buffer between the manager and players. The journeyman is the coach who does a good job but for one reason or another rarely keeps a job very long. This man is usually a bullpen catcher who catches batting practice, throws for extra hitting, and warms up the pitchers. He serves as part-time scout when the club is holding tryout camps in the park—a general, hard-working handyman.

There are coaches who are particular specialists—a Bill Dickey whose job was to help Yogi Berra, a Rogers Hornsby who taught hitting. A coach today must have qualifications to do a specific job. The actual work during a game is minor in comparison to his duties in the over-all picture. The first base coach's real value may lie in being able to teach outfield play. The third base coach is usually the manager's liaison man.

Many a former major league manager can be found in the coaching ranks. The fear of hiring a potential successor has decreased with proper understanding between front office and the field as to the job to be done.

One of the toughest jobs of the general manager is the release, whether it is the veteran who has given you his best but is no longer good enough, or the young player who has had a taste but now can't untrack himself and has to take the long ride back to Bushville. Cutdown time in spring

training is always tough. Season cutdown time is even tougher. The unconditional release is toughest, a cold typewritten notice that means it's the end, and we all live in the past.

An important link between the front office and the players is the traveling secretary. He is considered front office, but he lives with the players. He is the Pied Piper, official housemother, father confessor, travel agent, ticket broker, and floating bank—all rolled into one. His immediate boss is a timetable. Though his job has many facets, his whole life revolves around the job of getting the ball club to meet the schedule. If he's not at a game, or going to one, or leaving one, he is planning how to get to one.

The games of a season are scheduled by an authorized schedule-maker, who is given ninety days to make up the entire league schedule. But spring training games must be played and a schedule for them made up. For this, the traveling secretary turns schedule-maker. It is at a meeting during the All-Star game break that the next year's spring training schedule is drawn up among the secretaries. The clubs training in Florida get together, as do the clubs training in the West. There is no submitting a trial schedule, it is confirmed on the spot. The manager of the club won't know the spring training schedule until it is given to him. In contrast to the ninety-day period for working out the regular schedule, this one is drawn up in a day.

The secretary is the only man on the club who knows the timetables well enough to know if this trip or that trip can be made, and the regular schedule is submitted to both him and the general manager. The regular schedule is drawn up as single games except for occasional holiday double headers. It is now up to the GM and the secretary to schedule double headers and create open days. The variety of the

schedule is in the hands of these two men and their counterparts on the other clubs.

Baseball has become a night sport. Each club plays a heavy night schedule, but the official schedule-maker submits all single games as day games. The traveling secretary must know if a night game can be scheduled and tomorrow's city be reached in plenty of time.

Few of the secretaries ever see a complete game. Once a game starts, the traveling secretary becomes collector, tabulator, and league representative. Each turnstile is checked for admission after four and a half innings for the paid admissions for that game. The visiting club gets 27½ cents of each paid admission. The cut is the same for a bleacher seat as for box seats. The total paid admissions determine the visiting team's share, and the secretary collects on the spot. He also notes the league share based on 5 cents for each paid admission. After each series, the home team secretary must mail the league the check for the series total.

During the summer, the secretary travels with the team. He becomes banker, bookkeeper, ticket broker. Each major league player is given $8 a day for meals and can eat wherever he chooses. In spring training a player is allowed $6 a day plus $25 a week incidental money (tips, laundry, etc.). If he lives away from the hotel, he gets an amount equal to what the club would pay for his hotel bill. So it is a complicated bookkeeping and auditing system that the secretary must keep. Each week he makes up the payroll. Even Univac would need an overhauling after one season.

In one city, he worries about making the next part of the schedule. Rooming lists must be sent ahead to the hotels. Buses must be hired to take players to and from the airport and to and from the ballpark. Baggage companies willing to meet a 2 A.M. arrival must be contacted. Air travel has

speeded the process up and given extra flexibility, but the secretary's life is one of constant checking.

Baggage handling has been much simplified in recent years. A player brings his bag to the lobby before leaving for the park and finds it in the lobby of the hotel in the next city. With air travel, baggage weight has become a concern. The Los Angeles Dodgers issue traveling bags as part of the equipment in an effort to control the weight. The Milwaukee Braves have issued sports coats and slacks, as have the pro football teams, in an attempt to give the team the look of a traveling unit.

My first year in the big leagues we traveled only by train. The Pullman lists took the secretary some time. A club always used three cars, which, in those days, meant thirty-six lowers with three drawing rooms. The manager, coaches, and secretary used the drawing rooms. The regular line-up was placed in the middle of the cars, away from the wheels. The berths atop the wheels was the no-slumberland of the scrubinis.

Here's another example of the sec's problems. When a player is traded, he is given transportation and moving expenses. The major leagues are divided into three zones—the Eastern, including Philadelphia, Pittsburgh, New York, Baltimore, Washington, and Boston; the Central, including St. Louis, Cincinnati, both Chicago teams, Milwaukee, Cleveland, Detroit, and Kansas City; and the Western, Los Angeles and San Francisco. When a player is traded in the same zone, the expense check is $300; from East to Central, $600; from Central to West, $900, and from East to West, $1,200; and vice versa. The efficient, patient, and available traveling secretary not only gives the guy the right check—often he has to give him the news.

In representing a club, a traveling secretary makes his own

decisions and gets no credit. He is supposed to get the club there. In 1938 a flood fouled up transportation around Boston. Even boats couldn't leave, and highways were washed out. Western Union was out, but the Cardinals had to be in Chicago. A young man named Leo Ward (now veteran Cardinal secretary) chartered a mail plane and put twenty-one players aboard headed for Chicago. (This could be the first flight taken by a major league club.) Before Ward's telegram to St. Louis asking Sam Breadon, Cardinal president, for permission was delivered, the team was off, and it played in Chicago. The next day Breadon's reply came: "Do not think advisable to fly. Wait for other means."

That year, 1938, was a year of nightmare for Leo Ward. "It all happened—flood in spring training, trucker strike, taxi strike, and a seventh place ball club."

In 1946 the Cardinals ran into a railroad strike. Half the team flew to Cincinnati, and the rest of us took a bus from Philadelphia. We made the scheduled game.

The most painful thorn in the side of the traveling secretary is the pass list. Most players have wholesaling deals in each city, and they can turn a pass to the ball game into a pair of shoes, a sport shirt or a movie projector. Each player is given two pass cards, but the National League has a rule stating that a player's immediate family must also be taken care of. The immediate family is defined as wife, mother, father, and sisters and brothers of both the player and his wife. Though listed in the record book as an only child, a player's pass list may indicate he came from a family of fifteen sisters and fourteen brothers living in all parts of the country.

In 1959, Bob Rice, sec for the Pirates, was given in Los Angeles a list of twenty-five relatives (immediate family) for the first night by a player. He let it go through. The next night the private rooting section was increased by three

long-lost brothers. Although it would have set a new major league record for most passes on consecutive days, Rice scratched them all off the list.

"Sure we have our pets," says Rice. "How can you refuse a Vernon Law after he takes a fifteen-hour bus trip to reach a destination? He couldn't get a train or plane ticket, so he takes me off the hook by asking me if there were any buses running. And he was an established star and not a rookie breaking in."

"I didn't even know that Musial and Schoendienst were on the club," Leo Ward says. "Just two names on the rooming list. My biggest problem with them was spelling Schoendienst right."

It is only in recent years that the secretaries no longer depend on the players' vote for their shares in a first-division finish. Now the club, by league rule, must pay the secretary the full player's share of a first division finish.

A lifetime job is his reward. A traveling secretary is never fired because the team has a bad year. On the other hand, who can ask for a raise when the team finished a bad year? And a good finish by the team means extra money, so how can you ask for more pay when a windfall has come your way?

With the player he's a company man, though an all right guy. He understands the players and knows them. "A player is more needle than complaint," says Leo Ward. "When the club is winning, you hear complaints. When the club is losing, everybody is interested in getting on the right track."

Bill Wolf is a name that won't be found in any record book. He was a groundskeeper and my first close contact in organized baseball. (In 1941, Mr. Rickey, then Cardinal general manager, sent me to Springfield, Missouri, to work as groundskeeper, to catch batting practice, and to keep me away from other clubs. I was sixteen years old and was paid $60 a month

to be a groundskeeper's helper.) Though it be in a Class C park or a fine manicured infield of a major league park, the man dedicated to making it a place to play and a place to see is the groundskeeper.

Affectionately called groundhogs, his crew works to draw the casual comment: "Doesn't the park look nice?" It's only when the race of tarp against rain is on that the groundhogs are noticed. In recent years, they also give a fifth-inning performance in smoothing out the infield. The rest of the game, it's routine. A pitcher finishes warming up on the sidelines, the man with the rake takes over. Infield practice is over, and a two-man crew lays down the wooden stencil to mark the batter's box. Once in a great while a bag will come loose, and for a minute the groundskeeper becomes the most important man on the field.

Bill Wolf, Bill Stocksick, Matty Schwab, Emil Bossard, John Fogarty and Bobby Door—names that never showed on a scorecard. The official titles can be park superintendent or head groundskeeper—different names, different people with one idea, the keeper of the grounds, men dedicated to making a perfect stage for the greatest game in the world.

To a groundskeeper the park is alive. The grass is his baby to be nursed, to be kept alive and beautiful. The soil is a soft cushion with feeling. The foul lines are the border to the beautiful centerpiece. The mound is a calculated summit suited to the great heights that can be reached there. To a groundskeeper the park responds to treatment because it's alive.

Many times the groundskeeper becomes the tenth man in the lineup. Lou Boudreau's first move upon being named manager of the Kansas City Athletics was to call the Bossard family in Cleveland and offer the head groundskeeper job to the eldest son, Harold. The Bossard family has become a legend in Cleveland's Municipal Stadium. Emil, the father,

helped the Indians win at least ten games a year, Boudreau says.

"The infield was true. It was soft, and gave you the feel. I know it helped Gordon and me when we were finishing up," said Boudreau.

Convince the catcher that the ground is softer in one park than another, and his legs don't get as tired. Del Crandall, catching for the Milwaukee Braves, mentioned to his grounds-keeper that the area around home plate in St. Louis was the finest conditioned area in the league. "Can we get the same condition here at home?" Crandall asked County Stadium groundskeeper Al Oliver.

The letter from Oliver to Stocksick read:

DEAR BILL:

Del Crandall mentioned to me that you have the finest conditioned area around home plate. He told me that is his idea of what every catcher desires in wanting the best in terms of not being too hard or too soft for the catcher's legs which as you know take a terrific beating during a game.

As we in our profession are always striving to improve what we are presently doing, I am wondering if you could without too much trouble forward to me the classification of the soil you use around home plate and whether you have a special mixture of your own design. I have experimented with mica, etc., but have not been able to come up with the right feeling under the foot, resilient but not hard and yet not too soft for proper footing. It will be greatly appreciated.

Albert C. Oliver
(Superintendent)
Milwaukee Braves

The return-mail recipe of Cardinal Superintendent Bill

Stocksick: "You take some black topsoil, add a little sand to it and wet it down with the right amount of water. Be sure there isn't too much sand because it doesn't bind that way. It's all sifted together first and then put on the field. The players like it kind of soft, but not too soft, just the right footing."

It is with this same chef-like attention that the rest of the field is handled. The infield gets the same soil as the catcher's area. The pitcher's mound has to be a little tighter, and clay is used here, because the pitcher must be able to stop after taking a long stride and not slide each time he throws the ball.

The outfield has the topsoil-sand mixture, except that it is seeded. Stocksick seeds the field all the time, using bluegrass, a bit of Bermuda and a little perennial rye.

As Stocksick helped solve a Milwaukee problem, Cleveland's Bossard solved a Detroit problem. Bad hops and bumpy ground were the main complaints. The cause was caking of the dirt strip around the infield. The remedy was a new rolling process developed by Emil Bossard.

To make the field playable and beautiful is the job; to help the club pick up extra games is the profession.

A high bouncing ball over the infielder's head may look like luck, but it may be planned. A bunt rolling fair or foul may be pre-determined. A runner able to stretch a single up the middle to a double because it looked like the outfielder didn't charge the ball may have got an assist from the groundskeeper's office. A baseball diamond can be a beautiful booby trap for the visiting team in the hands of a skillful home team groundskeeper. Skilled hands can speed a diamond up one day, slow it down the next, and protect the infielders against a good bunting club the following day.

A good right-handed, pull-hitting ball club would certainly benefit by a "fast alley" along the third base side of the diamond. The first hop is the big one so the doctoring

(hardening in this case) begins near the plate. On defense there wouldn't be too much worry about bunts because they would literally jump off the ground. By tilting the ground towards the foul line, most bunts would roll into foul territory anyway. The third baseman wouldn't be too much concerned with bunts, being aware of the conditions.

If it's a slow-moving infield and the emphasis is placed on defense, the groundskeeper provides a soft infield which slows the ball down. The grass isn't cut too short and each blade works for the defense.

With a sinker ball pitcher working, the area in front of home plate is soaked to slow down a hit ground ball. Most sinker ball pitchers need good infield work, and this condition gave infielders plenty of time to get the extra step for the good defensive play.

Bob Nieman, while an outfielder with the Baltimore Orioles, wrote a guest column in which he said the Baltimore club would always soak the area in front of home plate when sinker ball pitcher Bill Wight was scheduled to work. Nieman claimed that Nellie Fox, the White Sox star, was able to pick up twenty hits a year at Comiskey Park by bunting the way the foul line was doctored.

A fast-running club likes the ground hard, and at home it can be tailor made. On the road the club will find the baselines give the feeling of running in sawdust. Soften the area around the bag so there is no grip, and even the most daring base runner will stay close.

The first thing that a visiting manager and coaches do is to check the condition of the infield grass, the base paths, and the foul lines. Is the infield hard or soft? During infield practice this is tested by batted balls. Outfielders check the grass. Is it slowing the ball down? Is the ground hard so a ball may shoot by you? The player who can bunt will check the foul lines for a reading on the roll of the ball. Though in-

field and batting practice may look routine, there is constant observation of the legal "booby traps" of the diamond medic.

The biggest threat to the groundskeeper is rain. He keeps in close touch with the weather man and protects the field before the game accordingly. During the game each man of the grounds crew has a specific job. Man your battle stations! Most crews, have occasional team practice in rolling out the tarp.

The most famous families among the groundskeepers are the Schwabs and the Bossards. Matty Schwab, for many years at Cincinnati, has a son with the Giants, first at the Polo Grounds and now in San Francisco. Emil Bossard is the dean of the American League, and one of his sons is the chief man with the Chicago White Sox.

Each keeper of the grounds, with the pride of an artist, develops his own methods. Emil Bossard is most proud of his drag. It is forty-two inches long by sixteen inches wide, and it is made up of 1,000 ten-penny nails. With this drag all the soil gets the same touch.

Bill Stocksick in St. Louis uses two kinds of drags to keep the infield in condition. One is a float board with steel on it, and the other is a steel drag that looks like a doormat. After the infield has been wetted down and before the players go on the infield for practice, depending on the condition of the ground and the humidity, Stocksick orders the proper drag. If you see no dust when a player is running or sliding, Stocksick is content.

Unless there is a special reason (doctoring), the grass in St. Louis is cut every other day. It is cross-cut, making it look like a checkerboard.

The beauty and cleanliness of the park is another part of the head groundskeeper's job. It takes a big and skillful crew to do the work—in St. Louis, a crew of seventy, including twenty-eight women who clean the stands and dust the seats.

These are among the social security numbers of baseball. No record is kept on their ability or performance. None has received a half vote for the All Star Game, but they, too, make baseball the game it is.

Another social security number is the public address announcer.

When Tex Rickard in Brooklyn announced that "a little boy has been found lost," the crowd realized that the public-address announcer is part of the game, too. Tex, during my career, did more than any of the other public-address announcers to make baseball a funny game. Tex, a well-to-do businessman, took the job as a sideline to keep him close to baseball. For thirty-three years he did the announcing for $5 a game until President O'Malley found out about it and raised him to $10. He was held in such high esteem that he was honored with a Tex Rickard Night in his beloved Ebbets Field.

Once there were some coats draped along the left field railing, and the umpire asked Rickard to tell the fans to get them off. "Attention, please!" came Rickard's call. "Will the fans behind the rail in left field please remove their clothing?"

Tex was asked to make a pre-game announcement during a Ladies' Day rush. The Dodger ticket manager wanted to keep the rotunda clear for sales to the reserved-seat customers. Tex's message over the loudspeaker came out: "General admission and ladies on sale on Sullivan Place."

"Please do not go on the playing field at the end of the game," was always his last request. "Use any exit that leads to the street."

Players took great delight in agitating Tex when he asked for first names. Gene Freese, an infielder, still answers to the name Augie. When Tex asked the Pirate players for his first name, they told him Augie to tease Augie Donatelli behind the plate.

Ham Fisher, creator of Joe Palooka, was a great baseball, and, particularly, a Dodger fan. Rickard once publicly thanked Joe Palooka for his interest in the Dodgers.

The field announcer relays information on controversial plays to the press box and serves as the field contact for the press. In many parks he works closely with the boys working inside the scoreboard.

The scoreboard man in Brooklyn couldn't get the name of the pitcher for the Chicago Cubs over at the Polo Grounds. Announcer Tex Rickard called the press box to find out. He was asked to wait a minute. His source returned to the phone, and this conversation took place:

Press Box: Tex?

Rickard: Yes.

Press Box: Bob Rush.

Rickard: Who?

Press Box: Bob Rush.

Rickard: Oh yes, Bob, how are you?

Pat Piper is a Chicago North Side legend. A restaurant waiter by night (there are no lights in Wrigley Field), Piper has been the field announcer for the Cubs for more than fifty years. Pat is the only announcer to continue the old tradition after giving the line-ups, of dramatically announcing *play ball*. Pat also claims the record for lost children found.

In Cincinnati the field announcer sits close to the visiting bench, and the players join in his routine. Between the name, number, and position, you can hear the players helping out: "Who?" . . . "What's his number?" . . . "Where does he play?" . . . and then a surprised, "Oh."

When I quit playing, I went to the other side of the fence and joined the society of the press and radio box. This is forbidden land to the fans. Only working press is allowed in the press box, but at some parks working press is often interpreted to mean banker, baker and candlestick maker.

The colony is made up of home and visiting newspapermen, Western Union operators (the only women allowed in the press box), a scoreboard operation, the official scorer, publicity men for both clubs, and club officials.

At a World Series or All-Star game only members with accredited press badges get in, but others try. The best attempt was made by a gentleman who claimed to be the sports editor of the *Congressional Record*.

The radio booth is usually apart from the press box. In some parks, such as the Coliseum in Los Angeles, it is more like a phone booth than a radio booth.

The scoreboard operator is a button man. St. Louis has the All-Star scoreboard operator in Lou Adamie. Many claim that he has the umpire's call on the big board in left field before the umpire makes the decision. At his job more than twenty years, he has studied the mannerisms of the umpires until a preliminary telltale move tells him whether the call will be a ball or a strike. In front of him is a button-filled panel board. With the dexterity of a concert pianist, he hits the right button.

II. *Of Official Scorers, Sports Writers, Broadcasters, and Others Who Also Serve*

The official scorer is a newspaperman appointed by the league. In many cities the job rotates, and each series or so a new scorer is on duty. He is paid for this extra work by the league. At his finger tip is the rule book for proper interpretation, but mostly it's a matter of his judgment as he flashes the red light for error or green for hit. In St. Louis, Ellis Veech of the *East St. Louis Journal* is the permanent official scorer and one of the best in either league.

The job of the official scorer is a thankless one, similar to that of the umpires. An error will anger the hitter. If the hit sign is flashed for the home team hitter, the visiting team immediately charges favoritism. If an error is charged on the visitor's hit, the scorer gets it from two sides—the visitor claims he is protecting the home team, and the erring player claims he is protecting the pitcher's earned run average at the expense of his fielding average. "We don't get the hits on the road, so we should get them at home," is a much-used sentence on the bench. Players often show their disgust at a call by waving towels from the bench.

Sometimes conferences are held and calls made to the field to get the views of the players on a questionable play. It is not uncommon to have a hit changed the next day to an error, or vice versa.

One of the scorer stories involves the rookie who had three hits in four times at bat, but the morning paper box score showed only two hits. The next day the rookie asked the scorer: "How come I didn't get three hits yesterday?"

"You got three hits yesterday."

"Oh yeah! The paper said two for four."

"That was a typographical error."

"What do you mean, error?" shouted the rookie. "Two were clean singles to left, and one was right up the middle."

All the teams have newspapermen traveling with them. Most newspapers pay their reporters' expenses so they will feel no obligation in writing their stories. Players are not concerned with deadlines, and many a reporter's hopeful lead ends up on the floor as the apparent victory turns into defeat. To make his deadline, a writer may have to anticipate results. Typewriters are pounded constantly as running accounts are turned out. Some writers never see the finish of the game because they must head for the clubhouse to pick up quotable comments.

There is usually one man from each paper traveling with the team, although some papers send an extra man along to do feature material or a daily column. When a crucial series approaches, the crew gets bigger, and the sports editor appears on the scene. At an All-Star or World Series game it sometimes seems to take the whole staff to do the job.

The regular writers live like the players, staying in the same hotels and using the same transportation. While many friendships of mutual value are formed, it is always interesting when a critical story is read by the player concerned.

A Yankee once chased a newspaperman through a string of railroad cars threatening to throw him off the train. Ebbets Field was often the scene of shoving and grabbing because of extra vivid descriptions and comments. While clubhouses are open to newspapermen, a good many individual newspapermen have been barred. Some managers set a cooling-off period of about 15 minutes after every game to allow players a chance to let off steam before the press is admitted.

One newspaperman who gave the players as many stories as he got from them was the late Chilly Doyle of the Pittsburgh *Sun-Telegraph*. Chilly lived only a couple of blocks from Forbes Field, but he frequently telephoned the park before leaving home: "Is it raining there?" "No, the sun's shining." "It's shining here, too," Chilly would tell the operator and leave for the park.

On one long spring training trip Chilly traveled and roomed with Al Abrams, sports editor of the *Post-Gazette*. Arriving at Griffiths Stadium, Chilly saw Al leaning against the batting cage. "Al!" he called, running over to shake hands, "when did you get in?"

When the Pirates took to airplane travel, Chilly reported, "The Pirates will fly by air this season." And once he came

into the front office for a special press conference and spotted Mr. Rickey's store teeth in a glass. "Are they false?" he asked.

Rookie writers often betray their inexperience. After Harvey Haddix pitched the longest perfect game in baseball history—thirty-six consecutive batters retired—a rookie writer asked him if that was the best game he ever pitched.

One of the press questions every veteran athlete must answer is: "When are you going to quit? What's going to tell you when it's time?" In one discussion on this question, one fellow said the legs go first, another said the eyes, a third said the reflexes, etc. Fred Apostoli, the former middleweight champion, declared they were all wrong. "You first notice it in your newspaper write-ups," he said.

Some time ago, Bob Addie of the Washington *Post*, painted a composite picture of the sports writer. As I recall, it went something like this: He is quick to defend and slow to offend. . . . He can count on the fingers of one hand the athletes who ever thanked him for a story, but if he had a dime for every guy who threatened him for critical stories, he would be too rich to write sports. . . . A football coach may have more than 100 plays that his team can execute with precision, but the sports writer doesn't hesitate to pontificate on the coach's strategy. . . . He figures all coaches and field managers are managing editors with their brains knocked out (or maybe it's the other way around). . . . He lives in a beautiful world where it's always game time and yesterday's tragedies have faded like ripples on a lake. . . . He is the eternal juvenile who wouldn't trade places with anybody. . . . He's Pagliacci, the Pied Piper, Walter Mitty, Peter Pan and Jack Armstrong, the all-American boy. . . .

In recent years baseball teams have hired publicity men to work with the press and the public. Their showcase, as far as

the fans are concerned, is the different "nights" staged by the home club. Be it a Little League night or the reunion of Hall of Famers, the details are worked out by the publicity men.

Red Patterson, then with the Yankees, demonstrated the ingenuity of these social security numbers when he came up with the tape measure for a Mickey Mantle home run. Though it sounds simple and inevitable, he was the first. Most publicity men are former newspapermen ever alert for a story.

Jim Toomey of the Cardinals described the premature Musial 3,000-hit party (Stan got it the next day) as "Musial's 3,000-hit party, marked down to 2,999."

Among other things, the publicity men send questionnaires to all their players so they will be able to answer questions about them or volunteer information that will find its way into the newspapers.

Joe O'Toole of the Pirates, while publicity man for the New Orleans team, once sent out a questionnaire with the usual routine questions. "Of what feat are you most proud?" One answer he got back: "I'm a catcher. I have nothing to be proud of." To the Dodger's questionnaire about denominational preference, the Dodger rookie wrote: "I like to be called Benny."

With the Dodgers is a publicity man and demon statistician named Allan Roth. Allan hands out the current averages and a sheet of team information to the press, but his big job is to keep pitch-by-pitch statistics for his team. Each pitch is charted, and the result is recorded.

Should his manager ask how important is it for a batter to be ahead of the pitcher or what happens when he's behind the pitcher, Roth provides the figures. Using the 1952 tabulations (which are now obsolete—his up-to-date figures are for confidential use only), Roy Campanella was a .339 hitter when he was ahead of the pitcher with a count of one ball and

no strikes, two and nothing, two and one, three and nothing, or three and one. But Campy hit only .188 when he was behind the pitcher with counts of one strike and no balls, two strikes, two strikes and one ball, and two strikes and two balls. Similar figures on other hitters during the '52 season . . . Hodges hit .325 and .211; and Snider, .389 and .244. When Joe Black, a star pitcher that year, was ahead of the hitters, the batting average against him was .129; when behind the hitters, it was .258. Erskine showed .154 and .354.

The next day's starting pitcher for the Dodgers charts his own game on the bench, using a system developed by Walter Alston. This chart will show the tendency of the various opposing hitters against different kinds of pitches. Alston constantly checked with statistician Roth to see how the bench book balanced with his figures.

As a player gets older, his reflexes get slower. Roth's figures show the rate at which a player's reflexes slow down. Year by year, the player's hits may be moving towards center field. For example, a strong left-handed pull hitter is now hitting .312, but the majority of his hits are now between center and left center, while they used to be from center to the right-field line. Still a valuable man, but here is an indication that this may be the year to trade him.

Almost everything about baseball is measured or recorded. The swing of Ted Kluszewski, while a member of the Cincinnati Reds, was clocked at 116 miles per hour; Gil Hodges and Duke Snider were clocked at 114 miles per hour.

In a game between the Washington Senators and the Kansas City Athletics, sports writer Dick Wade of the Kansas City *Star* clocked only ten minutes of actual action during a two hour and thirty-eight minute game.

Does a curve ball really curve or is it an optical illusion? Whitlow Wyatt, a great curve ball pitcher, said, "I'll tell you what. You stand behind a tree sixty feet six inches from me,

and I'll whomp you to death with an optical illusion." Dr. Lyman Briggs, director emeritus of the National Bureau of Standards, said that a curve ball curves as much as seventeen and a half inches. An aeronautical engineer at Case Tech claims that a baseball can curve five to eight inches in any direction (less than half of Dr. Briggs's claim).

The organist atop the ball park has in recent years become a standard part of the game at most parks. My wife was the organist at Busch Stadium. To her it was always a challenge to play the right song at the right time. After a Musial home run she played "My Man." Wally Moon's blasts were followed by "How High the Moon." The year (1956) Milwaukee lost the heart-breaking game in St. Louis that ended their pennant chase, they were accompanied off the field with the sympathetic understanding in "Que Sera, Sera" (What will be, will be).

The voice of the switchboard operator is known to thousands of fans. Whenever the dark cloud appears, she answers the nightmare question, "Is the game still on?" a thousand times or so without jumping into the snake pit. Answering queries as to whether certain players are going to play is part of her routine. She has heard a blast as to why the club doesn't start extra inning games earlier, and fans sometimes call the ball park to ask if there is a big line at the downtown ticket office.

It takes 25 players with numbers on their uniforms to make a major league ball club, and it takes 400 social security numbers at each ball park to make the game what it is to the fans. It takes about a million fans a season at each ball park to make any of it possible.

Each ball park has its own atmosphere, given it by its own fans. As a player it was always a thrill to walk into Ebbets Field. The fans were alive. As the late Commissioner of Baseball, Judge Landis, said, "This doggone park is like a pinball

machine." The Dodger Symphony followed you back with musical accompaniment after a ground out and gave you a drum roll as you sat down. When you struck out and walked to the water cooler, you were drinking to "How Dry I Am." Cookie Lavagetto had a personal rooter who would always let sail a barrage of balloons when he came to the plate. The most famous of the Dodger fans was Hilda Chester. Hilda had a voice that sounded like the ten-second buzzer at Madison Square Garden. When she let out you heard every word.

Pete Reiser, the former Dodger star, tells of a game at Ebbets Field, while Durocher was managing. Then a rookie, Pete handed Leo a note in the dugout. It read: "Curt Davis doesn't have a thing today. Get him out of there. Get him out quick."

Leo read the note, and jumped up and motioned to the bullpen. He began to moan aloud to himself. "If that guy wants to manage, why don't he manage down here or keep his nose out of it?"

Reiser asked Leo what he was talking about.

Leo said, "I'm talking about the guy who gave you this note. I'm talking about McPhail, that's who I'm talking about."

"McPhail didn't give me that note. Hilda Chester gave me that note," Pete told him.

The Pittsburgh Pirate fan is a patient fan. He is satisfied if he gets the feeling that his players are putting out their best. When the club lost 112 games in 1952, not once did the fans show their disappointment to the players. Disgusted with the front office, yes, but they felt the players were doing the best they could and just weren't good enough to compete.

In 1959, after the Pirates lost the first five games, a rabbit appeared on the field during a game with the Milwaukee Braves. The Pirates won the game, and the fans presented

the team with two rabbits, appropriately named Peter Pirates and Bucs Bunny. As I've said, while a Cardinal, I was booed by the Pirate fans for an incident with a Pirate player, but once I had a Pirate uniform on, all was forgiven and forgotten.

The Chicago Cub fan seems to be a transient. It is hard to put your finger on any special characteristic. A true Cub fan can never be a White Sox fan too, and the loyal ones stick, but most fans at Wrigley Field seem to be transients on a sightseeing tour who just stopped in to say hello.

The Philadelphia fan is the worst fan in the league. This will upset the true-blue Phillie fans, but the feeling the players have is that the fans there learn to say boo as their first word. They have the loudest grandstand jockeys. Though it be the City of Brotherly Love, the loudest boo birds are perched in Connie Mack Stadium.

The Cincinnati fan is conservative. The good burghers give the visiting player the impression that, "You told me to save my money to come out and watch you, and look how you play." They have their opinions and they express them.

In Milwaukee going to the ball game is a social event. The fashionable place to be seen is County Stadium. The Braves are knights on white chargers that can do no wrong. A slam against a Brave is a personal attack on the fan. Though it has simmered down some, I think the Milwaukee enthusiasm for the Braves and major league ball will endure through bad years as well as good.

San Francisco fans, like the Milwaukee fans, are new to major league baseball. They have a good knowledge of the game and are loyal rooters, but they are there to see their beloved Giants win. Gone are the real inside baseball discussions that were so common among fans at the Polo Grounds. When the visiting pitcher gets in trouble, the Giant fan will pull out a handkerchief and wave it to upset him.

All the old clichés from high school days are heard during a game. The feeling that the visiting team is an enemy is apparent here. Each loss is a catastrophe, each win calls for a victory party. It's new, and they like it.

In Los Angeles the game is important, but everybody is constantly checking the stands to see what movie stars are there tonight. At the Coliseum the stands are so far from the field that from some seats the game must look re-created. It is a carnival air, but nothing like Ebbets Field. There is more rooting for the visiting team here because of transplanted fans. "I used to live in St. Louis and am still a Cardinal fan."

I leave the St. Louis fan until last because I think a local boy gets a distorted impression of the home team fans.

I was born and raised in St. Louis and always dreamed of playing with the Cardinals. Having gone through it, having watched a Herman Wehmeier in his own Cincinnati and a Del Ennis in his own Philadelphia, I wouldn't want my youngsters to go through it. As a local boy, you are really public property. Everybody feels they know you. To other players a good day means congratulations, but the local boy got lucky. A bad day shows them your true picture, and many do not hesitate to tell you. Fred Haney, in a speech before the Junior Chamber of Commerce in Cincinnati put it as bluntly as this: "All you guys are jealous of Wehmeier because he is making more money than you are, and the way you trim him down to your size is by booing him at the ballpark."

Somebody remembers every sandlot strike-out and spreads the word that the local boy is lucky to be in the big leagues. "I remember a game where I struck him out when he was in high school, and I wasn't even a pitcher." "He never did get a hit off us when he played in the CYC league." "His batting average was about .150 when we played together."

It's only your friends who see you as a big leaguer. To most, you represent a lucky guy who got there because strings were pulled and you represent the sandlot strike-out or pop-up of ten years ago.

Every home town boy in the big leagues wants to be a good guy and tries hard. He gives a baseball to a friend and makes enemies. "You gave a ball to my cousin who went to night school with you, and I'm his neighbor." Say you can't do it and immediately you become a big head. Meanwhile you are too embarrassed to ask for more, and they are costing you $2.50 each.

You are allowed two passes to each game. Because a fellow delivers groceries to your cousin, is he entitled to see the game free? Say you can't do it, and you not only have him going against you, but your cousin accuses you of playing the role of the big shot sloughing off a lowly peasant.

During the off season you can make fourteen appearances a week and turn one down, and you hear, "Sure, you're a big leaguer so you don't know me now."

As a visiting player, the only thing the home town fan knows about you is the headline achievements. Unless he memorizes every box score, the errors are lost in the shuffle. As a home town boy, he either sees you in action, reads it, hears it on radio or TV, or gets it by word of mouth. And they're ready for you. In a strange town people seem more friendly than they do in your own home town. That's baseball, I guess.

The Banquet Trail

The winter banquet trail is a showcase for baseball. Now that I'm in the broadcasting business, it has become an even bigger part of my life than when I was a player.

As a player, every day was a speech day for me—talking to the players in the batter's box (my best audience was Henry Thompson of the Giants), talking to the umpires (my men were Dusty Boggess and Jocko Conlan); and jockeying for position down in the bullpen with such great orators as Del Wilber or Clyde McCullough.

From the day on the hospital bed in 1950 when I was told that this injury could have ended my playing days, I made a real effort to become a talk-for-pay guy. Every day I agitated Harry Caray, the St. Louis Cardinal broadcaster, about what a soft job he had. His answer was that if I could hit like I could talk, I wouldn't have any worries. The kidding got on the square when he kept encouraging me about a future in broadcasting. Harry was a big help to me as a broadcaster.

But there was a beginning before that—in the many Cub

177

Scout, Boy Scout, service club, and religious group meet-
ings I made as a player. Being a local boy playing with the
home town team, I was obliged to make every function. Any
group that thought it would be nice to hear a player—there
went Garagiola. Bing Devine (now general manager of the
Cardinals) and Jim Toomey were my bookers when I was a
player. The usual opening line was "Joe, I'm on a spot, help
me out." Away I would go. It was simple, because what the
fans wanted was authentic baseball talk. Blue and Gold ban-
quets (Cub Scouts) in February, Holy Name meetings on
Thursdays, Communion breakfasts on Sunday mornings,
Men's Club meetings on Monday, and Smokers when I could
make them. It got to where I was going to more meetings in
Protestant churches and Jewish temples than, maybe, any
Catholic in history.

The Blue and Gold banquets give a player his toughest
audience. These youngsters have the energy of four hydrogen
bombs each. You can't talk long about anything without a
restless reaction. They want action and right now. I always
fortify myself with group team pictures or autographed base-
balls, and I even bought a few simple magic tricks. My ace
in the hole for the Cubs is a long and complicated story about
a wild left-handed pitcher in the Philippines. It ends up with
a left-handed pinch-hitter, who decides to bat right-handed
in the twelfth inning of a 1 to 1 tie game and who gets a long
hit off our left-handed pitcher hero but who runs the wrong
way—third, second, first and home—and unties the score, so
we win 1 to 0 after all. It takes a story like that to hold the
interest of a modern kid. In my day as a kid, all we hoped
for was a chance to look at a major league player without
getting run by the cops.

Al Rosen, a former star in the American League, once said
it best about meetings with the kids: "They are great because
they always ask How and not Why." Though there are never

any honorariums or fees involved, I do have a championship collection of pins, letter sweaters, and honorary cub pack memberships to show for my time at the Blue and Gold.

The easiest audience is the one where the ladies are present. Regardless of the affair, it's a night out for them, and they are there to enjoy themselves. Men-only audiences are challenging. It's either, "Okay, I heard you're supposed to be funny, so make me laugh," or the speaker is a conventional evil who prolongs the time until the poker cards are dealt. If it is a repeat performance, it is doubly tough because you start to tell a story and the punch line is thrown back at you. Even though there are usually no fees involved and you come as a ballplayer, you are expected to be loaded with fresh material that would make Bob Hope's writers appear to be suffering from melancholy.

The banquet trail is well-scouted. Make a talk at a Kiwanis meeting, and you get a demand call from the Optimists, the Rotarians, and the Jay Cees, to say nothing of other civic and fraternal organizations. It really is a merry-go-round.

"You made the Downtown Club, don't you think we're good enough?" The usual inducement is, "We'll give you a good meal." What do they think I eat at home, fried catcher's mitts? As a player, it's a tough trail to walk, because you are always on display, and you are looked upon as public property. "We pay your way," is the pitch thrown to the players. The program chairman may be a successful man used to dealing in and paying for services, but he often takes it as the supreme insult if a player suggests an honorarium, or even travel expenses, for entertaining his club. The idea is that it is an honor to be invited. However, the player's material must be new or he is told off. Most luncheon clubs have a one-thirty deadline, and you had better be finished (regardless of when you got started) by then. If Moses were to do a repeat with the Ten Commandments at a luncheon meeting,

he had better get in all ten by one-thirty, or he would find himself in an empty room.

A banquet can be defined as a meeting of more than five people with the idea of killing an evening with a formal program. I use the number five, because I once appeared at a banquet attended by five. I was told by the secretary that he had sent out the wrong date, but he had called these two couples. "If you want to make your speech, we'll stay and listen." (Turn this organization's requests down next year, and you are a swell-head.)

The player who says he will come has to get there—regardless. I have been through snowstorms, sleet, rain, and washed-out highways. During a big ice storm, I telephoned to try to postpone a trip to central Illinois, but it was impossible according to the chairman. I tried to get to the depot in time to catch a train that would get me forty-six miles from my city (no train went to my destination), but traffic was so tied up I missed the train. I explained my plight to a cab-driving friend who said he would drive me up. We went . . . 165 miles of icy highway . . . we made it . . . there were twenty-five people there, and the chairman explained: "We would have had a bigger crowd, but you know it's pretty nasty out and people don't like to leave home on a night like this. . . ."

Yogi Berra came back to St. Louis for a visit with his family and was asked to make an appearance in a southeastern Missouri town. He tried to turn it down as graciously as possible, but the chairman wouldn't take no. "I don't have my car here and will have to take a train," Yogi said.

"That's okay, we'll pay the expenses." Yogi went. Upon asking for his train fare, he was told, "If you can't afford to pay your own way down here with the money you're making, we'll take up a collection for you."

But the banquet trail for me has been a wonderful ride. I started broadcasting in 1954, but my first real big banquet was in St. Louis, while I was still a player and living the peaceful life of a .250 hitter. One night I got a call from Biggie Garagnani, a restaurant partner of Stan Musial. It was after midnight, and I was sound asleep. "C'mon over. I gotta see you right now. It's important."

My friendship with Biggie went back to 1946 when he was chairman for Joe Garagiola Night at the ballpark. When I was sent back to the minor leagues in 1948, Biggie, outside of my family and a priest friend, was just about the only fan who knew I was still alive. So when the call came, I went.

With Biggie was Bob Broeg, then a sports writer and now the sports editor of the St. Louis *Post Dispatch*. Bob started in. "Joe, tomorrow Stan Musial is going to be presented with an oil painting of himself, and Biggie has a luncheon party all set up. You are going to introduce all the people that will be here."

"Introduce them! I don't even know them."

"We'll tell you a little bit about each one, and you can make up the introductions. Do it as a favor to me," said Biggie.

So I introduced the big people—from our city mayor to a visiting Hollywood star, and tried to say something funny and appropriate about each. One of the men introduced was Al Fleishman, public relations consultant to Anheuser-Busch. Later, Al told me that he made a note that day that the time would come when I would be making my living as a talk-for-pay guy.

Since that time I have been fortunate enough to make most of the major banquets in the country. The New York Baseball Writers, Washington Touchdown Club, the Hickok Award banquet in Rochester, the Dapper Dan in Pittsburgh,

Baltimore Writers Dinner, Milwaukee Writers, Philadelphia Writers, Los Angeles Writers, the Arkansas Hall of Fame, and many more.

Pittsburgh has been my good luck town. It was there I made my first appearance as a speaker outside St. Louis. I was a player. Chilly Doyle, the wonderful sports writer for the Pittsburgh *Sun-Telegraph,* was being honored. Chilly had always been good to me, and I kind of wanted to say thanks so I attended. Chilly always seemed to get a kick out of the broken English, Tony Paciagalupe Italian conversation I would give him in the clubhouse. Seeing me in the audience, he asked me to speak. All banquets are scouted. In this audience was Al Abrams, sports editor of the Pittsburgh *Post Gazette* and major domo behind the big Dapper Dan banquet held each winter in Pittsburgh. He asked me to be a speaker on his program for the coming banquet. From there I was asked to the Hickok banquet in Rochester and that led to the others.

The banquet trail is a front-running trail. Grab the brass ring during the World Series and the banquet merry-go-round is yours. Dusty Rhodes grabbed it in 1955, Don Larsen in 1956, Lew Burdette in 1957, Bob Turley in 1958, and in 1959 it was Larry Sherry. Often, though, the plaques and trophies that glitter in January and February seem to haunt a player during a slump the next July.

All players with any experience on the banquet trail appreciate how Ol' Pete Alexander felt when he came to another dinner and said, "Let's change it a little tonight, and let Lazzeri get a hit."

An athlete who used to train hard during the winter months for the next season may find himself on the banquet trail instead, being compared to the Walter Johnsons and Babe Ruths. The hours are tough. It's a cocktail party before each banquet and a celebration after. In each city, the ban-

quet is a big event on the sports calendar. Once over, it is a sigh of relief and a "Well, that's over for this year." But the star is on a plane to the next city to be met by the anxious chairman who feared he was snowed in and wouldn't make it.

The star can't take the next banquet for granted, or it will show, and he will disappoint the fans. He's got to come with fresh enthusiasm to each one.

I have sat at head tables with a good many of the stars. (Usually I can see fingers pointing at me and can almost hear the fans asking one another who that is, sitting next to Musial or Burdette.) The greatness of some of the stars comes through the microphone, no matter how simple or brief their words.

I remember the Hickok Belt Award dinner at Rochester as typical of the way some of the greatest athletes respond at banquets in their honor. Being honored that night were Mickey Mantle, Yogi Berra, Floyd Patterson (then heavyweight champion of the world), basketball star Bill Russell, and hockey star Jean Beliveau. Mantle and Beliveau simply said thanks for inviting them. Yogi said he made two speeches a year, one at contract time and one to the hitters in the batter's box. Floyd said that he had a speech all written but had forgotten it at home. And Bill Russell kidded Mickey about reporting the value of the expensive belt he had received as income. None a speaker, but all of them came through as champions in their own line.

Of all the stars and brass-ring winners I have known, Stan Musial gets my Number One place for being the most cooperative with fan groups and sports people on the banquet trail. He has been at it for many years, and he still regards it as an important part of the game in which he has earned fame and fortune. Lew Burdette is another of the most cooperative.

After his three wins in the 1957 World Series, Burdette had to pitch almost every inning over again on the banquet trail,

and he did it with the class of a true twenty-game winner. He had many commitments, and he made them all. Of him you never heard it said: "That dirty so and so was in Pittsburgh and Chicago, but he didn't come here like he promised."

Wherever he went, Burdette was always being ribbed about the controversial spitball. I know I always said I didn't know if he threw a spitball or not, but there was a player with the Dodgers who always put windshield wipers on his glasses when Burdette pitched. Jack Buck, St. Louis broadcaster, said that one day Burdette was pitching while wearing a Ted Williams glove, and when he put the ball in it, the glove spit back. At the Pittsburgh banquet Burdette was told that he had trouble pitching on hot dry days and that he pitched like Bridgitte Bardot walks—the only pitcher in baseball that could make coffee nervous.

Listen to this for a month and a half while being told that you are the greatest pitcher ever, and you can see you would need a strong constitution to get to the end of the banquet trail.

Burdette was a Herb Shriner, folksy type speaker. He never exactly denied the spitter. He would just say that his best pitch is one that he doesn't throw. He did admit that he had an FDR pitch . . . fire, duck, and run.

The funniest of the stars I have ever heard was Dusty Rhodes after the Giants World Series victory over Cleveland in 1954. His was a deep Alabama style. He relived every pinch hit and gave the impression that he knew all the time that he could do it. He hinted that if Durocher (the manager of the Giants that year) would have used him more, they could have clinched the pennant sooner. Dusty would always get to his fielding. "One day in Chicago, Durocher put me in for defense . . . ain't that a joke? Wanted to rest Monte Irvin. Anyhow, there I am in left field. The first ball comes out and I drift under it . . . I think . . . and the ball lands

behind me. But Leo's got confidence in me. One out later another one comes in my area, and I know I got it centered but it must have hit an air pocket because it goes about ten feet behind me. One out later and three runs later, here it comes again. I got a good jump on this one . . . the wrong way but a good jump . . . and it lands five feet in front of me. With some fast fielding I held my man to a triple, and now I call time. I run into the bench. 'You want sun glasses?' Leo asks. 'Sun glasses! Give me a helmet before I get killed!' "

Dusty was one of the few that returned to many a banquet the next year even though it wasn't his year to grab the hot hand.

Danny Murtaugh is also a big hit on the banquet trail. Being a scrapper, most of his stories are about umpires, and Danny being Irish, most involve Jocko Conlan.

"We're playing the Cardinals," Danny takes off. "Conlan is behind the plate. I got the count to three and two and here comes one I think is across my eyes. Conlan calls it strike three. Well I gave him a little beef, and finally he throws me out of the game. So now I stop and I say to Conlan, 'Jocko, just look around the infield. Musial, a Pole, at first base. Schoendienst, a Dutchman, at second base. Marion, I don't even know what he is, at short, and Kurowski, another Pole, at third base. Pollet, a Frenchman, is pitching, and look behind the plate—Garagiola, a spaghetti bender. There are only two Irishmen on the field, and you want to throw half of us out!' You know, he let me stay in."

Casey Stengel keeps everybody laughing, but afterwards nobody can remember exactly what he said, if anything. Vice President Nixon, after a Stengel treatment, asked Dizzy Dean if he could talk Stengelese. "Naw," said Diz, who can roll on like the Wabash Cannon Ball, "I ain't that good."

Yogi Berra is very funny when he gets rolling, but I think the best Yogi stories are the ones told about him. Jackie

Farrell, who represents the Yankees on the banquet trail, tells about the time he had to telephone Yogi real early one morning. "Yogi, did I get you out of bed?" Jackie asked. "No," said Yogi, "I had to get up to answer the phone anyway." And Umpire Larry Napp recalls the time he was walking out of Toots Shor's old restaurant with Yogi, who was carrying a big clock he had been given at the banquet. A drunk bumped into Yogi, "Excuse me," Yogi said. The drunk looked at him indignantly. "Why can't you wear a wrist watch like everybody else?"

Fred Haney, after winning his first World Series as manager of the Braves, told how his star, Henry Aaron, stopped Yogi Berra as a conversationalist at the plate. When Henry came up to hit, Yogi noticed that the trademark on the bat was down. "Henry," Yogi said, "you don't want to break that bat. Better turn it around so you can read the trademark." "Yogi," Henry replied, "I didn't come up here to read."

Yes, you hear a lot of wonderful stories on the banquet trail and a lot of wonderful things happen to you. A boys' club in Peru, Illinois, once gave me a clock with a picture of each player on their championship team set in over the numerals. Once I got a box of hard candy and overalls for my sons, Joey and Steve, as a token of appreciation for making a banquet. Another time I lugged home three trees to plant for my wife, and some friends in Billings, Montana, gave me a deer head and a buffalo head to take home to St. Louis. I got a gold baseball from the bantam team of St. John the Baptist and a prayer book from the kids at St. William's. An Illinois farmer insisted upon my coming home with him after a banquet, and he gave me two dozen fresh eggs, and the Elks once gave me a camera.

I went to the Lighthouse in St. Louis to make a talk before the blind. At the door, one of them was waiting for me. "Joe," he said, "don't feel sorry for us. You probably haven't been

around blind people much, so just grab my arm and I'll show you what to do." The twenty-two blind people present started to sing, "Take Me Out to the Ball Game," to welcome me. "What do you mean I haven't been around blind people?" I said to my guide. "I worked close to umpires, didn't I?"

At times I wish there were ground rules for the banquet trail. To many a player a banquet is real torture. It is just not his nature. He likes banquets, he thinks they're wonderful— but not for him.

The summer season is one of plenty of travel, and the winter time is the time he has for his family. No award is as treasured as a night with his family. He doesn't owe it to his public, he owes it to his wife and kids. It may be just "one night" as far as your organization is concerned, but every organization feels the same way.

In my case it is part of my job, as it is with Lefty Gomez, Rip Collins and others who have gone to work for individual companies. For the players, though, organizations would make the banquet trail a lot more pleasant if they observed these ground rules:

1. Don't lie about the schedule to make sure the personality gets there in plenty of time. If you want him at seven, don't say five and have him sitting around.

2. The player thinks his kids are great, too, and gets tired of seeing pictures of somebody else's Junior in a baseball suit followed with the remark, "I bet my kid can hit better than your kid."

3. Get your biographical information straight. Get him on the right team and pronounce his name right. I didn't mind it, but I'll bet Joe DiMaggio would do flips if he heard me introduced as him.

4. In introducing him, don't embarrass the player by making him greater than his record. Each year I don't play I get better. The first year on the banquet trail I was a former

ballplayer, the second year I was great, the third year one of baseball's stars, and just last year I was introduced as one of baseball's immortals. The older I get the more I realize that the worst break I had was playing.

5. If a player comes any distance, offer to pay his expenses.

6. Be as courteous after the banquet as before. I have been met in some cities by the mayor; after the banquet, nobody even said good-bye.

7. Let the ballplayer make his own social plans in your city. He'll tell you if he has nothing planned. Sitting around your living room after the banquet with your boss can be pretty rugged.

8. Tell the player beforehand what you have planned for him. He may have something else planned, and your request to visit a hospital puts him in a tough spot.

9. Give the player a break next time you meet him after the banquet. Even though you have every right to think he will remember you, keep in mind that he has seen many faces and heard a lot of names since then. So don't go up and say, "How've you been, Joe? Remember me?" Instead, say: "Joe, I'm Mr. Smith. We were together during the Father and Son banquet in Jonesville." He'll appreciate it, and, if the situation is right, he might say: "How ya been, Mr. Smith. We had a time that night, didn't we? I want you to know Stan Musial. Stan, this is my friend, Mr. Smith from Jonesville."

The Windup

When I was a kid on The Hill, I dreamed of being a big league ballplayer, and the Hall of Fame was my destination. After I left the boy's world where you hit make-believe grand slammers and had entered the man's world between the foul lines where you take pride in drawing a walk, I realized that only the real greats make the Hall of Fame and that I was going to fall short. It was about then that baseball began to mean more than just a game to me.

Baseball gives you every chance to be great. Then it puts every pressure on you to prove that you haven't got what it takes. It never takes away the chance, and it never eases up on the pressure.

Baseball is played out in the open where people pay their money to come and watch and players respond to test and challenge and pressure. An egghead friend of mine says that baseball is a popular art form the way the Greek theater in olden days was a popular art form. It's variations on ancient themes. He says people come to the ball games today the way they went to the theater in the days of Sophocles and

189

The Garagiola Page in The Register

Year. Club.	League	Pos.	G.	AB.	R.	H.	2B.	3B.	HR.	RBI.	B.A.	PO.	A.	E.	F.A.
1942—Springfield	W.A.	C-OF	67	181	20	46	4	1	5	26	.254	246	26	13	.954
1943—Columbus	A.A.	C	81	205	27	60	7	3	4	27	.293	246	27	9	.968
1944—Columbus	A.A.	C	1	3	1	0	0	0	0	0	.000	2	1	0	1.000
1944-45-46—St. Louis	Nat.					(In Military Service)									
1946—St. Louis	Nat.	C	74	211	21	50	4	1	3	22	.237	260	25	3	.990
1947—St. Louis	Nat.	C	77	183	20	47	10	2	5	25	.257	281	23	4	.987
1948—St. Louis	Nat.	C	24	56	9	6	1	0	2	7	.107	83	14	1	.990
1948—Columbus	A.A.	C	65	202	38	72	11	3	7	45	.356	249	19	8	.971
1949—St. Louis	Nat.	C	81	241	55	63	14	0	3	26	.261	332	35	6	.984
1950—St. Louis*	Nat.	C	34	88	8	28	6	1	2	20	.318	99	8	0	1.000
1951—St. L†-Pitts	Nat.	C	99	284	33	68	11	4	11	44	.239	336	36	4	.989
1952—Pittsburgh	Nat.	C	118	344	35	94	15	4	8	54	.273	418	63	11	.978
1953—Pitts.‡-Chicago	Nat.	C	101	301	30	79	14	4	3	35	.262	378	44	5	.988
1954—Chicago§-N.Y.	Nat.	C	68	164	17	46	7	0	5	22	.280	208	23	4	.983
Major League Totals			676	1872	228	481	82	16	42	255	.257	2395	271	38	.986

*Suffered shoulder separation in game, June 1; out most of season, appearing in 11 games at finish of 1950 schedule.

†Traded to Pittsburgh Pirates with Pitchers Howard Pollet and Ted Wilks, Infielder Dick Cole and Outfielder Bill Howerton for Pitcher Cliff Chambers and Outfielder Wally Westlake, June 15, 1951.

‡Traded to Chicago Cubs with Pitcher Howard Pollet, Outfielder Ralph Kiner and Outfielder-First Baseman George Metkovich for Pitcher Bob Schultz, Catcher Toby Atwell, First Baseman Preston Ward, Infielder George Freese, Outfielders Bob Addis and Gene Hermanski and estimated $100,000, June 4, 1953.

§Released on waivers to New York Giants, September 8, 1954.

WORLD'S SERIES RECORD

Year. Club.	League	Pos.	G.	AB.	R.	H.	2B.	3B.	HR.	RBI.	B.A.	PO.	A.	E.	F.A.
1946—St. Louis	Nat.	C	5	19	2	6	2	0	0	4	.316	22	2	0	1.000

Aeschylus. The people know what it's all about, but nobody knows how it's going to work out this time. In baseball, how can you tell how it's going to work out when the script for today's game is always written by those great collaborators, Ability, Pressure, Heart and Luck?

Baseball is just a boy's game that men play to make a living. Most people don't play games to make a living. They do serious and important work. But in most lines of work, there is no record. The good things you do often go unnoticed or are quickly forgotten, and the mistakes you make mostly go the same way.

Baseball is only a game, but they keep a book on you. All the hits you make and all the runs you score and all the errors you commit are marked down for all time. When it's all over for you, the game has got you measured.

Here is my page, my lifetime record, from *The Baseball Register*.* I would say it's about an average record for a major league player. I don't mind saying that I think average for a major leaguer is pretty good.

When I was a kid, I dreamed of going great in a World Series. You will note from the record that baseball gave me a chance in the World Series of 1946, and that I hit .316 and made no errors and helped the Cardinals win the World Championship from the Red Sox. As a player, that has to be my greatest thrill, being a part of that championship team.

Baseball means to me that nobody can make it alone. You've got to have it all alone, but you can't do it alone. You've got to get along with the other guys and play ball with them. You don't have to like them, but you have to play ball with them or quit playing ball.

Baseball means to me that everybody has got a chance. It's like what the United States of America stands for. But it's more honest in the game than it is in the real thing. In base-

* Reprinted, by permission, from *The Baseball Register*, published by *The Sporting News*, St. Louis, Missouri.

ball they don't give you anything but a chance. Nobody tells you that you can make it. That's up to you. But they give you a shot at it.

Baseball is a game where a little guy has got a chance, where a kid who wears glasses has got a chance, and where a black kid has got a chance. Let a double play ball come to the shortstop. Does he ask himself if the second baseman is Catholic, Baptist, Jew, Methodist, black, white, or polka dot? He knows this is the guy he is going to make a double play with if there is going to be a double play. So he shows him the ball, if he can, and feeds it to him at eye level the best way he can to help him make the double play.

Baseball is a game of race, creed, and color. The race is to first base. The creed is the rules of the game. The color? Well, the home team wears white uniforms, and the visiting team wears gray.

In baseball you're with every guy on your club and you're against every player on the other club from the time the game starts until it's over. You've got your whole club with you, too, but you're all alone sometimes where they can't help you.

Go to a Little League game, where all the parents come out to cheer their kids, and watch a ten-year-old boy step in the batter's box with the tying run at third, the lead run at second, two out in the ninth. The kid may wish he was home watching the Lone Ranger be brave on television. But he has to do it. It doesn't make any difference then whether his father is a banker, a baker, or in prison. Right then, what his father is can't help him. The kid has to stand up there and strike out, pop up, or get the big hit. He has to stand up there alone, and what counts is how he bears down.

The kid doesn't fail if he doesn't get the big hit. Stan Musial, with one of the greatest batting records in the history of the game, only gets about three hits for every ten times at bat. Does that mean that he fails the other seven times?

You stand up there alone and bear down.